THE LOST LANDSERS

D1597378

THE LOST

THE UNPUBLISHED PHOTOGRAPHIC HISTORY OF THE GERMAN ARMY

LANDSERS

SAND, SNOW AND MUD 1941–1942

VINCE MILANO AND PAUL BOTTING

In a scene that occurred in the not so distant past – yet a lifetime ago to most of us – an aged First World War veteran crouches in a culvert, where, decades before, he did just the same to save his very life. Watching him from above, as he re-lived the story of this moment, burned forever into his memory, was his son. His son had also served in the army, but at that moment he was fixed with a curiosity and drive that would fill his life from then onwards. His goal would be to keep the history and experiences of these veterans fresh in the minds of each young generation that he would interact with. Countless hours of research before delivering talks, lectures and taking tours to those old battlefields would bring alive the soldiers of the past he talked about. Those young people gained a rare insight into the Great War that they would otherwise not have had the chance to experience. In many cases it sparked a desire to learn more about their own ancestors whose fate they did not know. With his friends – affectionately known as the 'Harvey Pals', named after the school they taught in – this man kept a vital part of the historical record alive for those of us in ensuing generations. With great respect, we therefore dedicate this book to John Frederick Botting.

Thanks to the following for their support, encouragement and assistance: Vincent J. Albergo, Valerie and Jon Byron, Chris Coxon, Monica Dresler, Robert Jordan, Elizabeth Milano, Joachim and Martin Scholz, Guenter Schramm, Sergey Uskach and Ken Williams.

First published 2013

The History Press
The Mill, Brimscombe Port
Stroud, Gloucestershire, GL5 2QG
www.thehistorypress.co.uk

Typesetting and origination by The History Press
Printed in Great Britain

Contents

Preface

SAND, SNOW AND MUD – THE DISTANT BATTLEFIELDS

THIS WORK IS INTENDED to take the reader on a pictorial journey, retracing the steps of the German Army soldier, the Landser, as he travelled to lands far from home during the war years of 1941 and 1942.

The German army of this era was composed of men doing their national service, a system which was reinstated in the 1930s after a period where this was prevented by the Versailles Treaty. This service was a much honoured tradition in Germany since the time of Frederick the Great. These Landsers who had already gone through the heady days from 1939 to 1940 had yet to experience the bitter taste of defeat, knowing up until then only the pride, confidence and laurels that come with victories. This army was constantly bolstered by new recruits tempered to a fine fighting edge by the rigorous training that built physical endurance and strength. Instilled in them was a disciplined spirit and drive to function together as a well equipped, formidable fighting force. The younger Landsers yearned to show their military prowess and gain the same laurels as their older brothers-in-arms.

As the last minutes of 1940 ticked away, to the excited revellers across Germany that cold winter's night, these Landsers were, as yet, unaware where their fortunes would lie in the New Year. 1941 would bring major offensives: North Africa in February, Greece and Yugoslavia in April and the invasion of Russia, Operation Barbarossa, in June; the occupation duties in countries that had already fallen to the German Reich notwithstanding: France, Norway, the Low Countries and Poland. The massive amounts of materiel to support the hundreds of thousands of men while they stood guard in out-of-the-way places, not engaged in any of the campaigns, was staggering. Yet the Landser was confident of victory.

PREFACE

The overall history of these campaigns has been heavily documented over the ensuing years and as such this work is not intended to a be a detailed analysis of each battle. Quite the opposite, as this work delves into the less well known individual experience of being a soldier in this German Army during these years. The memories of these men have, in most cases, been lost to time as the number of veterans of all sides steadily declines. Father Time favours neither the victor nor the vanquished.

We are fortunate that what does remain is a photographic legacy, which enables us to see the war through their eyes. The 1930s saw camera technology evolve to the point where they were small enough to be carried easily and were affordable. Even so, they were not as simple as the digital point-and-click cameras we have today, of course. The extremely limited availability of film or developing in the field, compounded with the relative expense, forced those intending to use cameras during their military service to be much more selective in their choice of subject matter. Indeed, it was not always easy to operate a camera in the field. In sub-zero temperatures, the available cameras ran the risk of not functioning. In the desert, sand is the enemy of delicate instruments and it would not have been easy to mend a camera in the field once it was contaminated.

The photographs that follow were the images of these events seen through the eyes and captured in the lenses of ordinary Landsers during *their* war. These are not propaganda pictures designed to portray the all-conquering Germanic heroes of the Reich, rather they are a record of the everyday life and experiences of men who most likely would have preferred to have been at home with their loved ones than in the cold winter of the Russian Steppes or the sandy emptiness of the North African Desert.

What is important about these photographic records is not the quality of the images but the content. We make no apology for some of the poor technical detail. Each of these pictures meant something to the Landser who snapped it; enough for him to use some of his precious film. A pleasant souvenir perhaps of some place he visited, passed by or marched through. Perhaps reminders of some happy activity he was involved in with *Kameraden*. Or maybe it was a record of some hellish experience, travelling the never-ending dusty or muddy roads, a frost-bitten wintery hellhole, a mosquito-infested swampland, a sweltering camp in the desert. Then there exist those of a more personal nature: a friend's crudely marked grave in a place far from home, death and destruction rained onto an enemy convoy, or a post-action reminder that one was still alive.

There are some combat pictures but photos of this nature are of course few and far between, because there was little time or motivation to use a camera as bullets were flying and such activity was discouraged by leaders.

PREFACE

While this work focuses on the life and experiences of the average soldier in the German army during these years, it is not intended to be viewed as a glorification or justification of the regime under which he served and fought, but rather a glimpse into his military service.

It must be remembered that the Landsers whose photos are documented in this work were not the commanders, who knew the big picture. These men only knew the war as it affected them personally; one real truth of war known by every soldier who ever wore a uniform is that the view from the foxhole is vastly different from the view at the map table at headquarters.

1941

DAYS OF GLORY

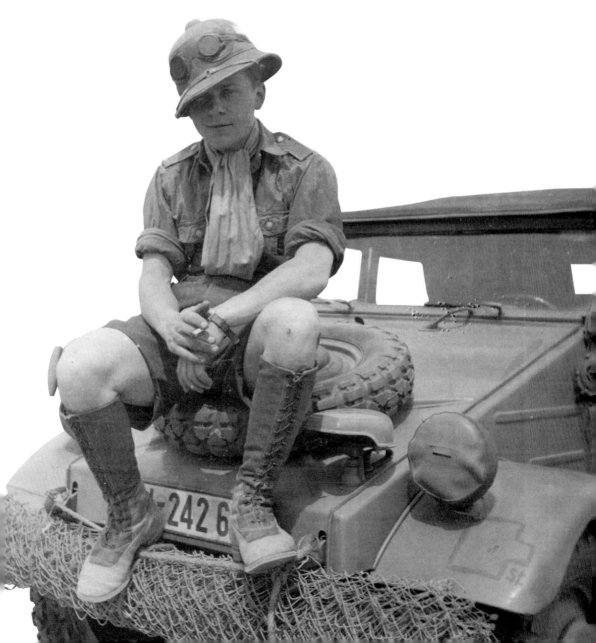

WHEN THE CLOCKS STRUCK MIDNIGHT on 31 December 1940, voices throughout the greater German Reich cheered and whistles greeted the New Year. There was good reason to be this happy. While the war had been going on for sixteen months and families had lost sons, fathers and other relatives, these casualties had been minimal. Both 1939 and 1940 had been years punctuated by thundering victories. Most felt that it was only a matter of time before Great Britain, fighting on alone, would ask for terms. Yet, as in all eras of history, an accretion of small things was in train that would bring the German Landser to distant battlefields most never expected to see.

In February a young Lt. General by the name of Erwin Rommel is named head of the German troops embarking for North Africa to aid the Italians; this force was to be called the 'Deutsches Afrikakorps', DAK for short. By the middle of the month Rommel is in Libya; a week later the DAK and British 8th Army clash for the first time, thus beginning a campaign that would create legends and heroes for both sides. Also in February, German troops move quietly through their allied state of Bulgaria towards the Greek border, again to assist Mussolini's forces, who are in deep trouble fighting the British and Greek armies.

March 1941 roars in with Rommel going on the offensive in North Africa but, in the Balkans, things go bad politically for the Axis powers with the deposing of the German-backed Prince Regent Paul and the crowning of the anti-German king, Peter II. This alters Hitler's plans for an early invasion of the Soviet Union because now he must have his military secure Yugoslavia. But by the end of April 1941, despite hard-fought campaigns by the Allies, both Yugoslavia and Greece are vanquished and are now occupied by the Axis.

The stage is now set for Hitler's largest effort of conquest to date and the largest operation mounted by the German Army during the war, the invasion of the Soviet Union. Thunderous barrages fill the skies and shatter the earth along Soviet-occupied Poland's frontiers. The drive to the east has begun; advancing into the rising sun, determined, disciplined and dusty soldiers head towards Moscow, confident of taking the city by the end of summer. From the Steppes of Russia to the Saharan Desert, Landsers will fight.

The Landser had started this year pleased with his contribution to the winning of the campaigns in Poland, France, Belgium, Holland and Norway. Many were demobilised and sent home just before Christmas 1940. Some hoped that the war would be over by the spring. This was not to be. Both veteran and green troops would see a very different war than that of the Blitzkrieg. The resistance grew tougher, the terrain was harder and the weather was extreme. His war changed, so he had to change. New uniforms and equipment were issued and new skills had to be learned. The Landser would see strange and exotic places,

meet different peoples of many races; many of which his government told him were inferior. These sights and experiences would change them: some were good changes and others were bad. Not just the faceless enemy, but comrades and family would die. The Landser was no different than any other soldier in any other army. That year began with him surrounded by the men he served with, many of whom would not survive the year. He may have had a brother who would fall on the battlefield. Like his English enemy, he could discover that his family had been killed or displaced from their home in an air raid while he was fighting at the front. This war was to be fought everywhere and anywhere on a scale none of these men had ever thought possible.

The Landser would face a war of certainties and possibilities. It was certain that he would, at some time, be sent to fight in Russia. It was possible he might be sent to North Africa to fight in the desert, though not as likely owing to the small size of the DAK. He was certain to be stationed on occupation duty somewhere on the continent of Europe before or after service on the Eastern Front. In the end, there was the certainty that he would endure another year of war far from home, sometimes flushed with the elation of victory and other times drained by the sobering sting of defeat.

The Landsers' theatre of operations – 1941

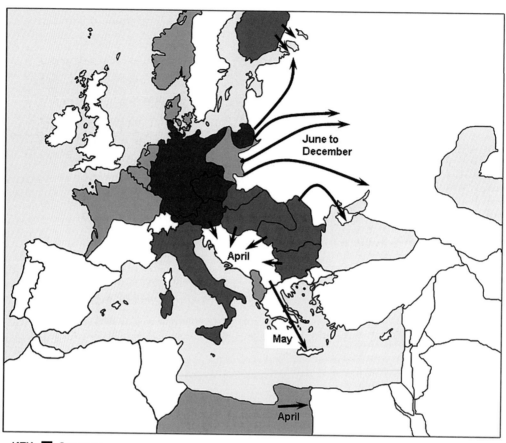

KEY: ■ Germany
■ Axis
■ Occupied

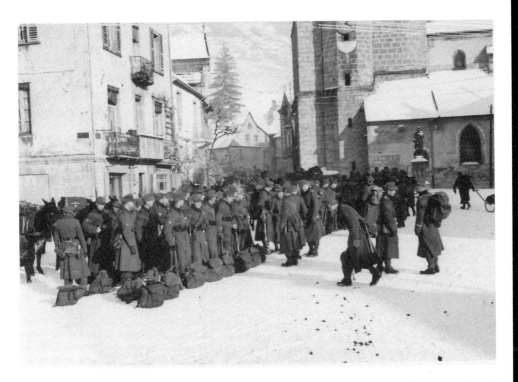

The year begins in relative peace for the men of the army. The Landser has won the campaigns in Poland and the West. Although an invasion of England did not materialise because of the failure of the Luftwaffe, many soldiers did hope for a negotiated peace. 'January 1941 – On our way to Oslo for duty' reads the caption. These *Gebirgsjäger*, Mountain Troops, wait to move out for occupation duties in Norway, a fairly easy station at this time.

February 1941: General Erwin Rommel arrives in North Africa to lead the newly formed German relief force for the Italian Army. It was to be called the *Deutsches Afrikakorps*, or DAK. This was to become one of the most famous and effective German military formations in history. Here an eager Rommel in his newly tailored tropical uniform confers with senior Royal Army officers. Technically, he is under their command. This will change, as will British thoughts of a quick victory in this theatre.

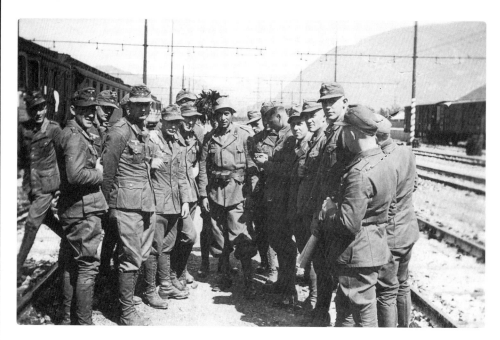

En route to Libya dressed in the issue tropical uniform, these men from the quickly formed 5th Light Division, later to become the 21st Panzer Division, chat with two Italian soldiers while at a rest stop on their long train ride south. The soldier in the centre is a *Besaglieri* with the distinctive black cockerel feathers on his M-33 helmet. These were well trained, highly mobile, light infantry units who fought with distinction in many campaigns. The soldier to the right wears the M-34 Field Cap. The uniforms and men of their Italian ally are a novelty as this new adventure gets underway.

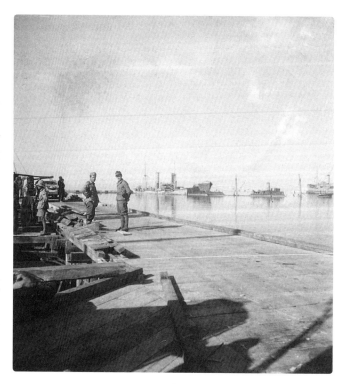

The first troops and equipment arrive in Libya. A German and Italian NCO confer about unloading on the docks in Tripoli in February of 1941, a serene and orderly view in a world at war.

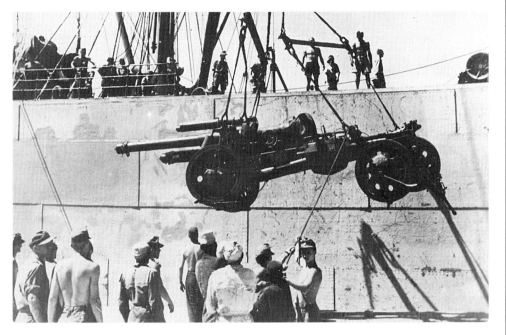

Carefully, quickly, the fledgling DAK unloaded everything that arrived in Tripoli. Rommel was going to move fast and hard against his British adversaries. In this instance a 15cm *schwere Feldhaubitze* 18, 150mm howitzer is lowered down to the dock in a joint effort by Germans, Italians and Libyans. It will be hooked to a waiting vehicle and moved to one of the many Lagers being set up by the DAK after the long voyage from Germany.

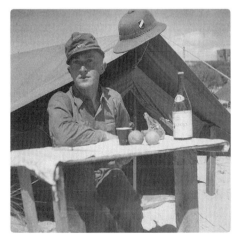 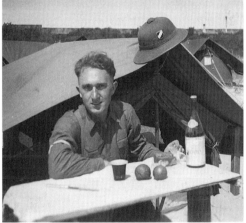

In one of these Lagers two fresh-faced soldiers of the DAK (no sun tan or scars from windblown sand yet) take their first souvenir photographs to send home. They show happy and proud young men, with food and wine upon a ramshackle table. Behind them is their new style of tropical tent, not the standard issue four-man shelter made from *Zeltbahns*. Their uniforms still have the deep olive colour, untouched as of yet by washing and fading in the sun. Perched atop the tent is the new Tropical Helmet as issued by the DAK, another indication to those back home that these men are on a very distant battlefield.

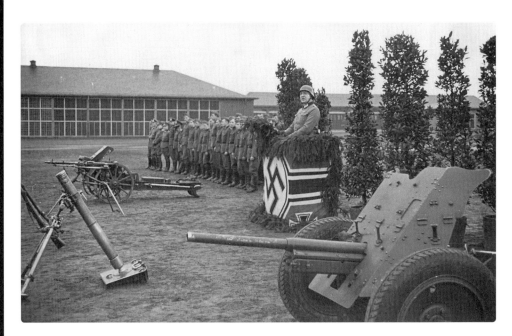

In Germany the Army still grows. A graduation ceremony for infantry recruits who have completed training is underway in the spring of 1941. With the officers and instructors lined up on his right and the weapons of the infantry arrayed to his front, the commanding officer of this training detachment, a rather portly Colonel, addresses the new Landsers. He is wearing his helmet as an indication of being 'Under Arms' as a soldier, as these men would now be. The arms displayed in front of him from right to left are a 7.5cm le.IG 18–75mm infantry support gun, MG-34 on tripod, stacked Kar-98k rifles, 8cm *Granatwerfer* 34–80mm mortar, and PAK 36–37mm anti-tank gun. The podium at which he speaks is adorned with the *Reichskriegflagge*, the German Battle Flag, which is traditional for this type of event. However, this flag has been placed upside down: note the Iron Cross on the bottom right. Someone probably got chewed out after this ceremony. The men he addresses will be sent to units as replacements. Each depot fed certain units with men, not the Army in general. This group would head to a garrison in Prussia, for now.

Right: Far away in the Libyan Desert, the same kind of shovel as top right finds its true purpose. This Panzer crewman was snapped just before he started the arduous task of digging the defensive position for the crew when resting outside the tank. The smile on his face is one that gives away his true feelings – 'I may be smiling but I am not happy about this'. He wears his issue sweater because in the desert the nights and early mornings are quite cold. To the upper left of the photograph is the dark outline of another Panzer behind a sand dune, also dug into a protective position.

In occupied France, life was not so bad. Here three Landsers mess around for the camera. The preoccupation with wearing civilian hats in uniform, as is jesting with a shovel or other implement, is a common joke among soldiers. France was good duty at the beginning of 1941. The image is captioned 'Waiting outside the Regimental Signals Centre. Gustav, Wilhelm and Erwin, France, Spring 1941'.

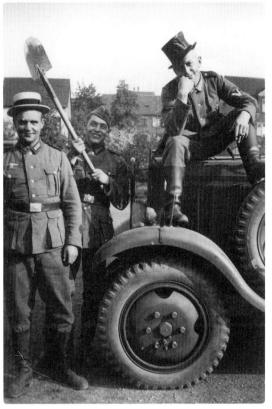

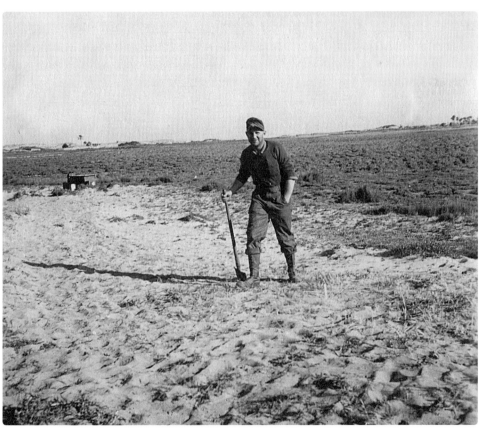

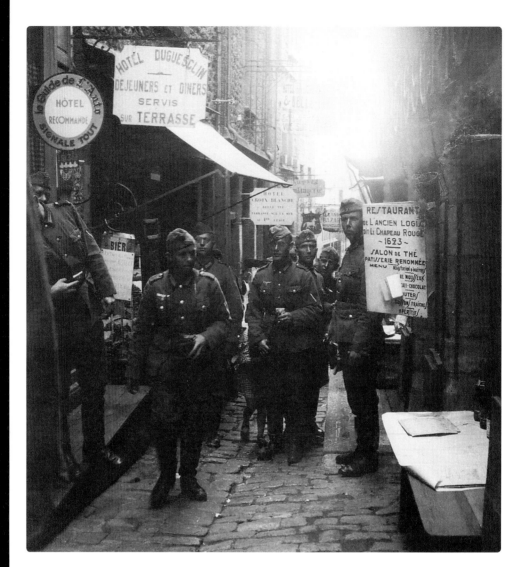

In a more agreeable part of the world his fellow Landsers enjoy some off-duty time in Mont-Saint-Michel, France. These 'tourists' take in the shops and cafes, which now cater for German taste. Bratwurst and other such items are advertised on menus such as the one under the large Hotel Duguesclin sign. Beer is served, spelled in German as 'BIER'. The *Gefreiter*, Lance Corporal, on the left keeps his hand firmly on his camera making sure it is not stolen, a common experience for tourists in and out of uniform. Notice that between him and the next Landser there is a child who appears to have his hand reaching into the pocket of the soldier on the right; no one is paying any attention to this. French streets at this time were to be walked warily more from crime than acts of resistance.

Rommel makes his move. He attacks the British 8th Army with what he has at hand and pushes them back, retaking most of Cyrenaica. The Panzer IV and III seen in the foreground as well as the other tanks rolling forward in formation are part of this drive. The vast, flat terrain of the desert is clear. The Landser in Africa was learning a new kind of warfare.

A familiar scene for many of the DAK troops who had seen service in France the previous year. British POWs wait to be boarded on trucks to transport them to the rear. Dust and heat play no favourites; captive and guard both suffer under these conditions.

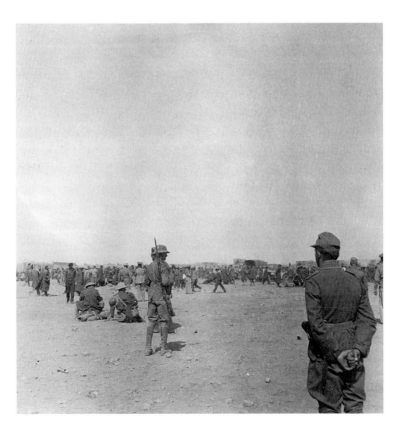

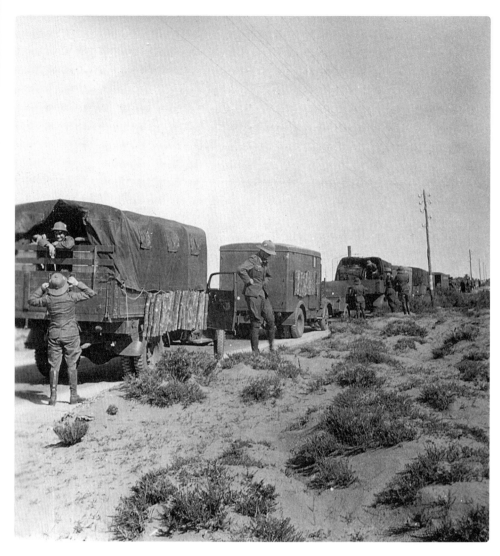

A convoy on the way to the front stops for a rest. The two Landsers at the rear seem to be enjoying the feel of their new Tropical Helmets, while another contemplates the terrain they now must survive in. His thoughts may be reaching back to the more fertile fields of home. In the bed of the 3rd truck from the rear, the field kitchen is now open for business and men are getting something to drink, perhaps coffee, that important logistical supply for most soldiers. The sides of these vehicles are slung with handmade wooden runners that would be placed under the tyres in the event that the vehicles got stuck in the sand.

'We cross the Frontier, April 6th 1941'. Germany, along with her Hungarian and Italian allies, commences operations against Yugoslavia to prevent a pro-Allied government from consolidating power. This 8.8cm Pak gun crew are taking it all in their stride as they pass the frontier in their Sd. Kfz.7, an 8-ton half-track that towed the gun. Even the canvas 'doors' are painted to match the camouflage scheme of the vehicle.

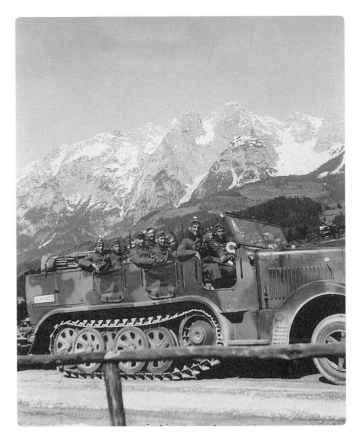

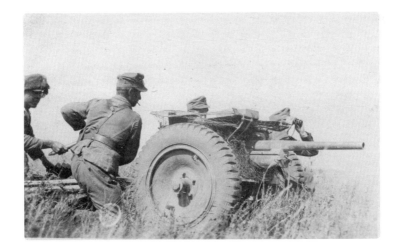

In the Balkans the Greeks, with British support, proved too much for the Italian Army, so aid was sent to mop up this campaign before the invasion of Russia could take place. The Allied armies put up a tough fight, but the Germans were at the top of their game and turned the tide. This PAK gun of a *Gebirgsjäger* Regiment fires direct support at targets during the fighting. The men are mostly old veterans from France and Norway; working with well-trained and honed skills the gun crew maintains continuous fire.

Men of the Artillerie Regiment 16 of the 16th Panzer Division take in a nice sunny spring day. These men are being held in reserve while the campaign in the Balkans unfolds. Not everyone is involved in the fighting in any operation. The vehicles are lined up and ready to go if needed. But for now it is a time of waiting and performing mundane duties. The car is a freshly drafted civilian cabriolet still with the civilian plate, indicating it originated from the Baden district. The letters 'WH', meaning 'Wehrmacht – Heer' or 'Armed Forces – Army', have been painted on the fender along with the tactical sign and unit designation. The soldier with glasses, shirtless in the middle, is wearing his work fatigue trousers with the knees all torn up. He was most likely doing the lion's share of maintenance work while the others watched, as is so often the case.

On 17 April the campaign is over, the Yugoslav Army surrenders. POWs file past a stopped Medical Column; some are wounded. A group of helmeted Landsers can be seen inspecting them as they walk past. To the right is a destroyed Yugoslav supply wagon and dead horses. The campaign lasted only eleven days and resulted in another major victory for the Axis powers.

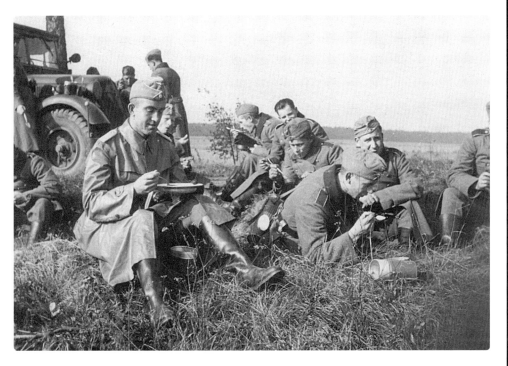

The fight over, a peaceful meal is enjoyed in the warmth of the sun. A good meal, as evidenced by the expressions on the faces of these Landsers, improved the morale of troops in any army. The officer eats out of a bowl whereas the enlisted men eat out of mess tins.

All across Europe, in the countries where the army had once surged through in victory, soldiers now take over the duties of occupation. They become policemen as well as soldiers. The duties they now perform daily include regulating travel, checking identity and attempting to control the growing black markets for goods. To the citizens of these places, the new regulations from new masters bring the realisation that the freedoms they once knew no longer exist. In the many months to come, the familiar refrain of 'Papers Please' will be repeated by many a Landser on his guard duty shift. Civilians, like this man on his bicycle, put up with these things because they must, as the consequences would be severe.

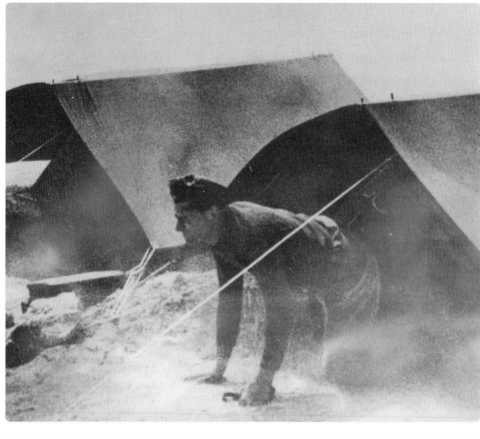

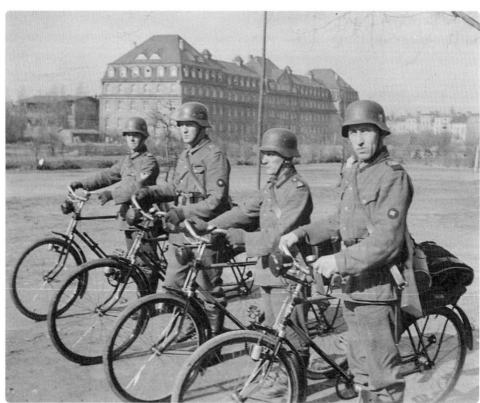

Opposite top: Same sun but a different world. The wind blasts sand through the tent and uniform of this Landser in North Africa. It was a kind of life that he had never trained for, nor had most like him envisioned they would ever endure.

Opposite bottom: Occupation duties were demanding more troops than was foreseen. The caption reads 'A remembrance of our first patrol in April 1941'. This patrol consists of just four Landsers mounted on bicycles, led by an *Obergefreiter*, Corporal. They have unit insignia on their epaulettes that indicate they are from a *Landesschützen* Battalion, 'L' with a number below. These were lower-calibre 'Territorial Defence' units that would be assigned to guard POW camps or for security operations in Germany or occupied countries, allowing regular troops to be deployed in theatre. The image of the motorized, heavily armed columns that patrolled every street, conjured up by most modern films, was not the norm. Rather, this was done in more dangerous areas that needed such actions. Germany did not possess the manpower or equipment to patrol in that way everywhere. These soldiers are armed only with Mauser -24(t) rifles, which were reissued Czech rifles acquired in 1938 after the annexation of the Sudentenland.

'Athens, May 1941'. Part of the Balkans Campaign was the invasion of Greece to save Mussolini from defeat at the hands of the Greek and UK forces. This was over on the mainland by the latter part of April and the Germans began a routine of occupation duties. The new tropical uniform was not just issued for North Africa; troops now garrisoning Greece were also to receive them. However, this would place a strain on the already limited supplies that Rommel and his DAK would be sent. Perhaps a small thing in the logistics of the war, but small things can add up to major problems. For now, these Landsers seem fairly happy with their tropical uniforms in their Greek duty station.

While others are fighting, or on patrol, or in training, there is always some sort of maintenance or fatigue work to be done. Such is the case with this Infantry unit. The crews of these 7.5cm IG -18 support guns are having a maintenance day. In the background to the left is the gun limber, which is being cleaned and reloaded with shells in wicker containers. To the right is the repair wagon with its doors open. On the top of this cart is a spare cannon wheel and other larger parts. The sides are open to check and clean the spare parts and tools. The three young Landsers lounging on the gun trails are in rather good spirits, enjoying a bottle in the heat of the day. Note the colour-coded tables on the gun shield; these are for the gun layer so he can set the charges of the shells for distance and type of target.

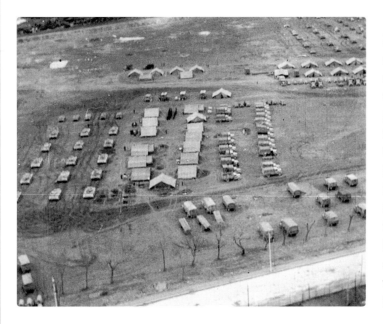

Libya: an aerial view of a camp of newly arrived troops and vehicles for the DAK – precious commodities for General Rommel. While he was the hero of the moment, his war was not to be the main focus of the German effort. Even so, he would do amazing things with what limited logistics he possessed.

Some of the fresh replacements in this camp. These are all Panzer men, posing for a shot for the folks back home. The details are fairly interesting. In the first row sitting is a *Feldwebel*; he is wearing his full black wool Panzer uniform except that he has a tropical shirt, tie and webbed belt. This is an unusual uniform combination, but it was done. Sitting next to him, reading, is an *Unteroffizier*; the tropical *litzen* is around his collar and on his shoulder boards; he also wears the Panzer Skulls affixed to his lapels. This was very commonly done by Panzer men on these uniforms. He wears his black tie, normally worn with the black wool Panzer uniform, rather than the tropical tie. Of the other five men, most wear the standard tropical service uniform, with the short fellow on the right lacking a tie completely and the Landser in the middle wearing the tropical version of the side cap normally issued to Panzer crews. The war would reach them all very quickly after this image was taken.

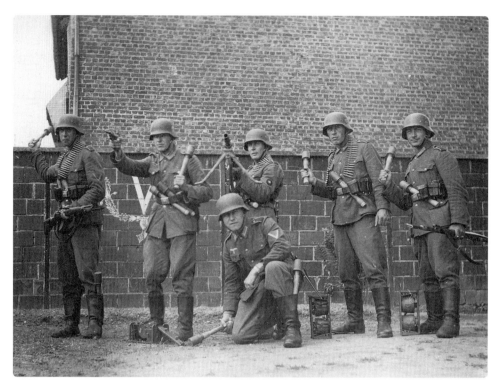

A Machine Gun Section strikes an aggressive though slightly comical pose behind the barracks, grenades ready to be thrown, bayonets fixed and the section leader's P-08 Luger aimed to fire. This is the classic view of the German soldier during the Second World War: stick grenades tucked in belts or boot tops ready for use, clean uniforms adorned with ammunition pouches or a holster, and the unmistakable helmet. Once the realities of conflict set in, the heroic pose and clean uniforms would rapidly disappear. Their special carriers for the 50-round belt drums are on the ground in front of three of the section members, They each carry two drums. One is open and a drum is missing. While the angle of the MG-34 prevents us from viewing the gun in its entirety, this drum is not mounted on it. Behind them painted on the wall is 'W III' surrounded by a wreath in honour of the former Kaiser, Wilhelm III. Many such vestiges of the Imperial Army were still present and scrupulously maintained at German barracks. The photo is dated May 1941. These Landsers are training for the largest land operation in history, though they may not know it yet.

While troops in Europe trained and performed fatigue or occupation duties, the Landsers in the DAK were fighting in the desert against a well-trained and determined enemy. Even so, every battle has lulls and personal needs must be met. Such is the case with this German camp in the desert. While the tents can be seen in the background, these Landser are in the common area used for answering the call of nature. In the desert the digging of latrines during short stays between highly mobile battles was not really done, as there was no issue with contamination of water levels. A scoop of a shovel covered the result and kept the flies down. Even so, these areas were situated some distance from the camp.

Many Landsers find themselves on trains moving east through German-occupied areas or those of their allies. New places and uniforms greet them. A Landser has taken a photograph of the Hungarian Gendarmerie, National Police, as he travels through Budapest towards the frontier.

Even while mounted on train cars, the cooks and field kitchens were at work. The Landsers needed to be given proper meals during transit. Here at a rest stop on the ride eastward men line up to be fed, this time out of the metal bowls that the kitchen has for such purposes, since most of the mess kits are stacked with packs inside the cattle cars. One man, however, standing on the ground fourth from the left, is eating out of a mess kit lid. On the car itself the *Hauptfeldwebel* – the unit's First Sergeant, called 'der Spiess' – enjoys his soup. He is denoted by the rings of lace on his cuffs. Opposite him is another NCO who still wears his Marksmanship Lanyard. Generally, this was not worn on duty days or in the field. The soldier on the rail bed wearing the greatcoat has his helmet hung by the chinstrap from one of the belt hooks from his tunic that protrude from the special holes in the coat. This was a very handy feature of German uniforms.

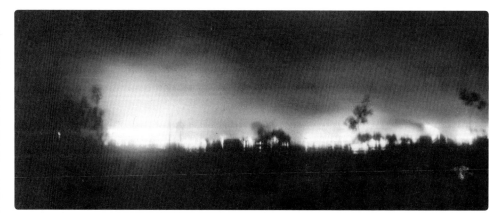

'Russia, June 22nd 1941'. At 03:15 that Sunday morning the Luftwaffe began bombing targets in the Soviet-occupied Zone of Poland and all along the Russian border areas from the Baltic to the Balkans. Operation Barbarossa had begun. When the Landsers first crossed the frontier the sky was on fire.

The drive east begins. This infantry unit is deployed in open order as it moves towards the enemy. In the rear closest to the camera are the support elements, including an 80mm mortar crew, who stand with their assigned part of the weapon ready to advance. Most mortar crews would stand while waiting unless they absolutely had to get down. To constantly kneel and rise bearing the weight of a base plate, tube or bipod on your body is difficult and tiring to say the least.

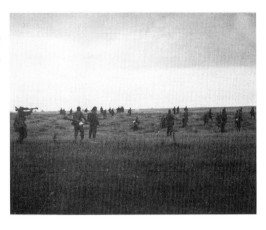

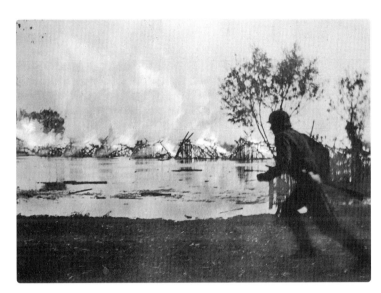

Houses, huts, barns, and anything built of wood burns. This Landser runs past a collapsing bridge. He is only wearing minimum gear – just what he needs to fight. This is an indication of tough combat and that his unit with support and supply wagons is close by.

'The first Russian Prisoners, 22nd June 1941'. With the sun just coming up, these Red Army soldiers have surrendered. The shadow of the helmeted Landser who took the image can be seen on the first prisoner. These men do not look as if they put up much of a fight and look happy to just be alive.

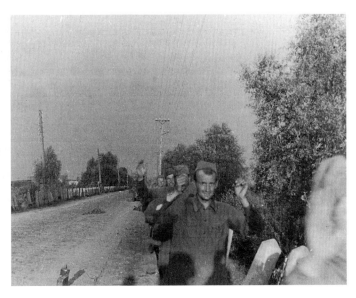

Russian mortars hit back at advancing German Infantry. Two rounds have scored good hits on the trench lines the Landsers are using to advance. On the left the upper torso of a Landser can be seen as he makes his way forward. Luck was with him this time.

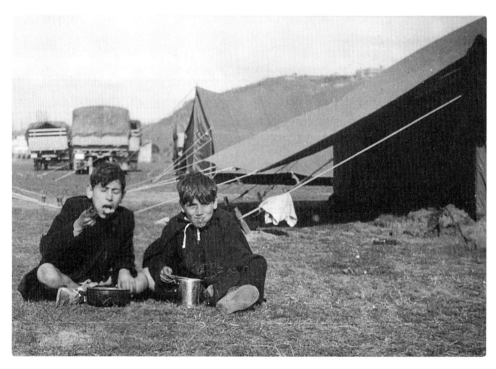

Far away in Libya, Italian youths are given a meal in the German Lager. Underwear hung out to dry and trucks loaded to move out, this is a normal military camp but someone has taken the time to perform an act of kindness for two children and their faces show the happiness it has brought. In war there are terrible things, but moments of generosity as well.

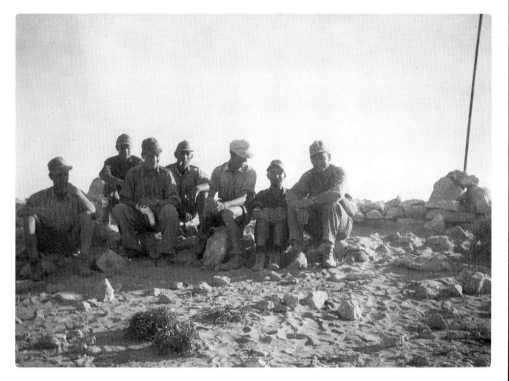

While his Kameraden were advancing deep into Soviet Russia, the Landser in North Africa had settled down to a more stable war. With Tobruk under siege and holding the line against 8th Army attacks during Operation Battleaxe, these men from the 5th Light Division take time out for a group photograph at their forward base. The 2nd and 3rd soldiers from the left both exhibit light wounds from the recent fighting. One has a shin wound and the other has a wounded right hand. They are tired but look well despite the conditions.

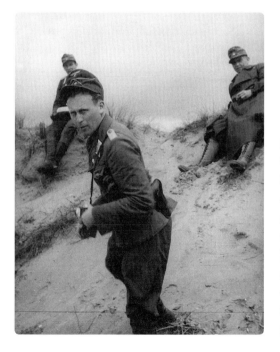

More troops and equipment trickle in for General Rommel. These Panzer men have just arrived in Libya and take the obligatory trek to the dunes for souvenir snapshots. The *Leutnant* has his camera ready to take them but his friend has beaten him to the punch, to the delight of those sitting on the dunes. This scene would be played out many times during the war by soldiers on both sides – nothing changes but the uniform.

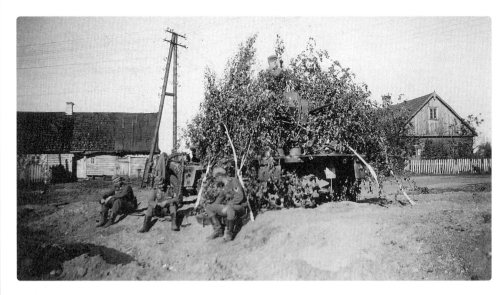

In the Soviet Union the advance continues East. At crossroads and other vital areas security measures are taken for various reasons, including attacks from Soviet aircraft still in the sky or from Red Army units who have been bypassed or cut off that are still threats. Here an Sd.Kfz 10/4 halftrack with a mounted 20mm flak gun performs this sort of task: 'Our Position on the Narew River Bridge, Russian Polish Border, 22-26 June 1941'. Though these men are technically in an anti-aircraft unit, this gun was very effective against infantry targets such as the massed troop attacks favoured by the Red Army, and light armoured vehicles. The gun is in a straight-on position for just such a target and the observer scans the horizon, not the sky, for threats.

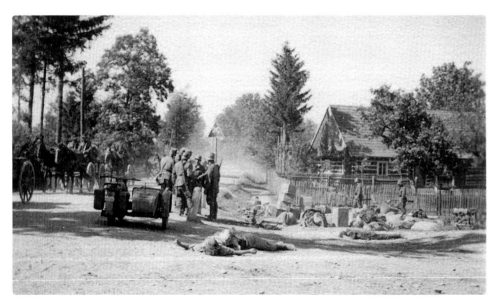

A short sharp action leaves both soldiers and civilians dead. A German horse-drawn supply column rolls by the still-smoking scene. An officer out of his motorcycle side car confers with an NCO as to what has happened. A bicycle lies on the ground and the bodies of the dead lay motionless as soldiers with fixed bayonets move through the carnage. We will never know exactly what happened here.

Death comes to Landsers as well:24-year-old *Obergefreiter* Bernhardt Zerbe, Artillery Forward Observer in the 3rd Company of *Beobachtenabteilung* 17, was killed in action on the first day of the campaign. He has been buried by his comrades, his helmet resting atop a cross of white birch.

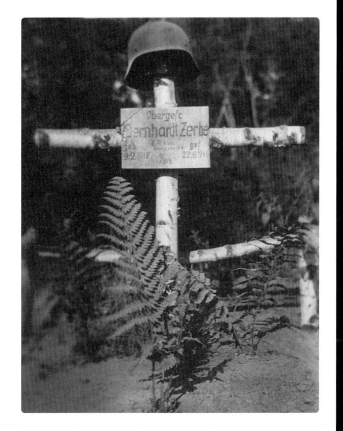

'Here rests our comrade *Obergefreiter* Adolf Irmler, 11th Company Infantry Regiment 83. Killed in action on 27 June 1941'. The helmet resting on top shows penetration holes to the front and side. This regiment was part of the 28th Infantry Division that served with distinction in Poland and France. They drove deep into Russia as part of Army Group Centre, fighting with aggressive zeal. By November they had to be withdrawn from the line because of high casualties. They would be refitted and renamed the 28th Jäger Division. This was one of many crosses that marked the path of this division across the steppes of Russia. The campaign was just beginning.

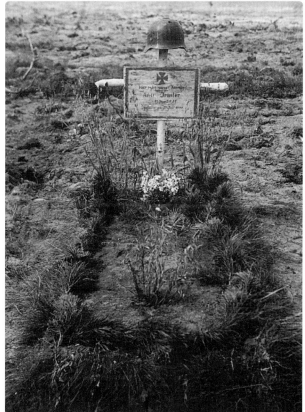

THE LOST LANDSERS |

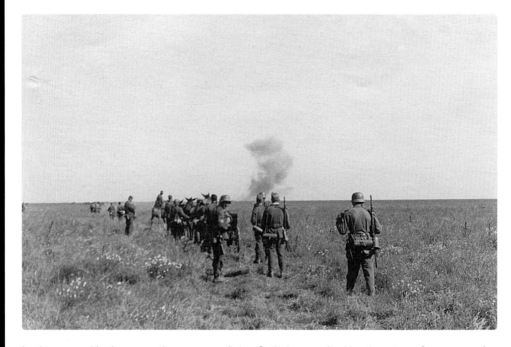

In the rear with the gear, these men of the *Stabskompanie*, Headquarters Company, of a *Gebirgsjäger* regiment wait to move forward just behind the combat elements. The smoke from an explosion or burning village rises into the sky. This may be the objective for the day. One Landser looks back, knowing his Kamerad will be taking a photograph. The three wagons, each pulled by a single horse, carry packs and supplies. One man is mounted, perhaps an officer but most likely a dispatch rider. More German hooves than steel treads invaded countries in Europe during the war.

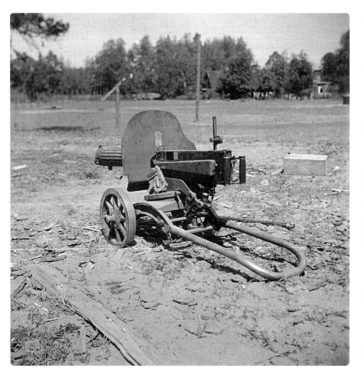

The last evidence of resistance put up by men of the Red Army is photographed by a Landser. A Russian Maxim Machine Gun on its wheeled mount sits on a patch of ground covered in the casings of expended rounds. Facing down a road in a completely exposed position, these men had no chance of winning but they fought on anyway. The Landser thought enough of the action to take this shot, to remember.

A retreating army can be brutal to its own. The caption reads 'Russian soldier shot by his own Commissar for cowardice, June 1941'. The young soldier was shot through the back of the head in typical Soviet fashion. His cap lies on the ground to the right.

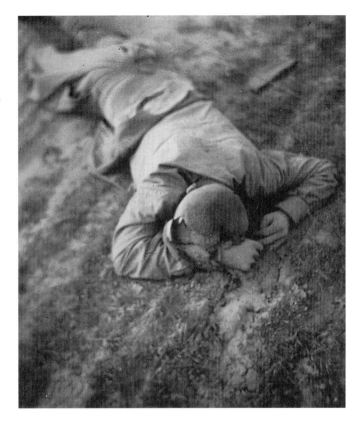

The *Kommissarbefehl,* in effect at the beginning of the invasion, was a directive by Hitler to execute all Soviet Commissars, Political Officers, who were taken prisoner. It would be rescinded the following year but for now the order was carried out. This Commissar was duly executed, and the photo is from the same Landser who took the previous image and wrote the caption. One cannot help but wonder if this Commissar was the one who carried out the previous execution.

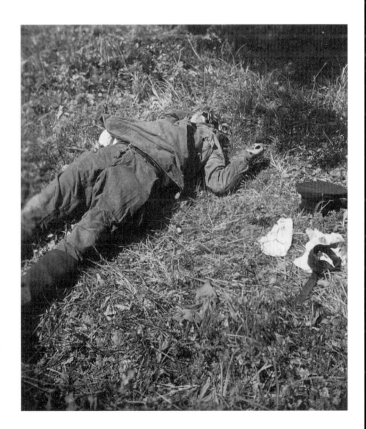

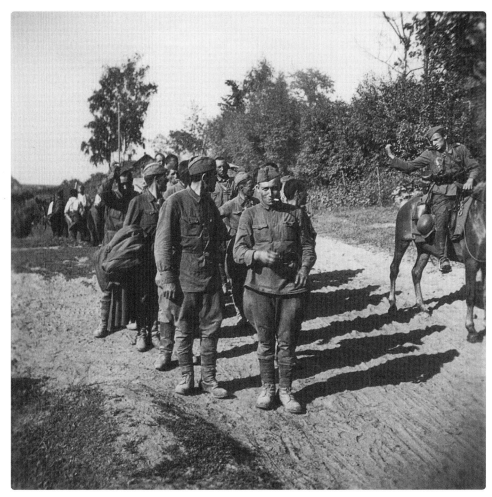

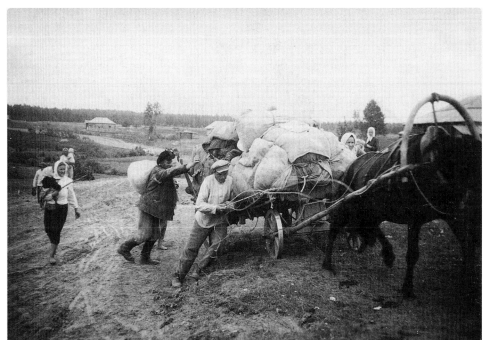

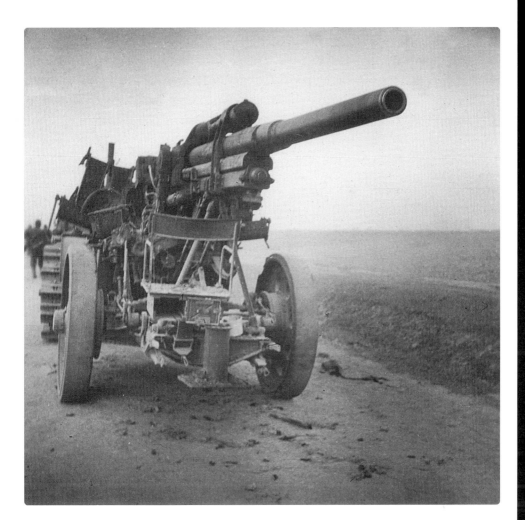

Above: Abandoned and destroyed equipment starts to be encountered everywhere. This is the sign that an army is beginning to disintegrate. This artillery piece and tractor have been left along the side of the road as Red Army troops flee eastwards. The Wehrmacht would collect and make good use of anything that was serviceable, which means some of these guns would fire again.

Opposite top: Taken by the same Landser as the previous two images, this shows a group of Red Army POWs. These Russians appear to be in good health. Behind them a group of German Cavalrymen rest, tunics off, in the sun. One trooper from their section sits astride his mount on guard. He is engaged in conversation with one of the prisoners, giving a hand gesture that means 'back in that direction'; his expression makes one thinks he may be telling his prisoners how lucky they are not to be back at the front. An interesting piece of equipment is the special leather harness that is worn with the helmet to allow it to be hung on the saddle.

Opposite bottom: 'Russian Farmers returning home move out of the road for us, summer 1941'. While most people hid or fled, the speed of the German advance would many times overtake civilians. In many cases these people would just return to their homes. These men struggle, along with the horse, to get the overloaded wagon out of the way. The faces of the barefoot women and children show little concern for their immediate safety.

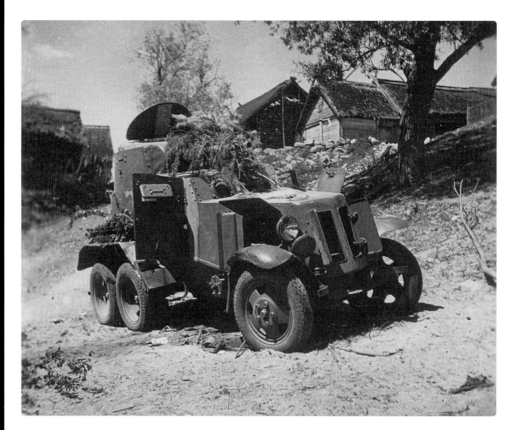

Above: Soviet BA-6 Armoured Car, still camouflaged, sits deserted in a Russian village. With the engine compartment doors all open, its fate looks more the result of a breakdown rather than action. Even so, the front bumper is missing, as is the spare tyre. There is no doubt that this vehicle saw some action before its demise. The 45mm main gun lies under a pile of pine boughs on the top deck. This vehicle would be repaired and most likely see service once again with new masters at the wheel.

Opposite top: Still in the same village but this time near the main road that passed it. This convoy of Red Army trucks and cars appear to have been destroyed by a quick, vicious action. While most are just transport vehicles, the centre of attention is the BA-20 Armoured Car that an inquisitive Landser has poked his head into. This has suffered battle damage to the front, with a tyre blown off. To the left just behind it a bullet-riddled truck shows the sharpness of the action. It can be surmised that rubbernecking wrecks on the side of the road slowed up the German advance more than the resistance of some Red Army soldiers, who merely surrendered at the first sight of the approaching Wehrmacht.

Opposite bottom: Enemy vehicles were not the only ones destroyed, nor were they the only wrecks that brought curious soldiers to a halt. The caption reads 'We are detailed to clean up one of our trucks that burned and exploded. Russia, June 1941'. The sour look upon the faces of the Kanoniere confirms the caption. The remains of this vehicle show the force of the explosion and fire. Unexploded shells can be seen in the mass of burnt wreckage. Other than their truck to be used to take away the damaged or destroyed munitions, vehicles of a medical unit are also parked here – large buses and ambulances.

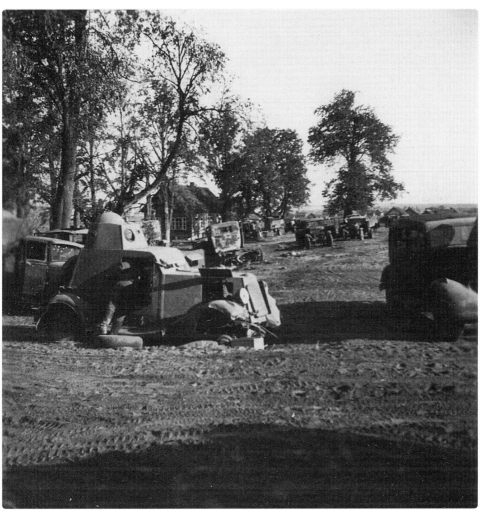

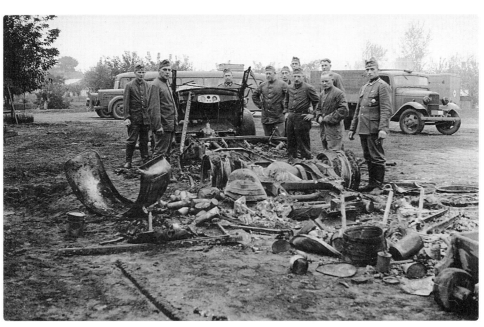

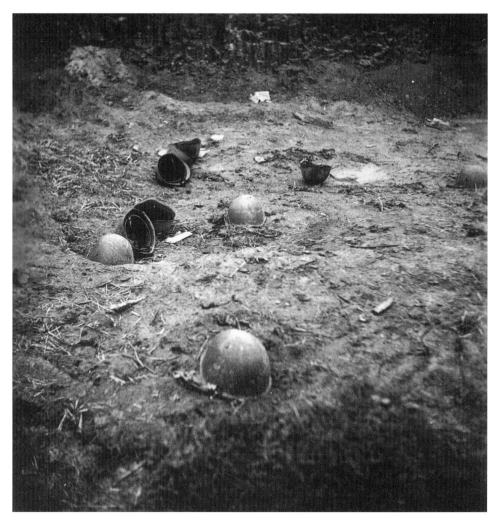

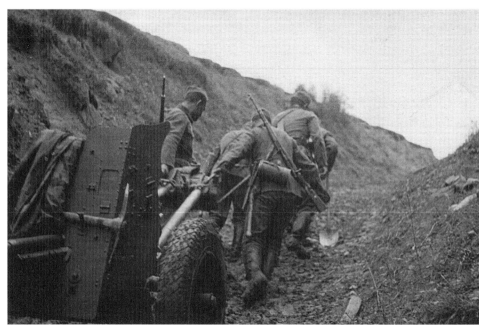

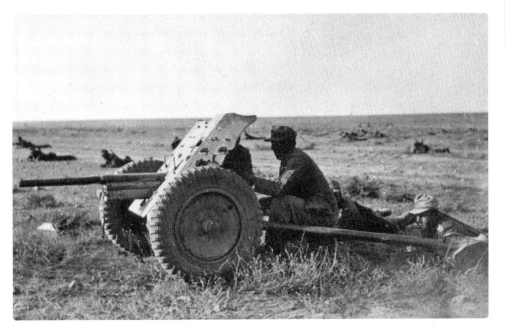

Above: Another PAK 36, this time in the heat of the desert. Landsers of the DAK wait in extended order as the gun prepares to fire. However, this is not a combat image. It was snapped by a Landser while they waited for the order to move. In the upper right corner above the gun crew a cameraman can be seen filming in the prone position. He is from a *Propagandakompanie*; films from the front played an important part in the lives of the people at home. Every country had cameramen taking and staging footage.

Opposite top: The site of surrender is marked by discarded Russian helmets and bits of paper from the pockets of the hapless men.

Opposite bottom: 'Near Smolensk, July 1941'. The crew of this PAK 36 struggle to pull it up a muddy hill towards the fighting. The lead gunner uses a shovel to gain traction. The rain has stopped for now and the Zeltbahns have been thrown over the gun in case they are needed quickly. Rain and mud had been a great hindrance for the units in 3rd Panzer Group under the command of General Hermann 'Papa' Hoth. The weather and the swampy ground delayed them enough to allow many Red Army units to escape encirclement despite the victory. The first gunner on the right still wears the prewar pattern of Reichswehr 3 buckle pattern Marching Boot. This gun was found to be increasingly ineffective against Soviet and British armour on all fronts but was kept in use against lighter armour or soft-skinned targets.

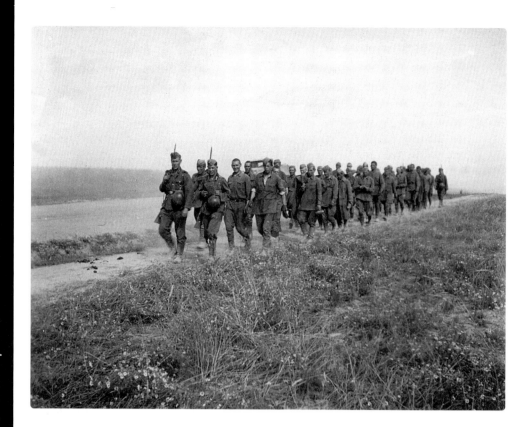

The constant stream of Soviet POWs never seems to end. Small groups and large columns continually head away from the battlefield. These men would have a desperate time in a German POW camp and those who survived would be tried as traitors when liberated. It is no wonder that large numbers of them would volunteer to fight against Stalin in the years to come.

Some prisoners were much more important than others. The caption simply reads 'Red Army Officer', but he has two mounted escorts, one officer in the lead and a *Gefreiter* at the rear, and a guard walking next to him. He is considered a high-value prisoner.

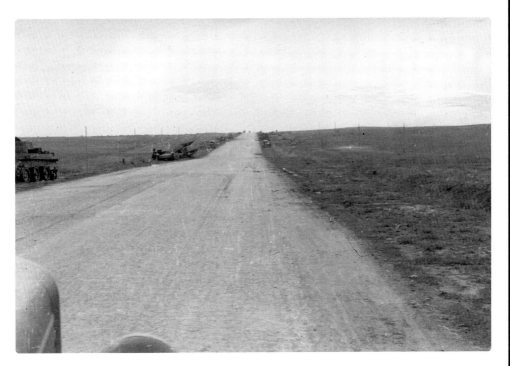

The view from the passenger side of a German car, showing the emptiness of the Russian Steppes. To either side of the road damaged and destroyed Soviet equipment can be seen. To the left is the hulk of a heavily damaged BT-5 light tank.

'Our "Otto" flying observation' is the caption. While the Luftwaffe ruled the skies in these opening battles, it was not just fighters and bombers that were in the air. The Fieseler Fi 156 Storch was a liaison aircraft that was used for many purposes, but flying Artillery Observation and Reconnaissance were among its primary roles. Here 'Otto' does just this for his unit.

By contrast, the Red Air Force was caught mostly on the ground. Those that did get up fought as best they could, but for now the air belonged to the Germans. The Landsers were intrigued by all of the different shapes and sizes of Soviet aircraft they encountered. Again, these aircraft may have slowed down the German advance as roadside curiosities more than they did when they were airborne. Here a Tupolev SB / B.71 sits abandoned, the tree branches once used as camouflage strewn on the ground around it.

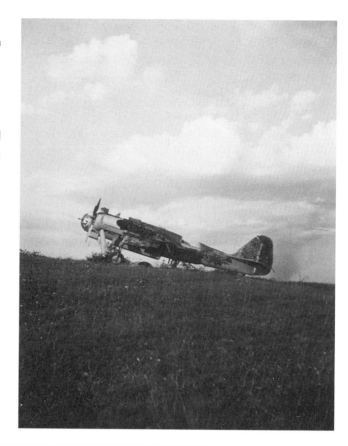

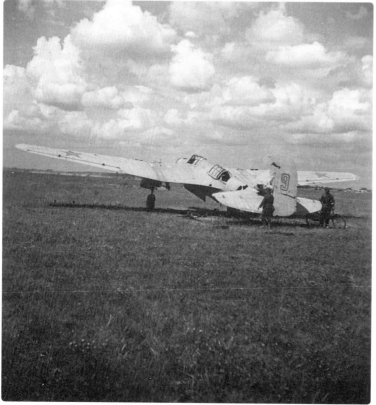

Another Tupolev, the SB 2 Model, has also become a point of interest to passing German troops.

'Shot down Soviet fighter near Luga'. This Polikarpov I-16 fighter was brought down by either German fighters or Flak over the Leningrad Front. Luga was the scene of fierce fighting. It eventually fell, but not before a heroic stand.

Another Tupolev, but this one was brought down in flames. Two Landsers inspect the wreckage, one interested in the machine guns in the nose. Behind them a building is in flames. Despite war going on all around them, soldiers will become tourists if given the chance.

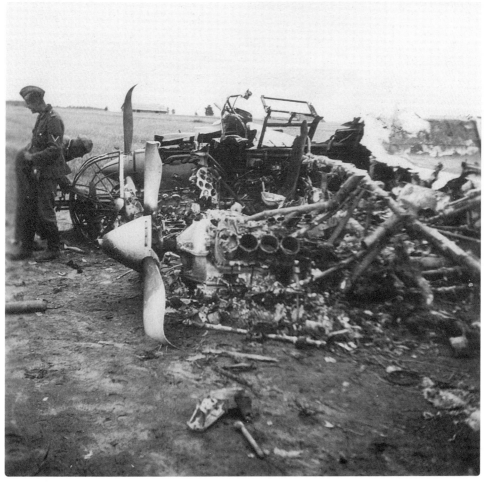

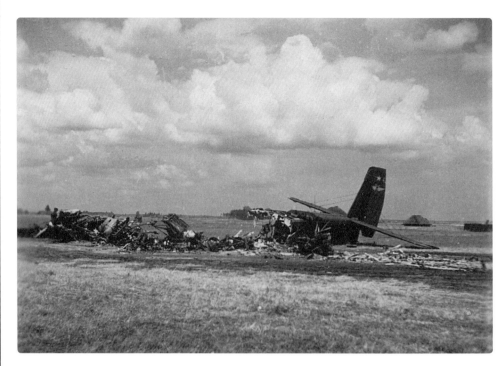

A larger four-engine Tupolev bomber. The mangled wreck gets its share of souvenir seekers.

'Gott im Himmel, what the hell were you thinking?' is probably what this Sergeant is saying to the driver of this truck, though his lecture is likely to be more laced with profanity. While the troops behind him find it much more amusing than he does. Note the helmeted soldier pointing back with his thumb; his thoughts are most likely 'This is pretty funny'. It has drawn a crowd of spectators who should be doing other duties.

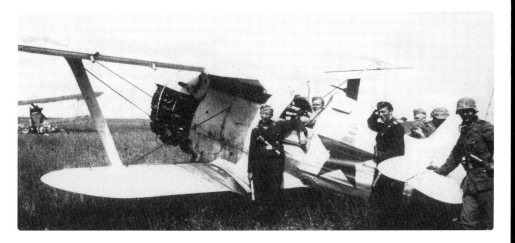

A Soviet Airfield is overrun by the 6th Panzer Regiment. The sightseeing begins as they rest and refuel. This Polikarpov I-15 biplane is the centre of attention. To the amusement of his comrades, one man has taken to the cockpit. The first Panzer man standing outside the cockpit is an NCO; the lace on his shoulder boards is visible. He wears the standard black Panzer uniform, albeit without the tie in the summer heat. His cap is not the black one that goes with this uniform but rather the Field Grey version worn with the standard issue uniform, which these soldiers also received. He holds a Model 24 Stick Grenade in one hand, with another tucked into his belt next to the holster for his side arm. The latter was not the norm for a Panzer crewman, since going in and out of hatches or moving in the confined interiors would be problematic. These small details indicate he may be part of the crew of a command vehicle, which would also give him the opportunity to throw out grenades for defence. To the right stands an officer in complete Panzer kit, his binoculars and holster visible, as is the silver piping on his cap indicating his status. The rest of the men are in standard issue uniforms. The goggles, dust-covered faces and limited gear worn indicate that these are troops are in some sort of vehicle. Most likely these are some of the Panzergrenadiers that support the armour. The Landser with the goggles on his helmet has a rather broad smile on his face as he holds up the helmet belonging to the fellow seated inside the plane, as if to indicate that it is time to get out and move off.

A view of the same airfield. Polikarpov I-16 fighters are on the left while the I-15 in the previous image can be seen to the upper right. Even at this distance, the black-uniformed Panzer tourists stand out against the white paint of the aircraft.

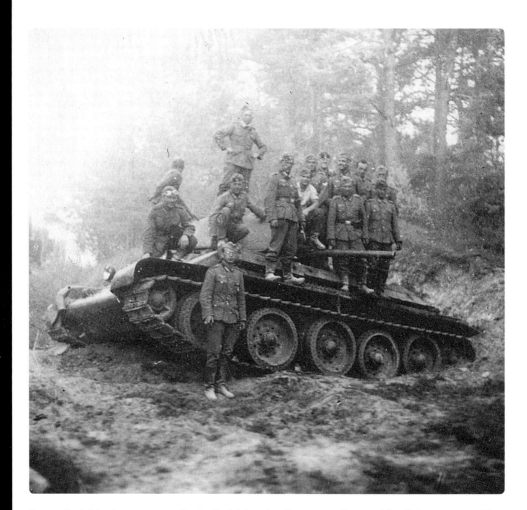

A new Soviet tank appears on the battlefield as the Germans advance. The T-34 was something that German planners had not bargained for in the planning of this operation. It was rugged, reliable and deadly, but not indestructible. These steel monsters would fight hard but for now there were not enough to stop the Wehrmacht. Landsers from the *Stammkompanie*, HQ Company, of Panzer Regiment 6 pose atop an early model T-34 taken out by one of their Panzers.

The Red Army was also 'horse powered'. The myth that both these armies were mechanised Goliaths hammering away at each other is just that; a myth. While every possible weapon with wheels and treads were pushed to the front by both armies, the fact remains that horses were the main source of transport for the support elements of both armies until US and UK logistical support started reaching the Soviet Union in quantity. But for now a common scene; dead Red Army horses and destroyed supply wagons litter the roads and ditches as German supply wagons pulled by more horses plod on ever eastwards. This wagon has the utility trailer attached to it. These trailers were not just for motor vehicles.

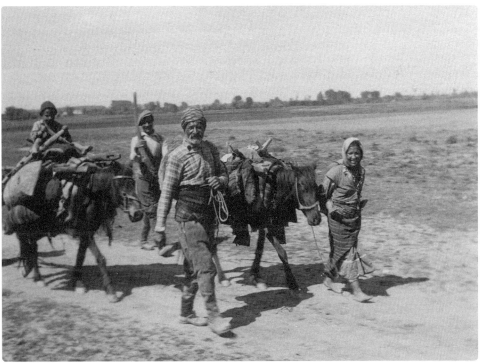

The same wagon passes Russian peasants heading west on the same road. It may be that they have decided to let the war pass them by and head back home, since there is nowhere else to go.

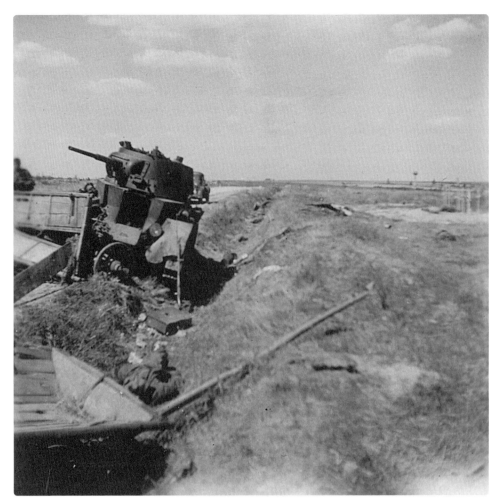

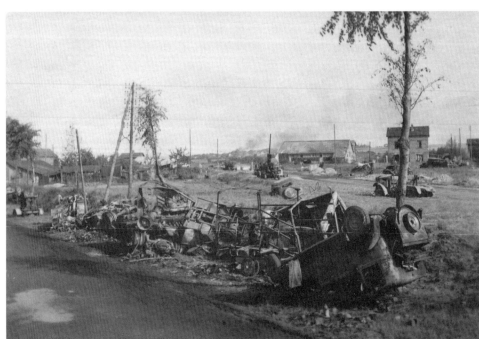

Opposite top: Wreckage along a Russian highway. The ditches are littered with bodies, carts and other destroyed equipment. A BT-5 tank sits knocked out on the side of the road. However, something is different now. The hull is facing east, retreating, but the turret is facing west, fighting. The resistance is growing much more determined.

Opposite bottom: With resistance ever stiffening, Red Army units are still destroyed. This artillery unit did not escape. The burnt wreckage of vehicles, guns and other equipment litter the crossroads in this village. The flak gun pointing skywards indicates that this devastation may have rained down from the air. Smoke rises from a scene of new fighting further east.

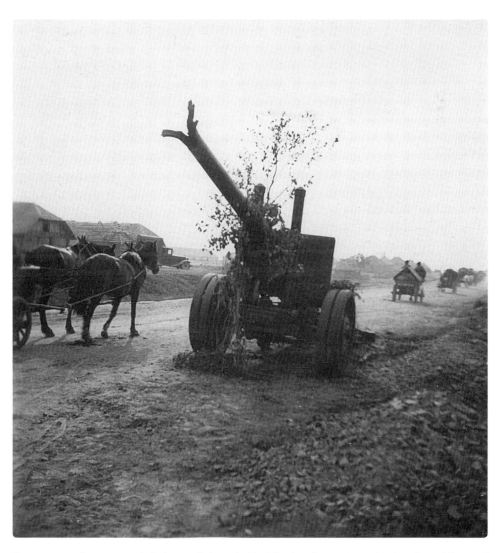

German supply wagons of all sizes roll along behind the frontline troops, passing the evidence of fighting and the retreating Red Army. This time however the Russian Artillerymen have destroyed their gun before retreating. It is the beginning of the scorched-earth tactics by Stalin: leave nothing behind to the Germans, even homes and farms.

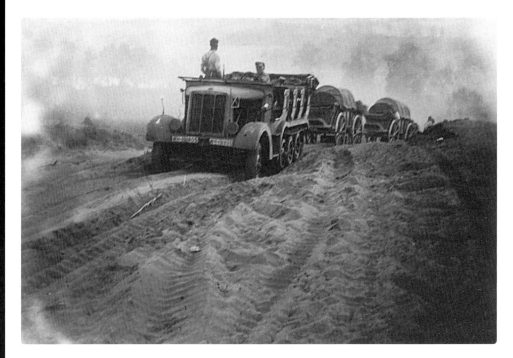

The dust chokes men in the heat. The sides of the engine cowling for this Sd.Kfz. 9, an 18-ton monster with a towing capacity of 28 tons, have been removed to allow the engine to keep cooler. Most often used in towing heavy artillery or in tank recovery roles, this one is being put to use towing several supply wagons of a mechanized unit.

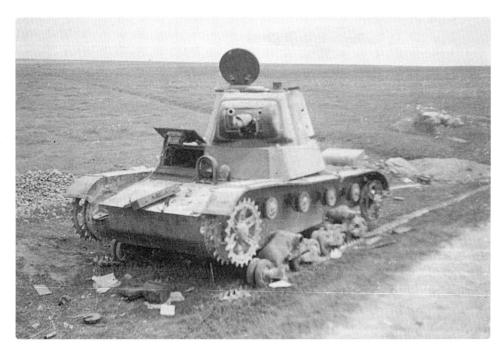

A Soviet T-26 tank greets advancing Landsers, its gun and treads destroyed by an explosion just to the front, the tank continued to roll forward over the crater leaving its treads trailing behind. This one is facing west and was advancing towards the Germans when it met its fate.

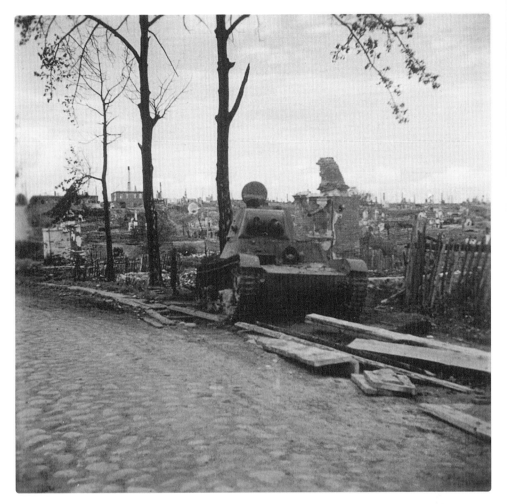

Another variant of the Soviet tank sits abandoned in the rubble of a city. This crew decided flight was better than fight.

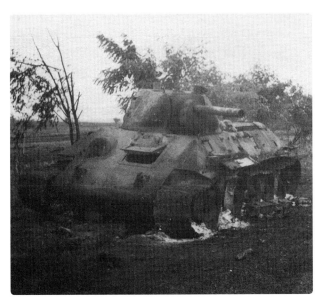

The crew of this T-34 met death in battle. Ashes mark where the rubber on the bogie wheels has burnt away. It was hit from the left side, igniting the engine. A veil of smoke still rises from the wreck, making the trees in the background look greyer than those next to them. Just above the open driver's hatch on the blackened turret two hits can be seen, but these did not penetrate. German troops were already requesting better anti-tank weapons.

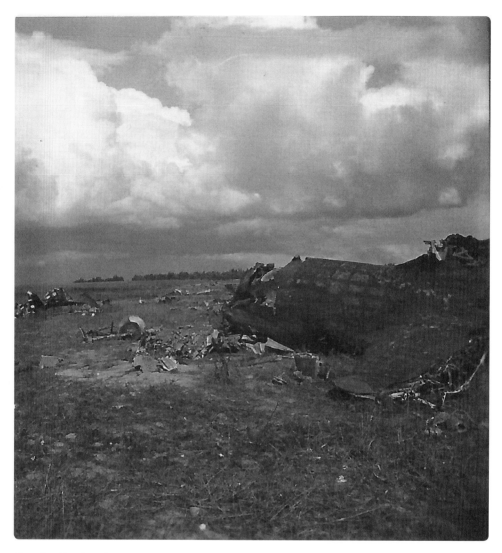

'Russian Bomber that attacked our column, July 1941'. The wreckage is strewn over a vast open space.

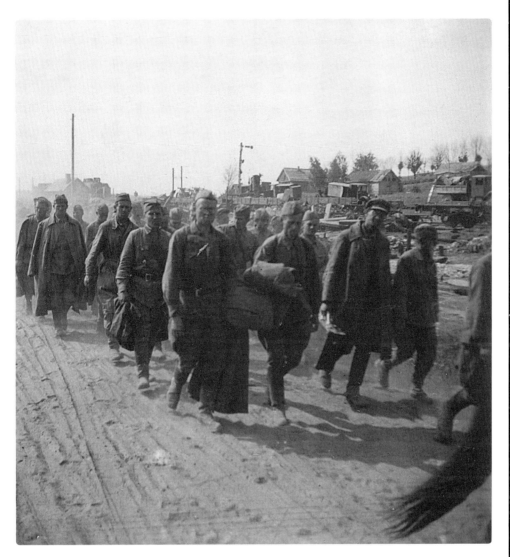

Tired and dirty Red Army POWs shuffle to the rear, choking on the same dust as the Landsers who captured them. The tail of the horse upon which the guard is mounted can be seen. The first man on the left of the second rank is an officer, still wearing his Sam Brown Belt Rig; for now he has not been segregated from his men. On the right is a railway line with loaded flatbed cars. The cars are full of abandoned Soviet equipment: some is damaged and will be repaired for use, while other items will be scrapped and recycled. The German war machine would let nothing go to waste if at all possible. Perhaps this train will take these prisoners further west to some POW camp.

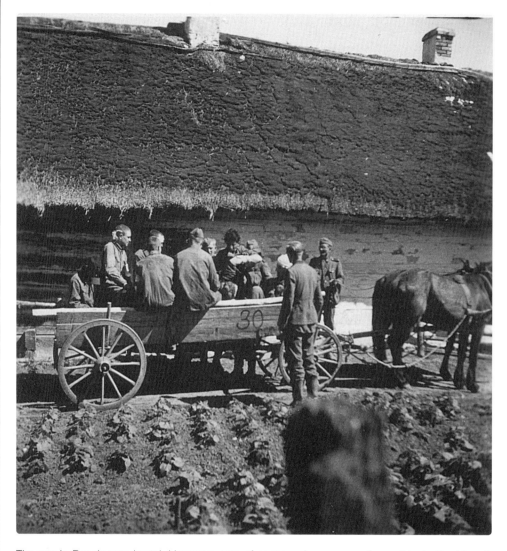

The war in Russia was brutal. However, acts of compassion were performed by both sides. A farmhouse has been converted into a field hospital by this German medical unit; a vegetable garden is only feet from the door. A wagon is loaded with Red Army POWs who have received treatment and are now to be transported to POW collection points. A soldier with a severely wounded left arm, which is bandaged and in a splint, is lowered with care by a German medical orderly into Wagon Number 30. The driver, who is unarmed, stands to the right holding the reins in his hand. The caption simply says 'Russia, Summer 1941'.

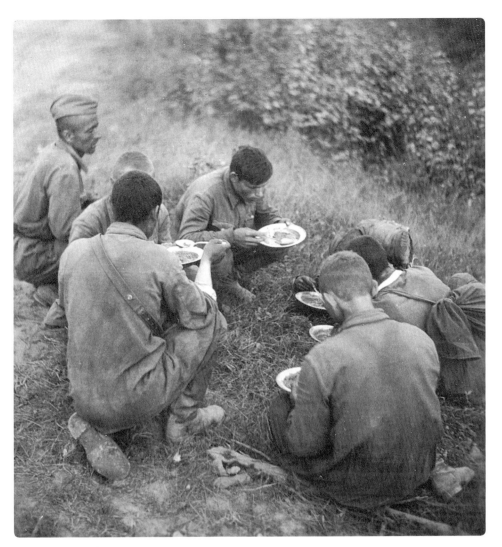

'Ivan' was the collective name given by the Landser to his Red Army adversary. In another act not associated with the savagery of this war, POWs are fed from a German unit's Field Kitchen. '7 Ivans share our meal, Summer 1941'.

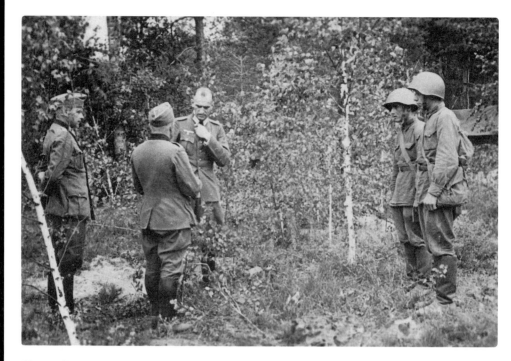

Above: Sometimes senior officers would visit the front and need some sort of diversion. It is the same for all armies. In this case, three Field Grade officers have been given the chance to 'interrogate' two Red Army POWs. These are still wearing helmets, gas masks, rucksacks and belts. The one on the right is holding a booklet in his hand, perhaps his Party Membership book.

Opposite top: A campaign is not spent in constant action against an enemy. Units are rotated from the front to reserve and then to refit on a regular basis, or at least this is how operations are supposed to be carried out. The invasion of Russia factored this into the equation. The speed of previous campaigns undertaken by the German Army usually meant that such rest and refitting was done after the event. This was not the case in the vastness of Russia. Landsers would get time away from the front but would always be close enough to the fighting in case they were needed. This infantry unit has set up a rather comfortable Lager in the yard of a farmhouse and is performing weapons maintenance. The soldier sitting bare-chested in shorts cleans the barrel of an MG-34. The front of this machine gun sits on the makeshift table to the left. Around his neck he wears the leather pouch that contains his identity disc. The eight-man Zeltbahn tent is positioned in the shade with a makeshift storage shed for gear and eight helmets hung in order along the front of it. Fatigue duties yes, but a welcome and well-deserved respite from the dust-choked campaign trail.

Opposite bottom: Even the truck drivers get to have a break and a snack. But these men and vehicles, just like their horse-drawn counterparts, were constantly on the move back and forth from the front. They would bring up rations, munitions, supplies and replacements. Sometimes they would bring back wounded, POWs and the dead.

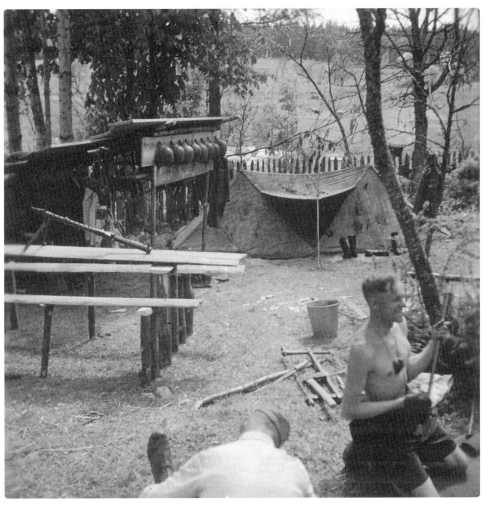

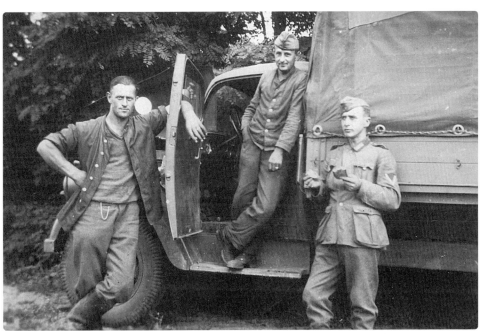

'Velikiye Luki, 27th of July 1941. The Heavy Platoon fires directly at the enemy'. The 15cm sIG 33, *schwere Infantriegeschütz* 33, was the main heavy gun assigned to infantry regiments at this stage of the war. The gun fires on a low trajectory at close-by enemy positions as the fire is observed and directed by the team under cover of the fence on the left. This town would see fierce fighting for quite a long time to come. This platoon belongs to Infantry Regiment 453, 253rd Infantry Division.

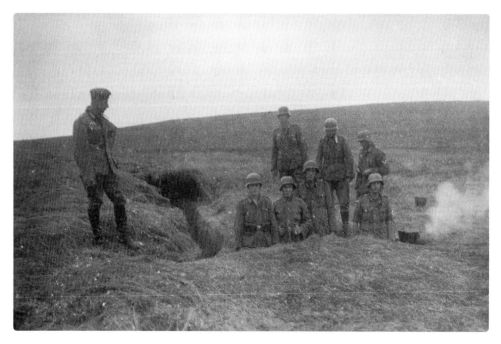

'Velikiye Luki, the Meat and Potato Firing Position'. A play on words since each gun had to be dug into a firing position. The helmeted cooks have the pot on the boil; smoke rises from the cook hole. It is a safe assumption that potatoes are once again on the menu, as they were almost every day.

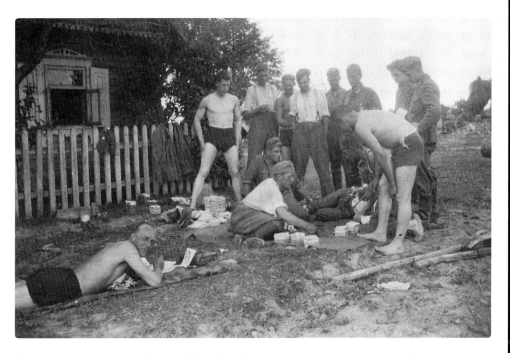

The caption simply reads 'Booty'. This unit takes some time out of the war at a Russian cottage to rest, perform maintenance and distribute captured enemy goods; in this case a huge trove of Russian cigarettes. Not the best ones but if you smoke, something is better than nothing and free is a good price. Notice the older man on the left. He is stretched out on his Zeltbahn in the sun, writing a letter home and a picture of him and his wife is propped up in front of him, to remember her face and the last time they saw one another. Priorities are different for each man.

An officer and the Spiess of this *Stammkompanie* take a smoke break while listening to the radio, which is in one of the storage bins on the side of the supply wagon. A shovel is used to prop up the compartment door, allowing it to be used also as a shelf of sorts. This is just a short rest; the horses are still harnessed and this column will be moving forward once again in short order.

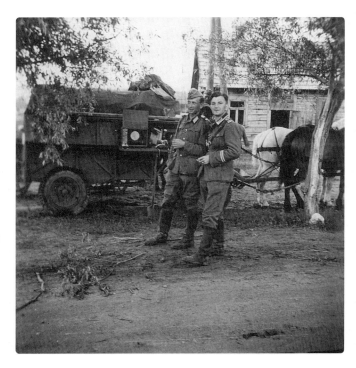

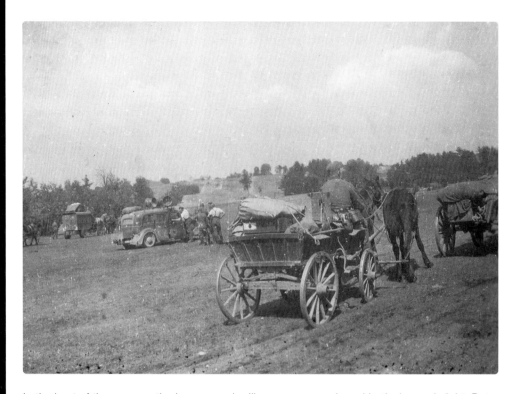

In the heat of the summer the hooves and rolling wagons are heard both day and night. But a new, more modern vehicle for this war is seen here. The large van in the middle has loudspeakers mounted on the top – very large ones indeed. This is a car for making propaganda broadcasts to the local population and Red Army Soldiers. PsyOps was at the front and mobile in this war, and had been since 1939.

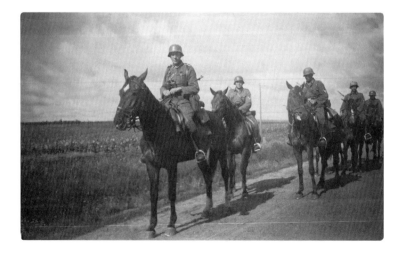

Along with the wagons the cavalryman, in service for centuries now, was still on this modern battlefield. The uniforms and weapons were different but the tasks were the same: reconnaissance, speed of attack and all the missions associated with his antecedents. This cavalry patrol carries no sabres. The decorated *Oberfeldwebel* who leads it carries an MP-40 and his men Bolt Action Kar.98k rifles, a melding of Napoleonic tactics with twentieth-century war.

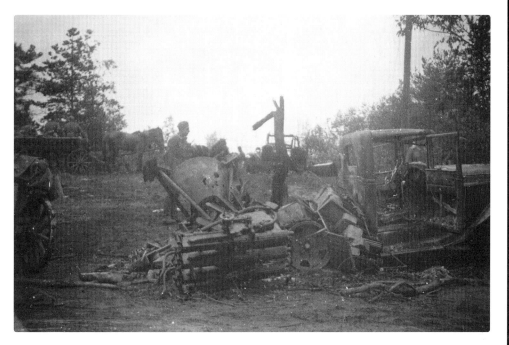

One more stop along the Horse Drawn Tour of Russia that the Landsers would have in the summer of 1941. This Red Army column has been utterly destroyed by air or artillery bombardment. The main point of interest is what is left of the truck that once mounted four Maxim machine guns for anti-aircraft purposes. The tree it was parked under did not fare so well either. In the background a wagonload of troops waits to pull out for the next excursion.

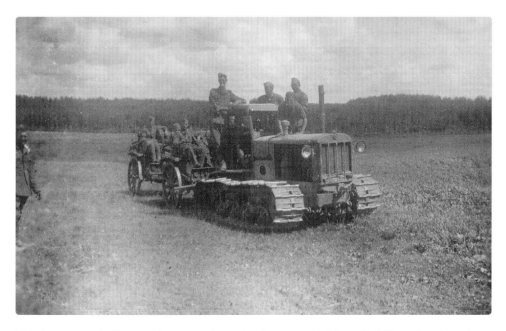

Why leave a perfectly good tractor and march when you don't have to? These Landsers have hooked up two gun limbers to a captured Soviet Artillery tractor to make an improvised troop carrier, a rather smart use of assets that were just lying around. The fellow on the left who is watching this spectacle finds it all highly amusing. Comedy is good medicine in a combat zone.

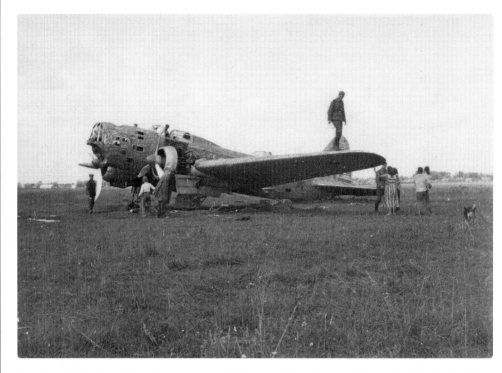

Another Soviet aircraft has become a roadside attraction: this time it is an Ilyushin Il-4 Medium Bomber. Russian civilians are part of the crowd, giving the young Landser on the right some time to interact with some of the local female population.

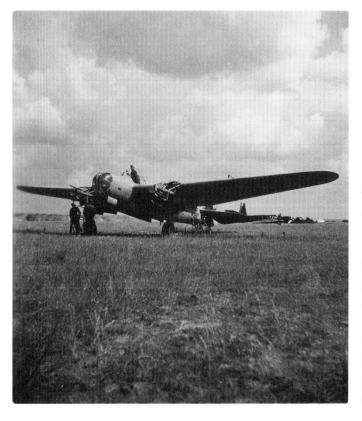

One more overrun airfield. But this time the Red Air Force has only left behind wrecks and aircraft that were in need of repair. This Tupolev has had its engines removed before the field was evacuated. Landsers check it out. In the background planes that have made belly landings have been left on the field.

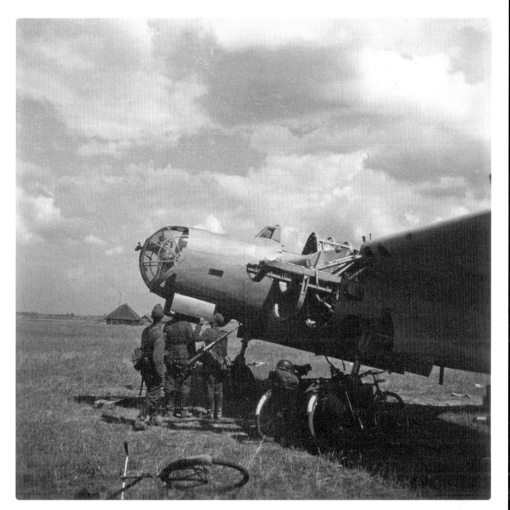

A closer view of the same Tupolev. What is of interest here is the Landsers on bicycles, the *Radfahrtruppen*. This is another mode of transport that is overlooked in the newsreel footage of the day and in propaganda put out by Germany and the Allies. In order to bolster men to fight harder against a vaunted enemy, you did not show them a column of soldiers pedalling down a dusty road on bicycles. Nor was it good for newspapers to print the details of victories over anything but elite troops with lots of Panzers. In reality, just as with horses, many more German bicycles than Panzers saw service at the fronts all over Europe and North Africa. Bicycles require little maintenance in comparison to horses and motorised vehicles. Many countries had been using bicycle troops for decades. Troops could pedal along for miles with relative ease, packs and extra gear mounted onto the bicycles, and dismount to fight with the basic combat load. To make things easier, many vehicles had specific tow ropes with hand loops so that these men could just hold on and coast along, keeping their strength for the fighting.

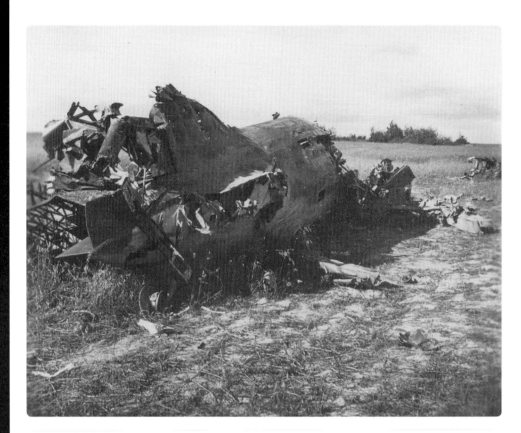

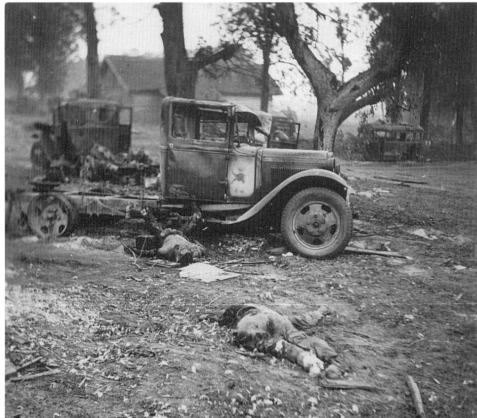

Opposite top: 'Soviet Bomber that attacked our lines. Luftwaffe shot it down; it exploded in the air just before it hit the ground. Ukraine, August 1941'.

Opposite bottom: This Red Army convoy was hit by artillery, causing many vehicles to ignite and burn severely. The dead lay all about, some burnt and some just broken by the blast and shrapnel. *Unteroffizier* Werner Stahnke was a member of a Forward Observation Section of Artillerie Regiment 208, which drove deep into southern Russia. He was a friend to the authors over many decades. In a letter dated 19 September 1985 he states: 'We were always forward with the Infantry to call for fire missions when needed. I will never forget the smells we encountered. Long before we saw anything we would smell the burning. A combination of fuels, cordite, paint, rubber, leather, wool and flesh, this stays with me even now as I write this to you.' Werner would make it to Stalingrad and be lucky enough to be one of the few who made it out.

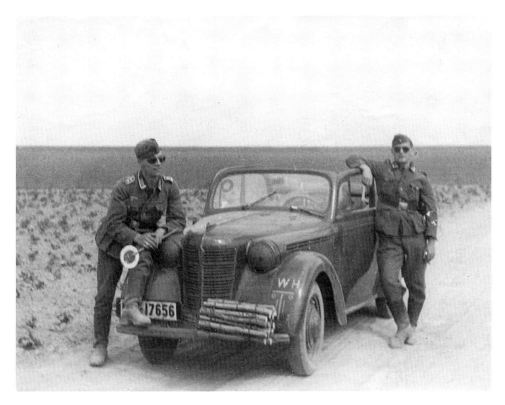

'Southern Russia 1941'. These two Sergeants from a motorised artillery unit have been assigned a traffic detail, to make sure the vehicles of their detachment take the right road. The *Oberfeldwebel* on the left sits on the fender of his car, Vehicle Signal Wand in hand. This was nicknamed 'the Lollipop' for obvious reasons. They both enjoy the benefit of sunglasses against the bright sun. Their ride is a civilian Opel Olympia Cabrio-Limousine, quite a car in its day. The fender has the painted 'WH' for 'Wehrmacht–Heer' over the unit designation sign. This is because it still bears the civilian registration plate: though partially obscured by the boot of the Oberfeldwebel, the first number is a Roman numeral, not a military designation. The bundle of sticks is to place under the tyres in case the vehicle becomes stuck in sand or mud.

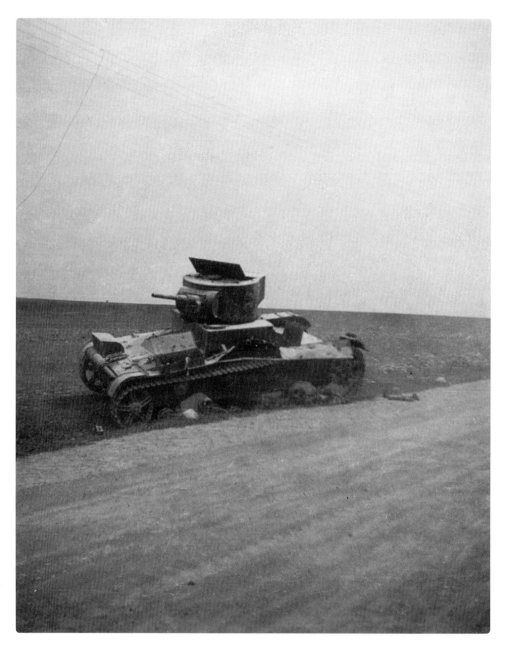

Another Soviet T-26 knocked out on the side of the road, hit on the hull. It was running but the turret is turned towards the enemy; it was a fighting retreat.

Radfahrtruppen and supply wagons work their way through the wreckage of a Red Army column clogging the road. German Engineers and special recovery troops will clear the roads and salvage any good equipment and supplies. They had quite a bit of work to do at all hours of the day and night. A Red Army fuel tanker sits on the roadside having lost a wheel. Most likely it was drained to supply other retreating vehicles, if there was time to do so. If not, the Soviet fuel would have been used to refill German vehicles.

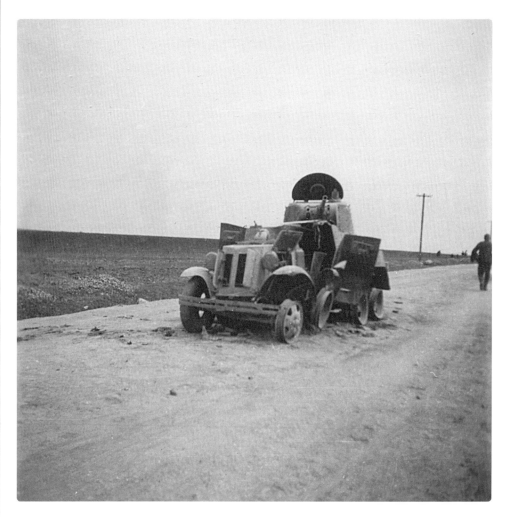

A Soviet BA-10 Armoured Car that made a head-on attack against Germans advancing down a main highway. This vehicle stood no chance against the forces facing it. It was done to buy time, stalling the Germans as much as possible. The side of it is blown wide open.

Opposite top: Further down the Smolensk to Moscow highway, another exit and overpass. In the distance a convoy of wagons is headed back from the front, to get resupplied, in all likelihood. On the overpass, trucks are crossing, together with the omnipresent wagons and horses.

Opposite bottom: Still on the highway, but time for a sightseeing break. Soviet artillery pulled by tractors. Perhaps they can find some booty or a souvenir but – judging from the items littering the ground – someone, Russian or German, has already searched.

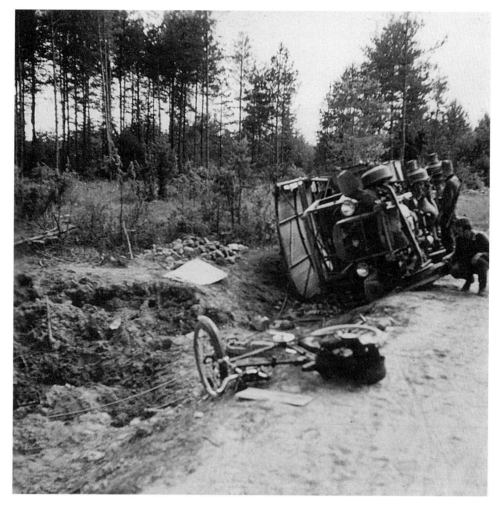

Opposite top: A different road, but curiosity has once more caused these *Radfahrtruppen* to stop and inspect the overturned Soviet truck. The side of the road has a large crater from several artillery strikes and one can see a rope that goes from this wreck towards another point to be tied off as a safety barrier. Perhaps another wrecked vehicle is on the other end of it. The bicycle is heavily laden.

Opposite bottom: German Panzers were thrown into the Russian campaign in the greatest numbers that could be mustered. Here a Panzer IV Ausf. F rumbles down the road past a Luftwaffe Command post, the pennants indicating the presence of a senior officer. The short-barreled 75mm main gun would prove effective against older Soviet armour but would come up short in duels with the new T-34. German designers were already making adjustments and improvements to counter the threat.

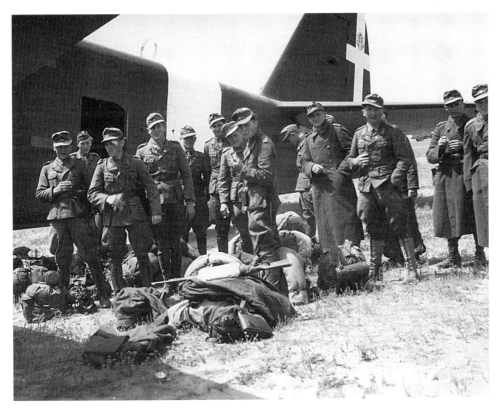

German replacements land in North Africa after a flight in an Italian transport aircraft. The main effort in this theatre was by the Italians. More responsibility would fall onto them because this was now more of a side show; the Eastern Front had become the main focus. Fewer and fewer men and resources would arrive in North Africa as the need for them increased in Russia. These are mostly Panzer men, denoted by the silver skulls on their lapels. One young soldier seems to have been knocked about during the journey. He sports a bandaged brow.

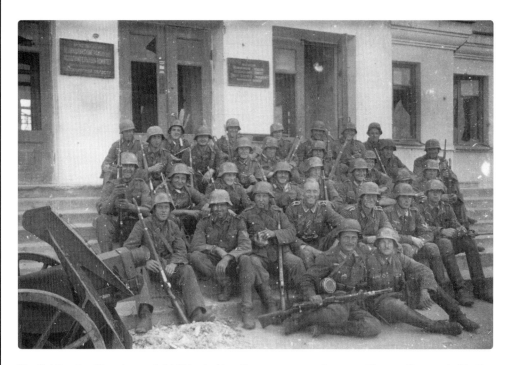

The fighting is still raging on in Velikiye Luki as the summer weeks pass. The caption reads 'Battle-tested warriors'. Sitting on the steps of some Soviet municipal office scarred by the fighting, this platoon from the Gun Company of Infantry Regiment 453, 253rd Infantry Division, all break into a smile for the photograph. These men are unshaven; some have grown full moustaches and are covered in dust. They are tired but still smile widely, happy to be alive. They wear very little gear; in fighting such as this the Landser would normally wear *Sturmgepack*, assault rig. This means weapon, bayonet and cartridge pouches, with canteen if really needed. Basically, take only what you need to fight. This is also an indication that they are close to their supply wagons and support elements. Several are wearing the harness straps used to pull the Infantry support guns along. One such gun can be seen to the left.

Opposite top: The grave of two Red Army soldiers is marked by their helmets and a cross cut from turf, despite the official communist stance on religion.

Opposite bottom: 'Ivan': a close up character study of a Red Army Soldier. This prisoner stares back with grim determination into the camera lens of the Landser who took this photograph. His Asiatic or Slav features probably prompted the taking of this shot. His cap badge has been removed as a souvenir or been thrown away by him.

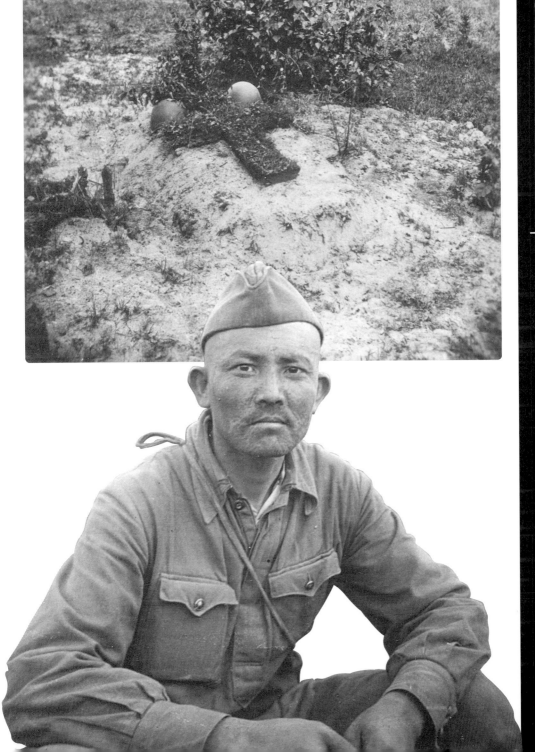

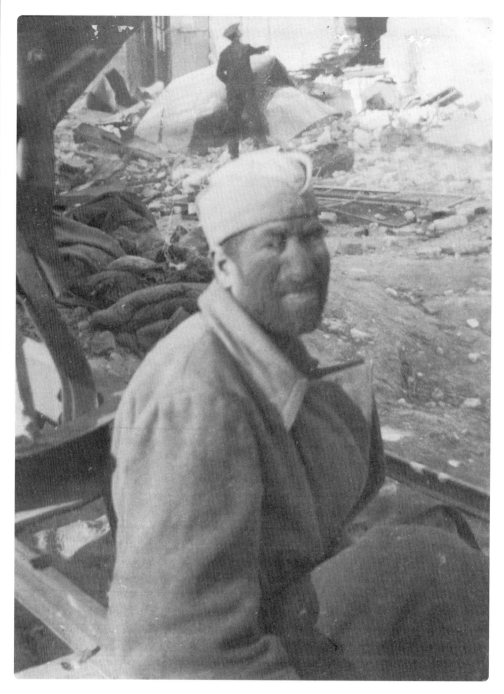

In contrast, this dishevelled dusty Ivan is unshaven for some time and seems in shock as he puts on some sort of a ghastly smile for the camera.

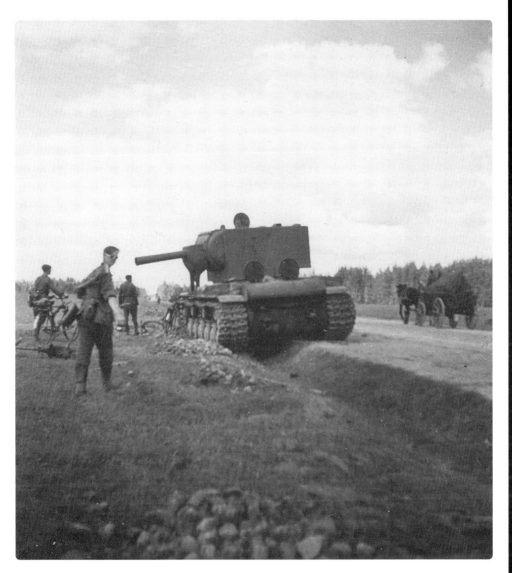

A Behemoth on treads, the Klementi-Voroshilov 2, known as the KV-2, was a tank intended to give front-line artillery support. The idea was to lob 152mm rounds at enemy troops or objectives while advancing with infantry. The armour was thick and could withstand fire from most of the German anti-tank weapons at this stage of the war. This said, it was not without major problems. The silhouette allowed for easy spotting along the Russian steppes, thus allowing Landsers time to call for air support or heavier guns to take them out. The large, heavy turret was unwieldy at best during combat operation and fuel consumption was very high. Fewer than 300 were built, but if you are an infantryman and this steel monster is advancing towards you or you towards it, there is quite a fear factor involved. This one though has become just another roadside stop for the curious 'tourists' in field grey; most likely it broke down and was abandoned as the engine deck hatches are open, as are all the crew compartment hatches. Rifle slung across his back, the *Radfahr* soldier looks back at the cameraman; he knows his Kamerad is a 'shutter bug'.

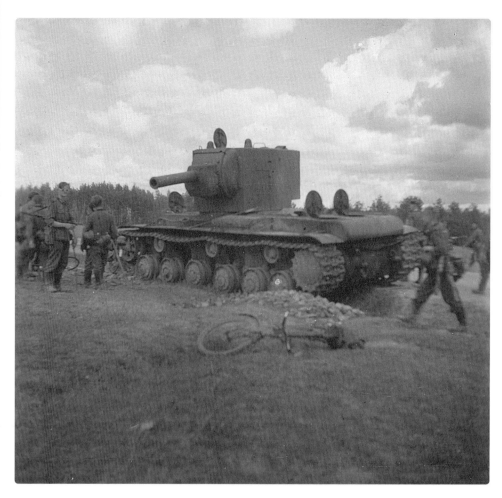

A closer view of this KV-2, seen from the side. The *Radfahrtruppen* have left their bicycles all around the hull to dismount and get a good look. They are, by comparison to the walking infantryman at the rear of this tank, lightly equipped. Their gear is mounted on the bicycles. He carries his.

Opposite top: Something to look at while the horses are given a rest out of their harnesses. An abandoned but still camouflaged 152mm Howitzer and tractor are left sitting on the road.

Opposite bottom: The shattered wreck of a Red Air Force fighter lays camouflaged with foliage on the side of the road. It is possibly a Polikarpov I-16. It is odd that someone would take the time to do this unless it was hoped that it would not be seen by Reconnaissance aircraft. As always, the German wagons roll towards the front in the background.

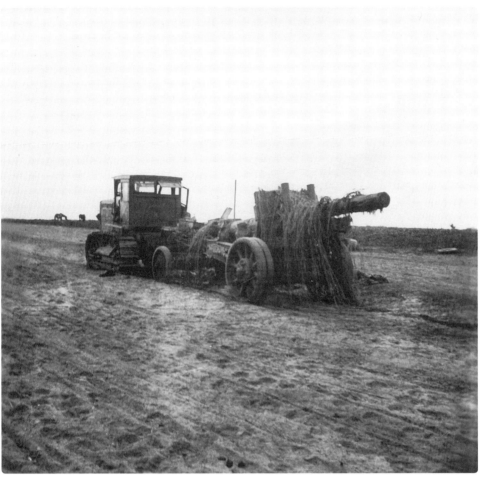

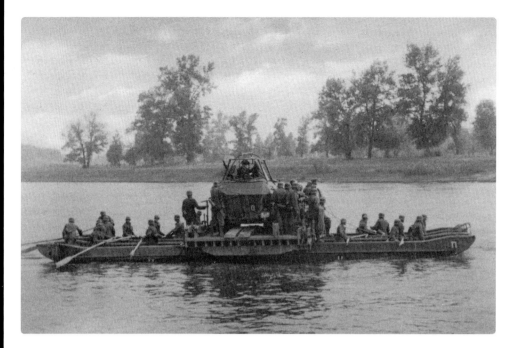

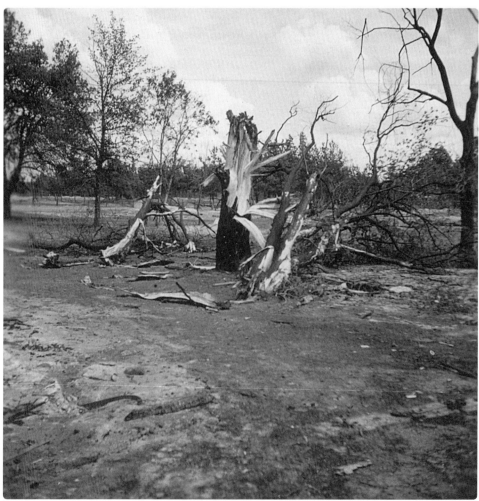

Opposite top: This Sd.Kfz. 251/6 Command Halftrack and crew are rowed across a river on a ferry made of pontoons and a section of bridging. This vehicle may have been the one used by Guderian: the large antenna for the radio equipment is visible and the letter 'G' is prominently displayed. The power for this ferry is supplied by oars worked by Landsers of an Engineer Bridge detachment. It looks like they are letting the current do most of the work, as shifting this beast would be difficult. War brings odd jobs into a soldier's life.

Opposite bottom: The effects of artillery. The round shattered this tree and the effect of the blast can be seen in a large area around it. Splinters of wood, as shrapnel, can be just as deadly as steel.

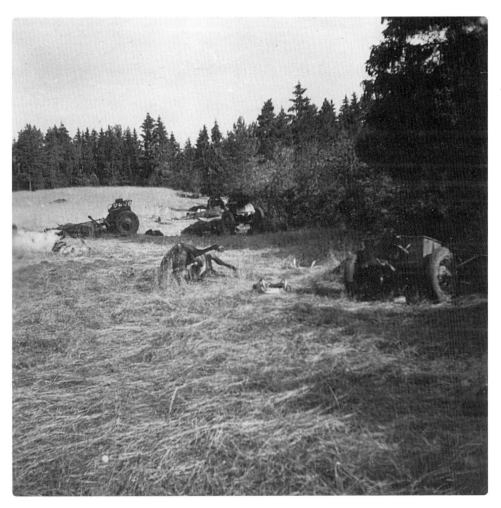

The aftermath. A Red Army Artillery battery is caught while setting up their guns in a wood line. The firefight is swift and fierce. Left behind are the gun limbers and the dead; both men and horses.

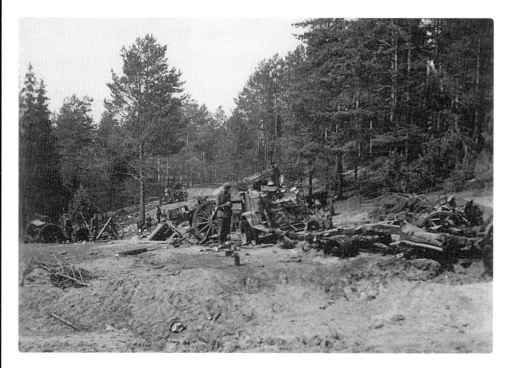

Another pile of wreckage that was also once an artillery battery. The Landsers survey the destruction. It is like this day after day; they think surely this war will be over sooner rather than later, because they have never seen so much destroyed.

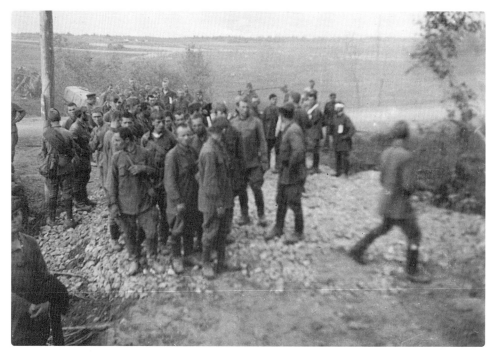

The survivors are gathered as prisoners from this devastated battery. Some are wounded and wearing the same wound tags as a German soldier would if he were hit. Vehicles still smouldering in the background give off a haze of smoke.

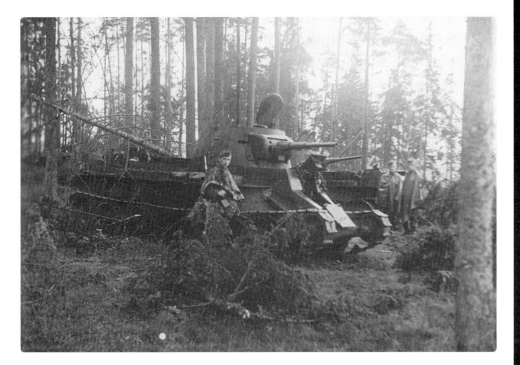

Quite a lot of Soviet equipment was hidden in forests in hopes of returning to use it later. The image is captioned 'Guarding a forest full of enemy tanks and guns'. The Landsers wear their Zeltbahns as ponchos against the rain as they stand duty over these BT-5 tanks. These would be moved out as soon as possible to be refitted and used by the Wehrmacht or be scrapped for the raw materials.

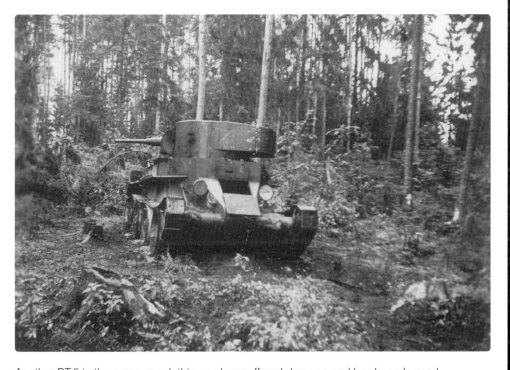

Another BT-5 in the same wood; this one has suffered damage and has been burned.

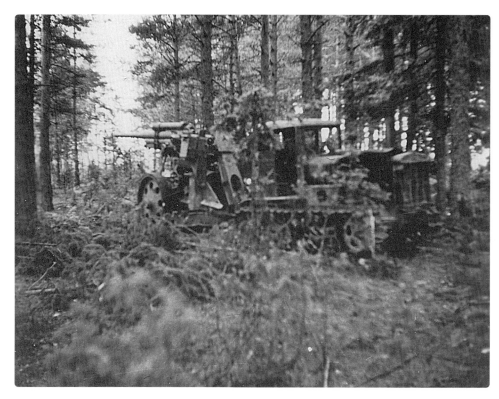

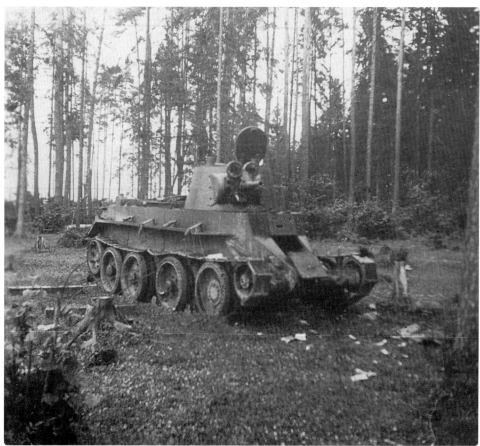

Opposite top: More spoils of war; hidden in the trees is a heavy gun and its tractor. This would also be put to work in German service. The Reich could afford to waste nothing.

Opposite bottom: This earlier variant of the BT-5 is also found in the cache. There was no shortage of interesting things to take photographs of for the family and friends back home.

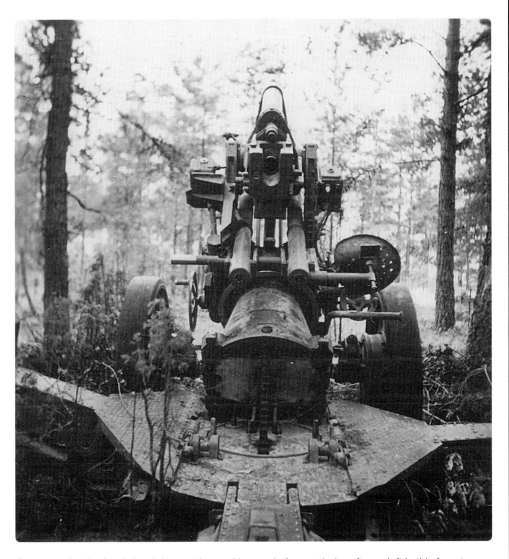

One more for the family back home, the working end of an anti-aircraft gun left in this forest area.

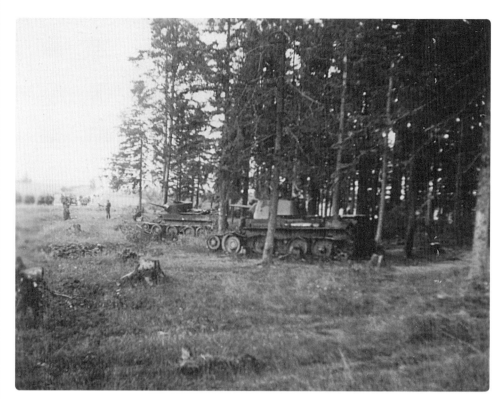

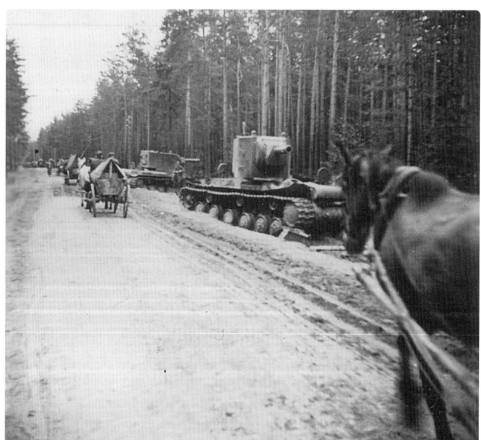

Opposite top: A view from the edge of this wooded area where so much equipment was abandoned. It may have been an assembly or repair area for the Red Army hidden among the trees; either way it was a treasure trove of valuable equipment and materials.

Opposite bottom: There is a bit of a chill on this cool, grey morning as the never-ending columns of German horses and wagons plod on towards Moscow. They pass two more of the giant KV-2 tanks left on the roadside. The hulls both point towards the road but the turrets point towards the rear of each tank; it was a fighting retreat, to be sure.

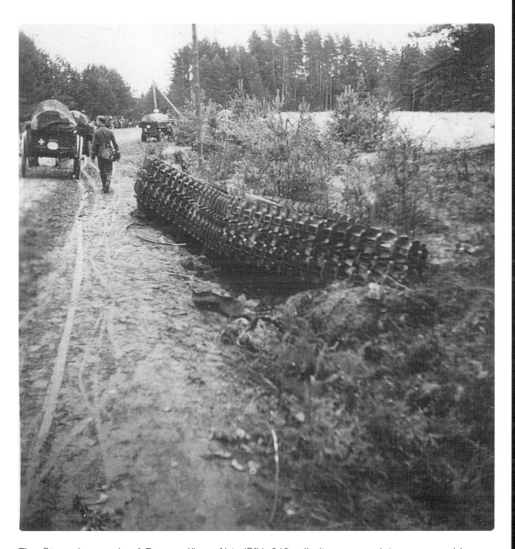

The *Stammkompanie* of Panzer Jäger Abt. (Sfl.) 643 rolls its wagons into an assembly area during a rest stop. The unit insignia can be seen painted on the rear of the supply wagon – a large white Iron Cross. On the right side of the road sits the complete set of tracks and wheels to a tank. This seems to not have the attention of the walking Landser behind the wagon; he is intrigued, but by something on the other side of the road.

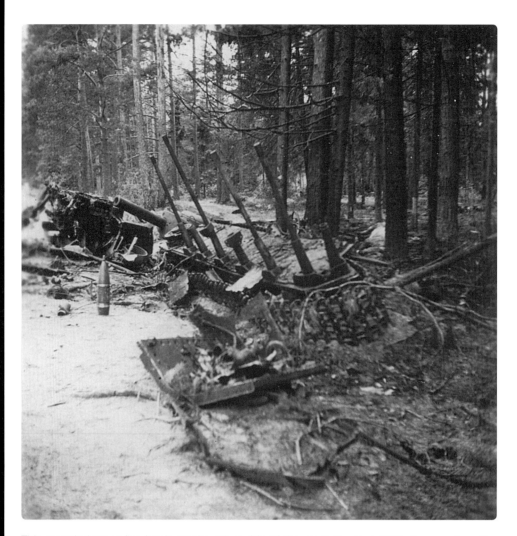

This mangled mess is what is on the other side of the road. It was a KV-2; the gun from the turret is visible in the centre of the wreckage and a shell still stands upright as if placed there by a member of the crew. The force of the explosion that wreaked this havoc had to be massive in order to utterly destroy such a large and heavily armoured tank.

Opposite top: Another view of the remains of this tank. The turret ring lays on the engine block; the gun mantle is separate from the rest of the turret. The sharp-eyed might notice a crater from the blast on the edge of the road; more evidence of a massive explosion.

Opposite bottom: Further down this country road this same column encounters another KV-2, this time intact and abandoned. It is facing away from German advance, so perhaps the fate of their comrades in the shattered tank in the previous images was just too much for them.

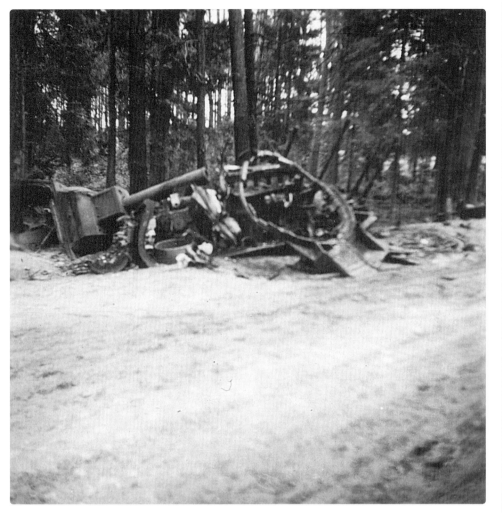

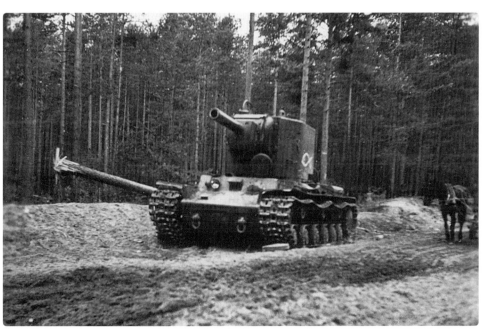

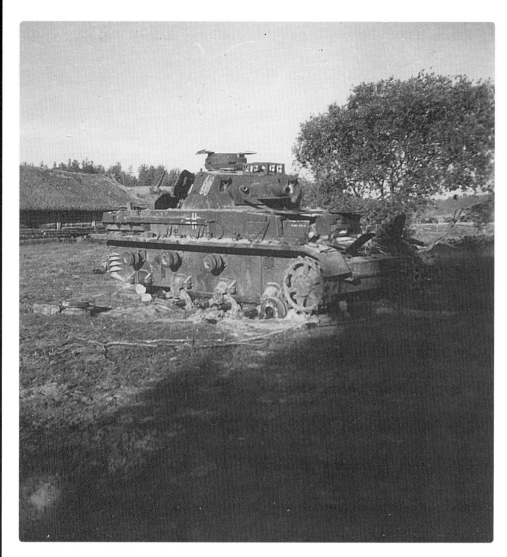

Not every tank wreck was a Soviet one. The Panzer IV was hit in the right side advancing through this Russian village. Its tracks and some wheels were blown off, causing it to catch fire. All the hatches are open so perhaps some or all of the crew got out alive.

Opposite top: A fighting retreat making for the bridge leading into the Russian town was attempted by the crew of this BT-5. They failed but bought time for others. The war moves on once again.

Opposite bottom: In stark contrast, the crew of this T-26 were just running. It was hit in the rear and made it no further. Just beyond it, Landsers relax while enjoying a meal.

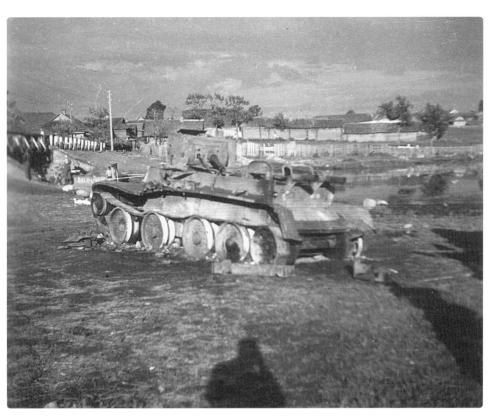

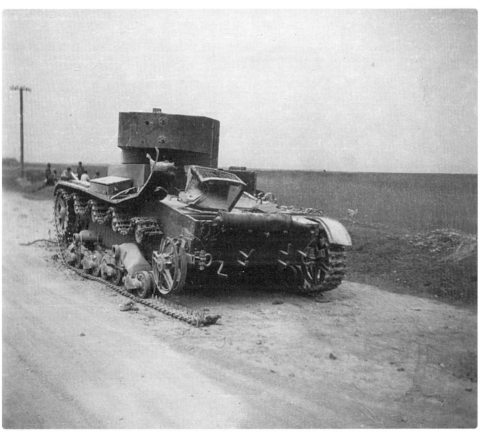

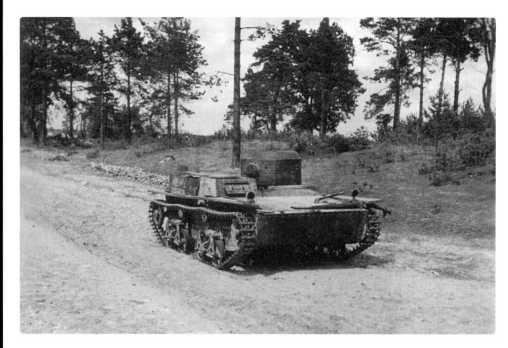

Something new and different is encountered every now and then during this campaign. A T-38 Amphibious Scout Tank sits knocked out on the side of the road. The front armour plate is separated from the hull top. She was struck on her left front and that was all it took. She won't float now.

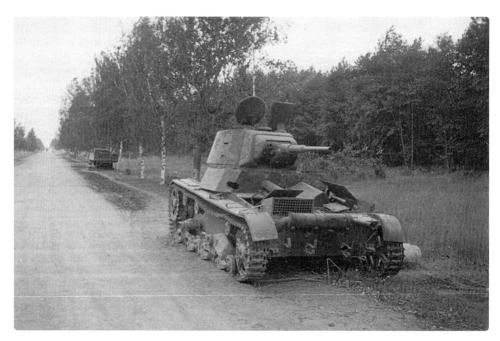

A German truck leaves a trail of dust as it speeds down this road. The evidence of the fight that occurred along here is still in place: another T-26 that made a fighting retreat but lost, a round having gone through the rear and blown the engine apart. Beyond it sits the remains of a Soviet truck.

A fine portrait of a Russian peasant taken by a Landser. His name, his village and his fate we will never know, but his bearded, weathered face has been recorded for the ages.

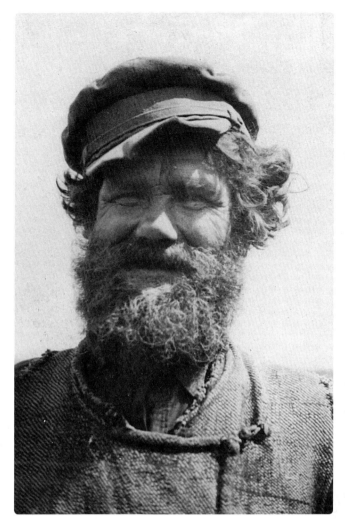

Another Russian village is occupied. Barefoot children interact with the new soldiers who have arrived in their world – the curiosity of the innocents.

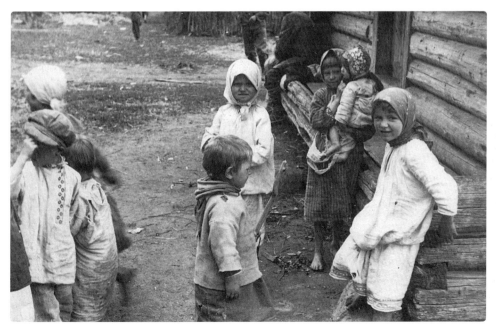

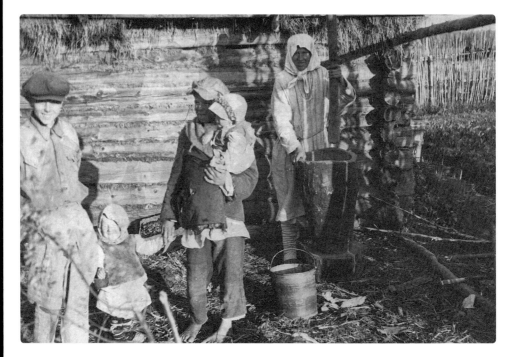

'Poor Russian Peasant's [sic] make flour, the children are barefoot. Russia 1941'. Some of the things these men see are not of the same century and it surprises them, especially those from the cities. The smiling lad on the left wears a discarded Red Army shirt.

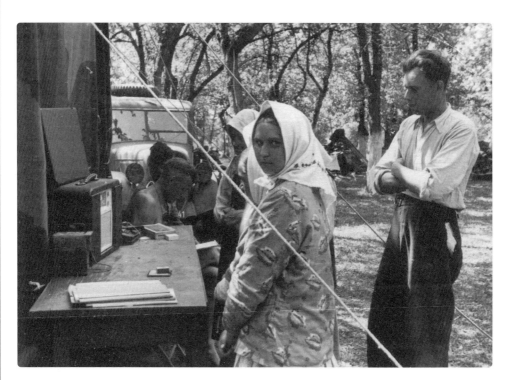

'Kulikow July 1941. Ukrainian Girls from the village listen to our radio', writes the Landser who took this picture. In the quiet of a shaded wood the men of this headquarters unit catch up on paperwork, and the essential, ubiquitous rubber stamp can be seen on the table.

Ukrainian women and children interact with these Landsers assigned to a traffic control point in their village, finding a motorcycle and side car very interesting.

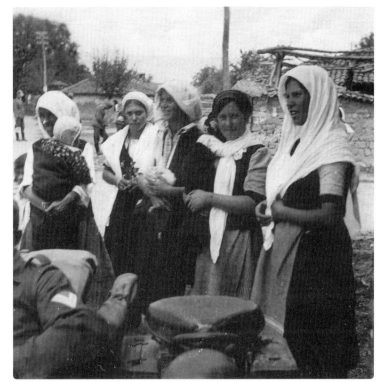

It was not only in Russia that Landsers interacted with locals. Here in North Africa, soldiers of the DAK talk with an Arab. The Landser on the left has a camera hanging from his hand by the strap; a sight-seeing trip during some off-duty time. The man on the left is an Italian colonial policeman.

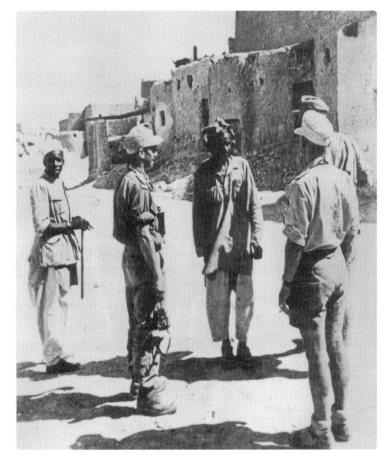

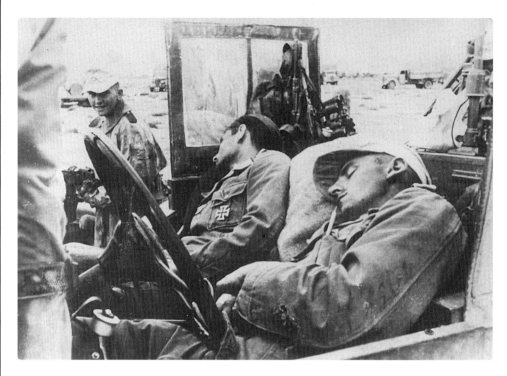

The true meaning of fatigue. Under the watchful smile of a Kamerad and a camera, these two Landsers sleep the exhausted sleep of soldiers. The one on the left wears both the 1st and 2nd Class Iron Cross on his tunic; the ribbon and shiny new medal stand out against the grubby uniform. The driver also wears a new ribbon for the Iron Cross 2nd Class. His sleeve shows holes of wear on the cuff and his cap is bleached almost white from the sun. This is a Signals unit. The driver's canteen is hung within reach just behind the steering wheel. Behind them rifles, binoculars and other gear are piled up, out of the way, just so they can get some rest. Next to them attending to his motorcycle is a dispatch rider. He wears a small sun-bleached cap and on his distinctive rubberised motorcycle overcoat the shoulder boards are still the standard issue for Continental Service, and not for the Tropical uniform. The DAK was not getting the supplies it needed – uniforms and men were wearing out.

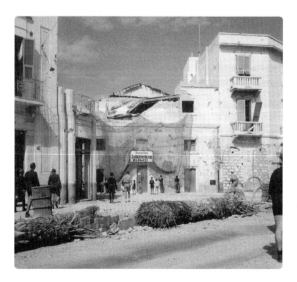

Every army since the First World War made efforts to give troops entertainment and off-duty recreation, no matter what part of the world they found themselves in. The German Army was no different. In a battle-scarred Benghazi a damaged building serves as a theatre for Landers. Both German and Italian soldiers approach the entrance for the next show.

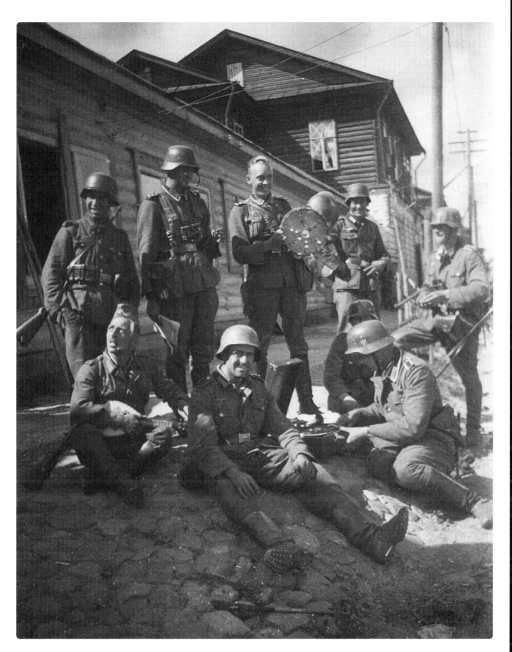

'Velikiye Luki August 1941, if you're going to sing, then get in the swing'. During a lull in the hard fighting for this town, these Landsers take a well-earned break. An *Unterfeldwebel*, kneeling on the right, cranks up a phonograph they have acquired somewhere along the way. The paper cover of the record has been thrown away, now lying on the ground in the lower right corner. To the left sitting on the ground a *Gefreiter*, rifle slung across his back, tunes his Balalaika, yet his gaze shows he is paying attention to something else. In the centre of the standing men a bareheaded *Oberfeldwebel* uses his helmet to accompany his tambourine. The sounds of a scratchy record accompanied by instruments and singing will echo strangely, along with the din of weapon fire, through the streets of this town. The proliferation of NCOs with map cases and the lack of full gear on the other ranks indicate that these are probably men from a headquarters detachment, with their supply and baggage wagons somewhere close by.

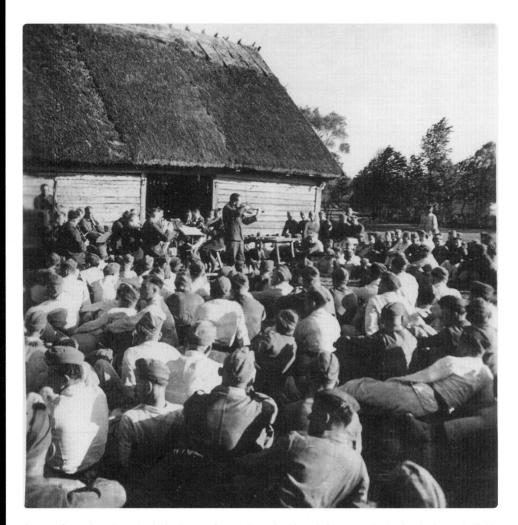

A more formal and no doubt better performed musical break from combat, also in August 1941. The concert party took on many forms in many armies but the idea was the same: bringing entertainment to the troops in forward areas. A Russian barn serves as the backdrop for this violin solo.

Opposite top: Even in the windswept North African desert the Regimental Band gives a performance for their fellow Landsers. They endure the same hardships as any soldiers in the desert since when not playing they usually find themselves in some sort of a support role, as stretcher bearers perhaps, or some function with the branch that the regiment belongs to – infantry, artillery and so on. This is evidenced by at least two men with bandaged wounds on their legs, the white of the dressings contrasting with the sun-tanned skin. The second Bandsman from the left has a captured British water bottle slung over his shoulder; playing a clarinet in the desert surely will make one thirsty.

Opposite bottom: This car and its men from Panzer Artillerie Regiment 16 of the 16th Panzer Division sat out the Balkans Operations in reserve but now they are engaged in Operation Barbarossa, beginning in late July. This meant that they had to cross large areas of land already taken to reach the front. They speed along to their destinations, which would at this time include Kiev.

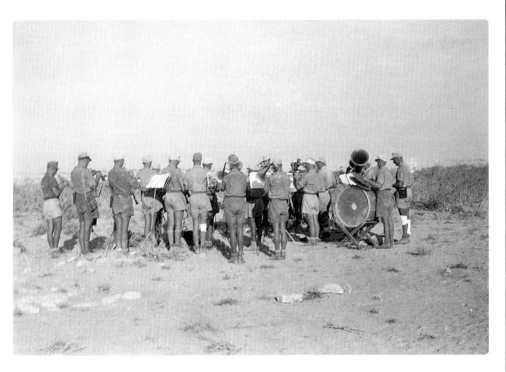

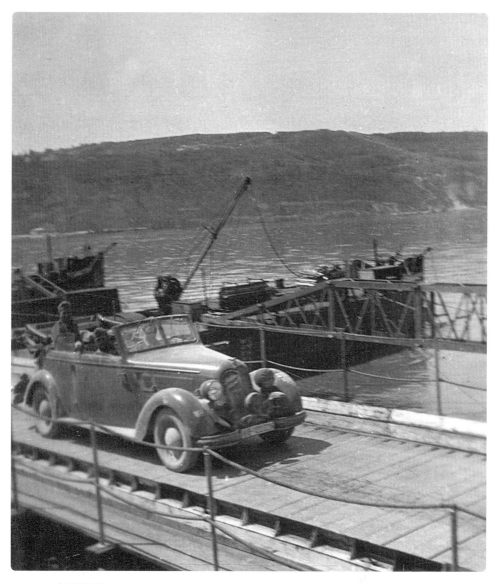

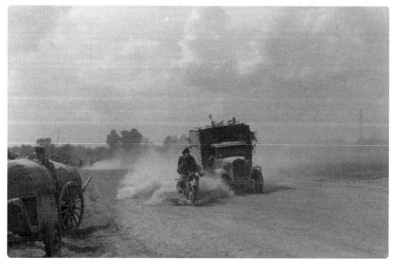

Opposite top: Through the hills and over the river they go onwards towards the front. Life isn't so bad with a nice car and plenty of fuel. For now they enjoy the war.

Opposite bottom: The men of a *Gebirgsjäger* horse-drawn baggage train turn their heads away from the dust coming from the road; they have smartly stopped on the side which is not downwind of bothersome clouds kicked up by vehicles. A despatch rider on his motorcycle with a passenger speeds by a lumbering truck, kicking up even a bigger storm of sand. The truck is loaded in a lopsided way; it is noticeably leaning to one side. You can feel the grit in your teeth.

The column of a motorised signals battalion takes a break from the road in this damaged Russian city. The fighting has been rough through here, yet still civilians are seen going about their business.

THE LOST LANDSERS

Infantry marches steadily onwards to the east as the sun is rising. These men were up before the sun, ate whatever meal they were given and have been on the move since then. They are led by a young officer, wearing an enlisted man's belt and buckle rather than the one for his rank. He has decided that he would rather walk with his men than ride: a smart move that his men will take as a sign of respect and good leadership. His mount is tied to the rear of this company's supply wagon.

Across the fields and back onto the road, the Panzer III is making its way between two trees to enter the rear of a convoy. This tank is probably in reserve, being used for rear area security or convoy protection. First, it has a bundle of Jerry cans strapped together on the top of the turret, complete with helmets hanging from them. This is not something any tank crew wants to have in place going into a fight. Second, the MG-34 on the cupola mount is under its canvas cover and not ready for action. There are other indications. The repair of battle damage is underway. Note the steamroller repairing damage from earlier actions.

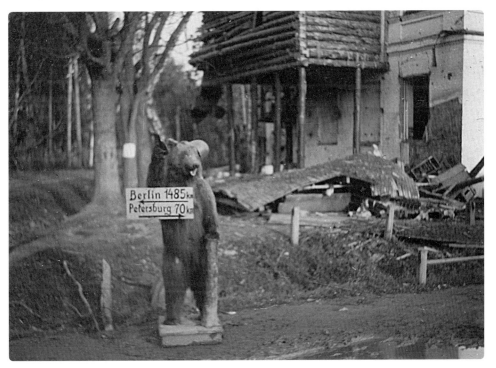

On the northern front the remains of an old hunting lodge from the days of Tsarist Russia, a Dacha, which was being used by Soviet officials, has provided an arresting road sign. A stuffed bear complete with Soviet helmet indicates that St Petersburg, Leningrad to the Soviets, is 70 kilometres away, and Berlin a whole lot farther. The caption reads 'Westwards is the way home to kin and hearth'.

Taking pride in one's work; this bridge bears the sign: 'Breslau Lerge bridge built by Pionier Battalion 48'.

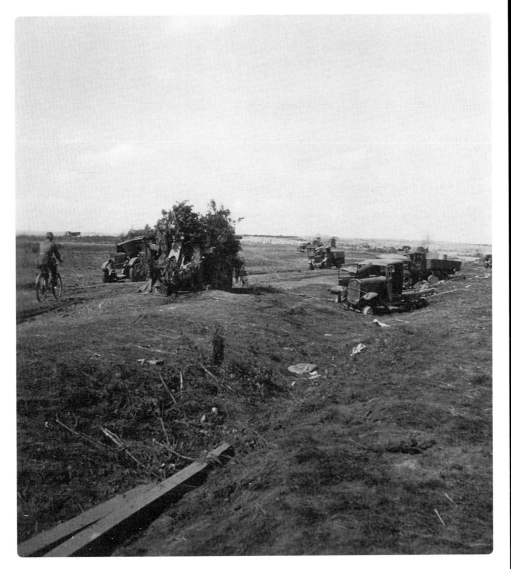

A Landser on his bicycle but without any gear on pedals through a field littered with the shattered remains left by the retreating Red Army. A camouflaged artillery piece sits amidst broken, destroyed or abandoned trucks. Most Germans were thinking that this campaign would be over very soon, as they had seen the destruction of so much material and captured so many men. A road obscured by dust from the wheels of German convoys is his destination.

Opposite bottom: The crew of this heavy SKODA truck poses proudly for a souvenir photograph. On the right fender, left as you see it, is the 'Flying Ghost' insignia of the 11th Panzer Division. The other fender has a second symbol for this unit, a circle with a central dividing line. The symbols below it indicate that the truck belongs to the Administration Troops of one of the regiments of Panzergrenadiers. A heavy-duty truck – all that paper and those typewriters weigh a lot.

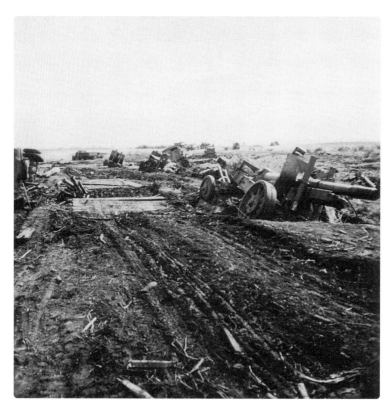

Caught in the open by German artillery, this Red Army column was pounded to destruction. The Germans have made the road passable for now by building wooden 'bridges' to span the massive craters.

Abandoned Russian 37mm Anti-Aircraft gun; it is set up and still has the canvas cover on the barrel. The new owners will put it to use once more.

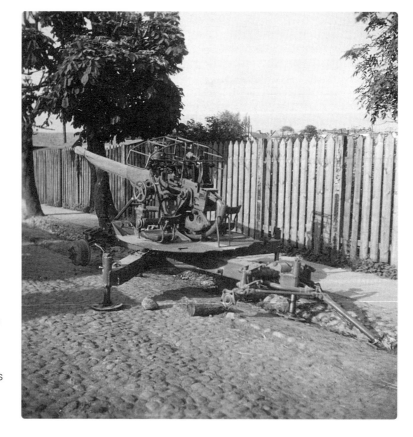

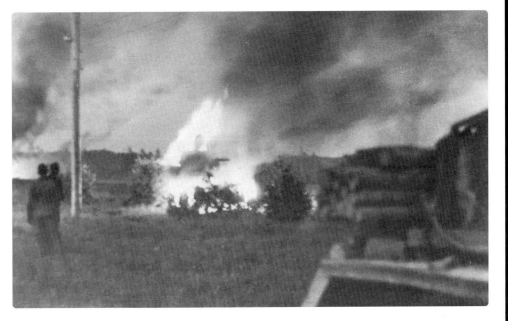

'On the Berezina (river) August 1941'. A T-34 is engulfed in flames; the heat is so intense that a telegraph pole has caught on fire at the edge of the road. Other Soviet tanks burn in the distance; though they are not visible the flames brighten the background.

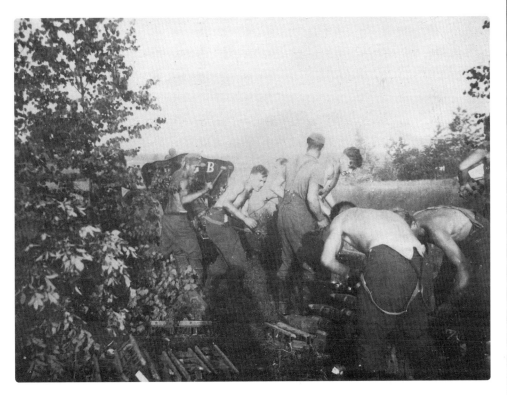

The 10.5cm leFH 18 was one of the main divisional artillery guns in the German Army. Most of the crew turn away from the gun as it fires. Shells ready, they will load fast and fire until the mission is done for the day; hard, hot work in the sun for these *Kanoniere*.

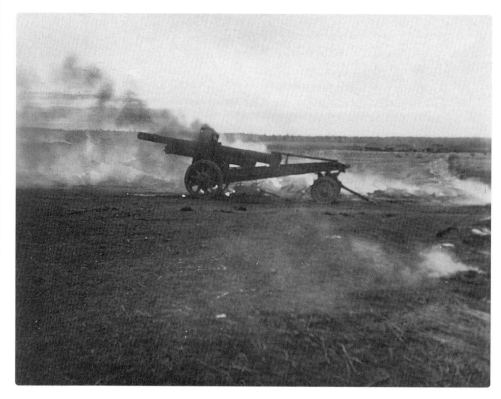

The ground still smouldering from the blasts of incoming artillery, another Soviet gun sits abandoned on the side of the road.

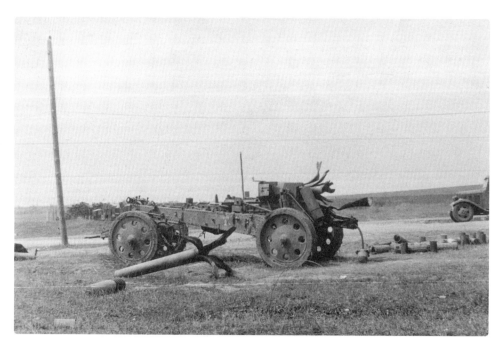

The crew of this same type of gun decided to destroy it rather than just abandon it. And they did a complete job. Stalin would perhaps applaud their thoroughness, then court-martial them for retreating.

'What the hell was this idiot thinking?' must have been the Landser's reaction. The driver of the BT-5 tried to get through this huge, deep shell hole to attack oncoming Germans. The result was inevitable. The road has been blocked for safety reasons but traffic passes easily to either side. In the shade of the trees a *Radfahr* soldier repairs the tyres of his bicycle.

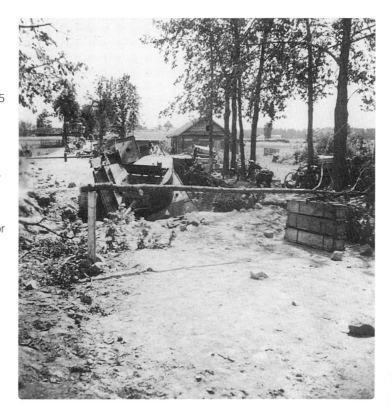

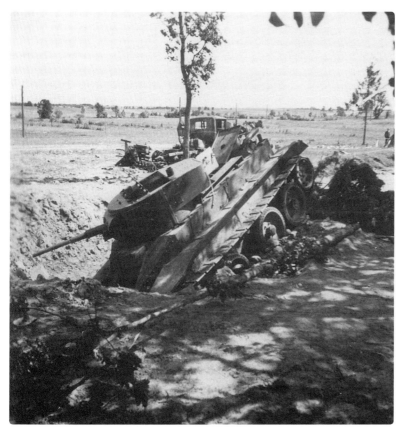

Another view of the same BT-5. It is clear that there was sufficient room for him to pass to one side.

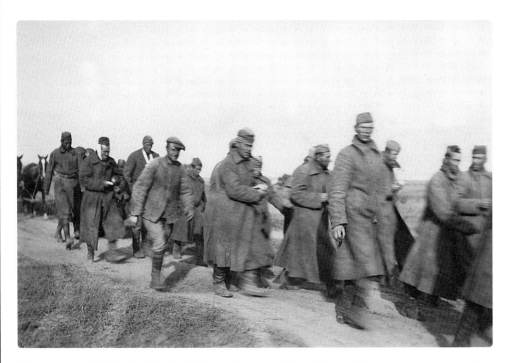

'Russia August 1941 in the Ukraine'. The nights are getting colder, as these prisoners are wearing greatcoats and padded jackets as they march.

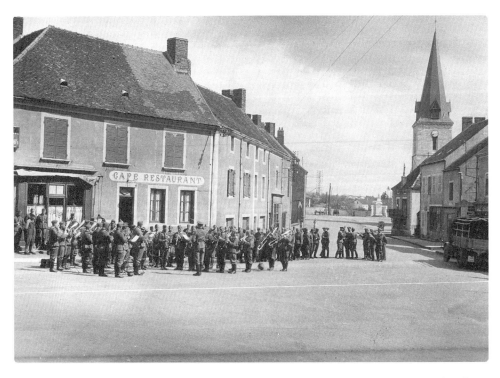

The same month: in occupied France, life is still pretty good. A concert party serenades these Landsers as they wait in line to get into the local café.

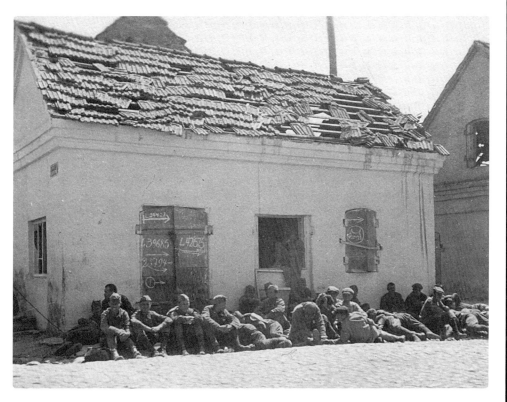

Soviet POWs rest in front of a house that has been turned into a notice board. On either side of the one prisoner who has taken up a perch in the open window, the door and shutters indicate units in the area. These are all the *Feldpost* numbers assigned to units by the German military mail system sometimes employed for security purposes. We do know that these are all Luftwaffe units, because they begin with an 'L' prefix. On the shutter is the symbol of a Scottish terrier in a circle, which indicates that *Stukageschwader* 2 was around. The Junkers 87, or Stuka, was one of the best dive bombers and ground support aircraft of the war. These POWs seem to be in greater danger from loose roof tiles than enemy action at this point.

Sergeant on a mission. He approaches the abandoned Soviet tractor and wagon to check out the possibilities. The rest of his men march along behind the ubiquitous baggage and supply wagons.

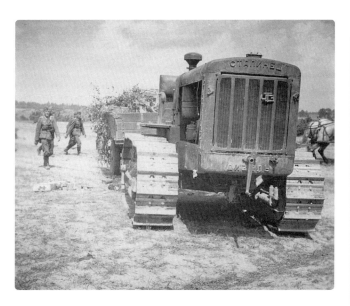

'On the Black Sea Coast, 1941'. The dust-caked motorcycle despatch rider is a long way from home; the beach is to the right.

Opposite bottom: Summer is waning. Early in the morning this view of Smolensk may give the appearance of being in flames, but it is only the smoke from the many chimneys of the inhabitants. Two lanes of traffic head towards the front and one lane heads to the rear. The grumbling of the truck driver stuck behind the wagon going up the hill can almost be heard.

Pioniere take a break along a bridge they have repaired. The original one is a mass of twisted metal. They have done quick work and watch as the first wagons come rolling over it.

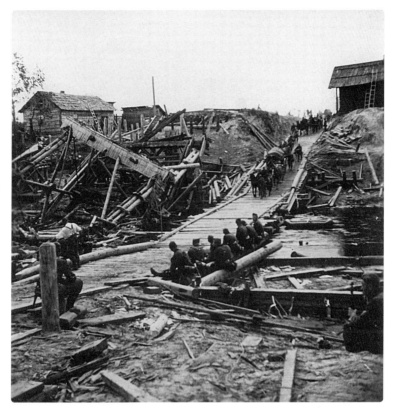

In Smolensk a wrecked
T-26 serves as a German
sign post.

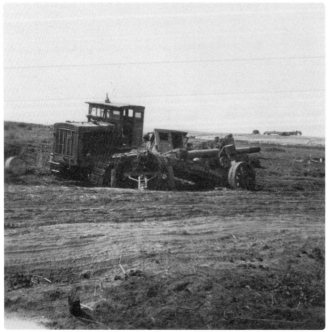

The summer has passed
and still Soviet equipment
is found destroyed
or abandoned on the
roadsides, but not in the
same quantity as in the first
weeks of the invasion.

A Soviet bunker hidden in the woods, no shots apparently fired from it.

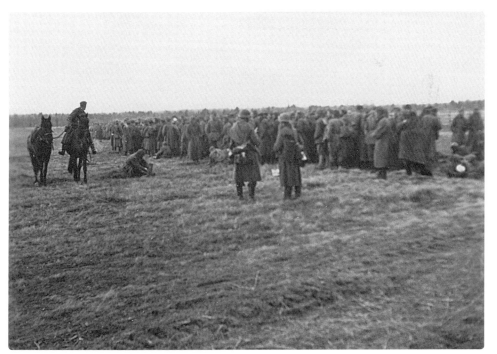

Thousands of Soviet POWs huddle in the cold of an October morning. One to the left of the prisoner formation is digging a fire pit with a vent pipe to cook whatever he has available. The mounted soldier leads a pack horse and has just left rations for the prisoners at a point behind him. He looks back because some commotion there has caught his attention.

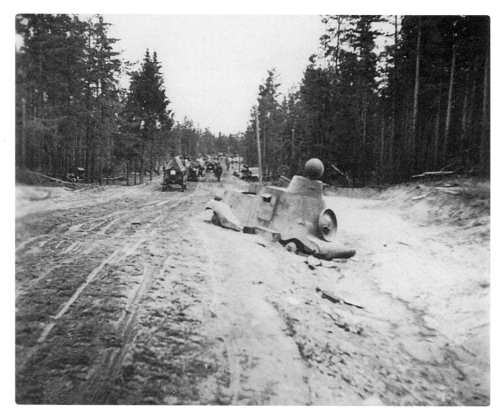

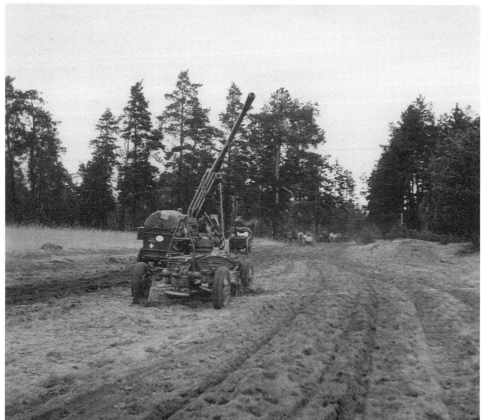

Opposite top: The roadside is littered with Soviet armoured cars and light tanks that made a counter-attack. It was doomed but is perhaps a sign of things to come. 'Russians that attacked us on the road were destroyed and pushed back. We continue to advance. October 1941'.

Opposite bottom: Another Red Army traffic hazard, an abandoned Anti-Aircraft gun parked in the middle of the road.

Having sifted through the wreckage, on the right up near the road, a Landser walks back to his wagon with his treasures. He carries a suitcase and a bundle under his arm. In the foreground a medic, his armband just visible, looks inside the storage compartment of a gun caisson. One man's trash can save another's life in war.

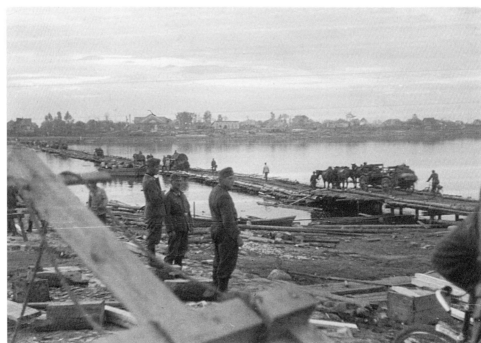

Opposite top: The roads are becoming muddier every day but are still not too bad. Landsers march down a forest road littered with armour and tractors. A KV-2 is in the background.

Opposite bottom: In the rear areas bridges are being rebuilt or new ones constructed to keep the supplies rolling forward.

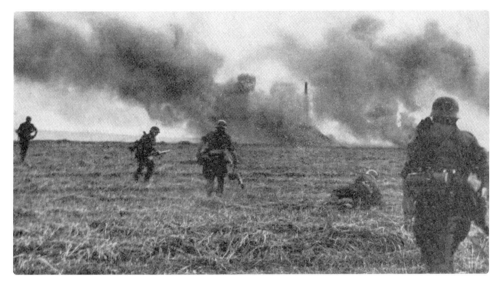

In September the Ukrainian capital Kiev falls, but the Ivans torch everything before evacuating.

Western Europe is not as dangerous as the Soviet Union or North Africa. But there are still risks. A speeding ambulance driver has failed to make the turn.

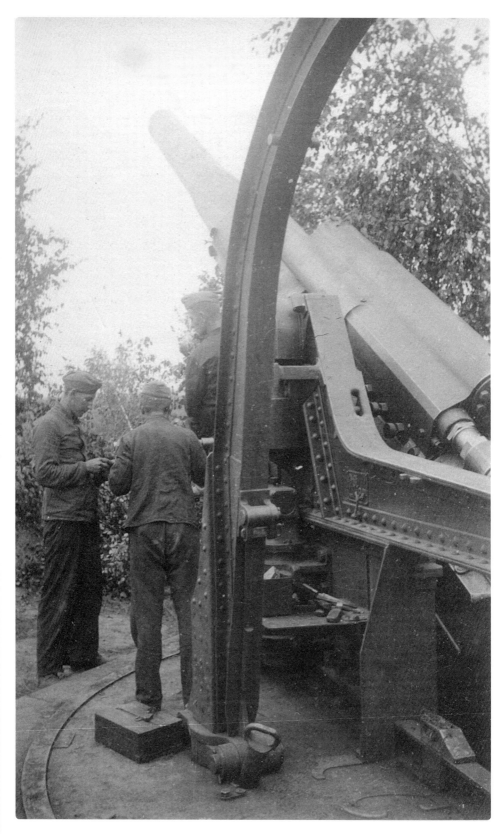

Training continues: 'Cigarette time; a break in our gun training, October 9th 1941'.

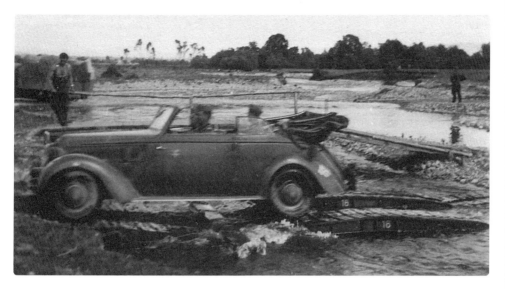

A Staff Car, plate IVB 122221, from the 16th Panzer Division bounces across a very small 'bridge' in the hinterland of Russia, image dated October 1941.

An enjoyable trip still for the occupants of IVB 122221, which sits off to the right. 'Russian Girls greet us with flowers, October 1941'. All smiles in this town now, but the fate of these girls was most certainly grim should this act ever become known to Red Army troops.

The ruts in the mud are getting deeper with every passing vehicle. A Russian family watches the road as a German truck struggles to get past their house. The sign indicates a Field Phone station is nearby.

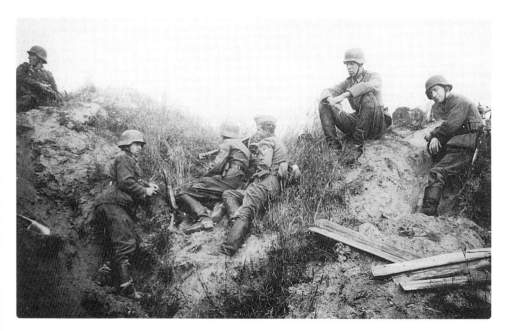

Right after the action, October 1941. These Landsers are in an old Soviet position. The MG-34 of the man on the right can be seen just beside him, the ammunition belt laid carefully out over a rock so that it does not get dirty. Next to him is an officer, apparently deep in thought. The three men in the middle wear riding breeches, boots and spurs, indicating that these enlisted men are mounted. The way they sit exposed on the top of this position indicates they are in a safe area with regard to enemy rifle fire. They are from a Headquarters section.

The days were still warm and sunny but the mud was getting deeper and deeper. The Landser on the right is standing ankle deep in it. The convoy is at a stop for this Artillery unit, but it will not be a long one or they risk sinking deeper into the sea of mud.

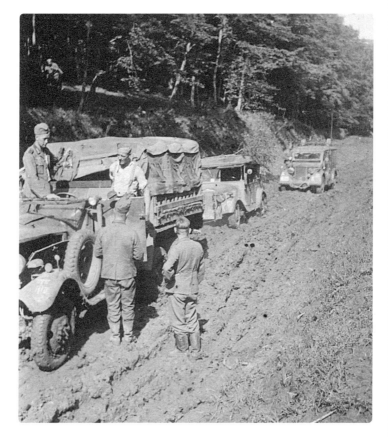

The mud, thick and like cement, curls through the rim holes of this tyre. The chains don't help.

Opposite top: Large defensive works like this are encountered the closer to Moscow or bigger cities the Germans get, but many prove useless, just like this anti-tank ditch, which has only stopped the Landser who took the image.

Opposite bottom: The first snows have fallen and the muddy roads freeze at night, leaving deep, rutted channels for vehicles to negotiate. This vehicle from the *Stammbatterie*, HQ Battery, of Panzer Artillerie Regiment 19, part of the 19th Panzer Division, grinds and jolts on towards Moscow.

Back in the newly occupied parts of the Ukraine and Russia, the local populations are being put to work, some forced and some hired, in cleaning up the debris of earlier battles. A civilian smiles at the camera, pausing in his task of clearing up the wreckage of a crashed Soviet bomber.

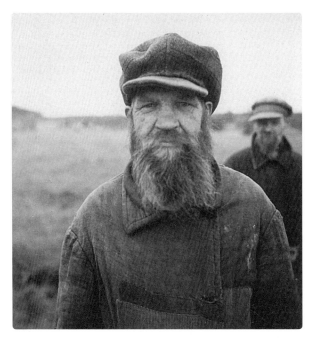

Two more men of the same work party. They are much more grim-faced about the task. The clothes they wear tell of a life of poverty and hardship.

The faces of these Landsers show grave concern at something as they move along the mud-filled trench.

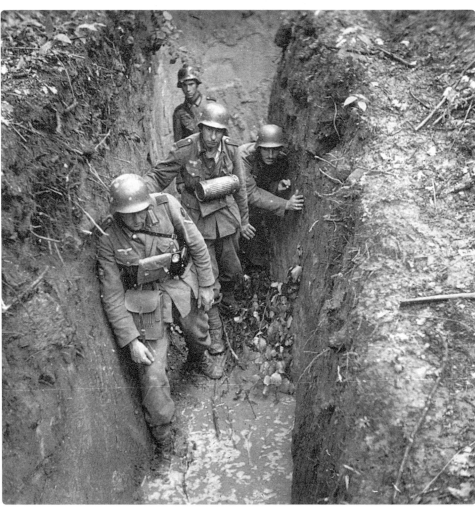

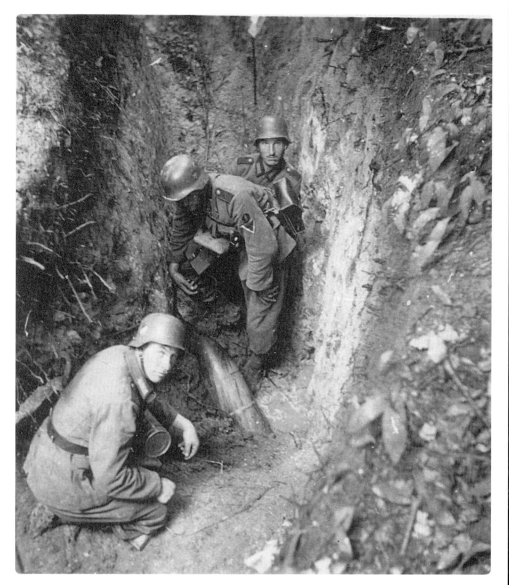

This is the reason for their caution: an unexploded Soviet artillery round. They are relieved, as it turned out to be a dud and spared all their lives. But the fear factor was intense, as the look upon the man with the moustache who is staring directly into the camera clearly indicates.

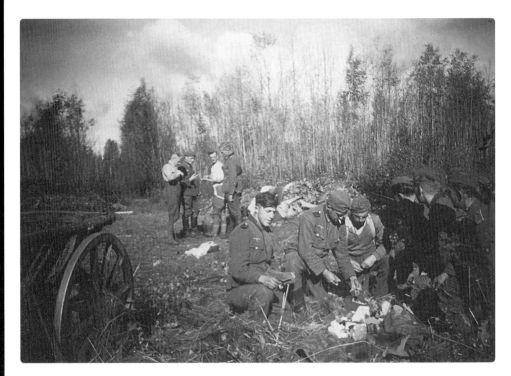

These are the times that troops in all armies look forward to when far away from home. 'Mail and rations are distributed, autumn 1941'.

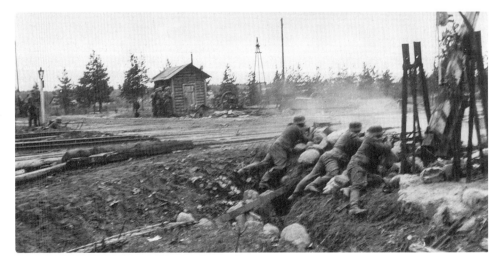

The blurring of this image is understandable. On the right three men lay down fire; two with rifles and one with a captured Russian DP LMG. To the left of the image an MG-34 gives covering fire as the Squad leader stands behind a lamp post directing the suppression fire. A manoeuvre element of five men waits behind the shack at this railroad crossing for the order to attack and flank the enemy. The ground is harder and there is a hint of white. But the day-by-day fighting like this goes steadily on.

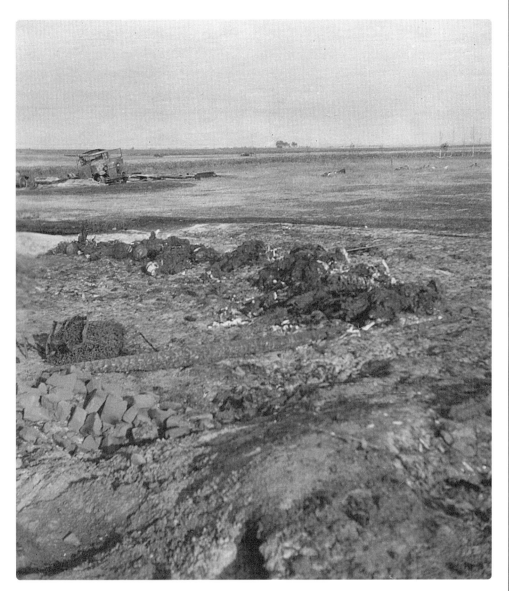

The aftermath of a Red Army night attack. Bodies lay in rows or in heaps across the road. But the 'Ivans' are getting more and more aggressive.

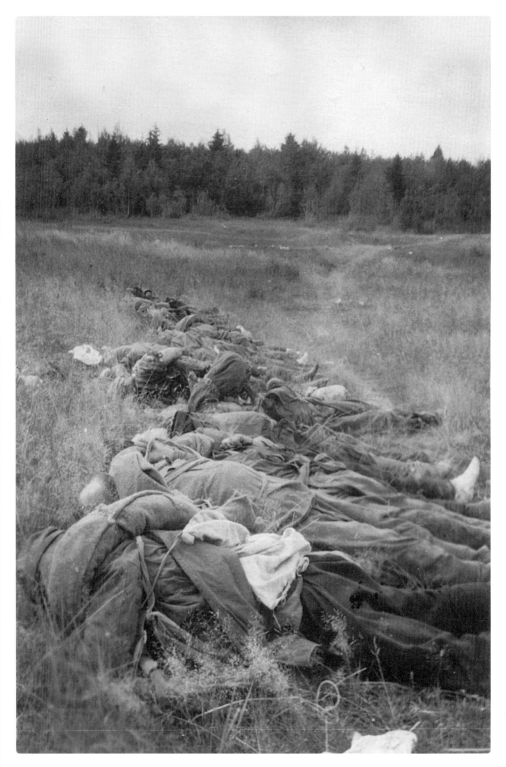

'In a suicide attack these men charged us, only a few rifles but nothing else and some were barefoot. It took only seconds to stop the attack. Fall 1941, yours, Richard'.

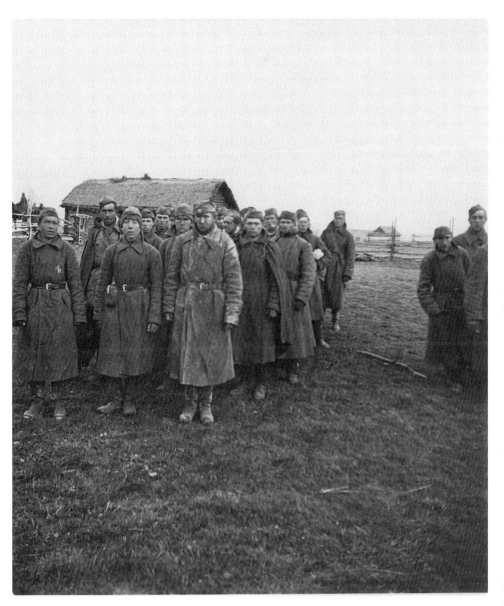

Others would survive attacks and go into captivity. These Ivans are cold, tired and hungry. They have escaped death in this action; however, enduring captivity will be another challenge.

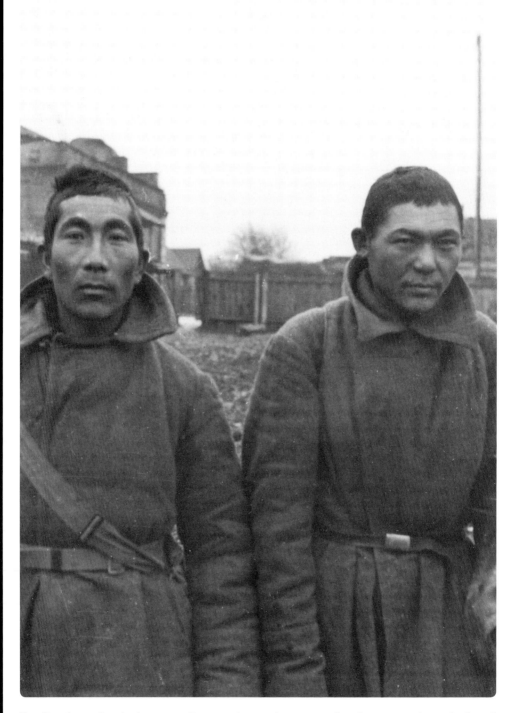

Two Russians taken in the same village as the previous group. Landsers were always intrigued by those of Asiatic ethnicity in the Red Army. It fitted with what they had been told by Goebbels' Propaganda Ministry.

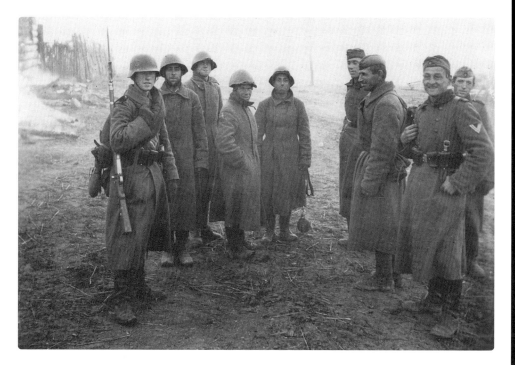

More prisoners from the same action. Both the victorious and the defeated look glad to be alive. The Landser on the left with fixed bayonet wears a blanket roll over his shoulder, which was not common among Germans but more so with Russians.

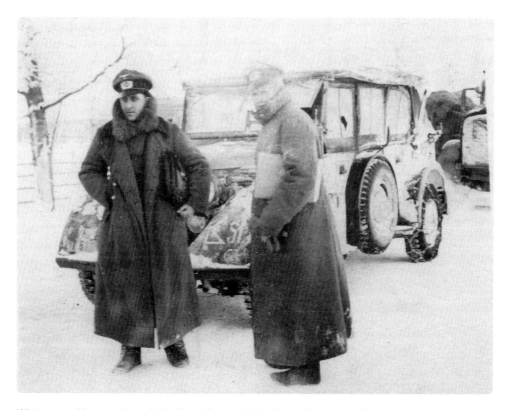

Winter conditions set in quickly. The officers of this *Panzerjäger* Battalion are dressed for it.

Far away in North Africa the seasonal change is much more bearable.

'Road repair somewhere before Moscow, 1941'. Luckily, across the road from them is a house where some shelter could be found.

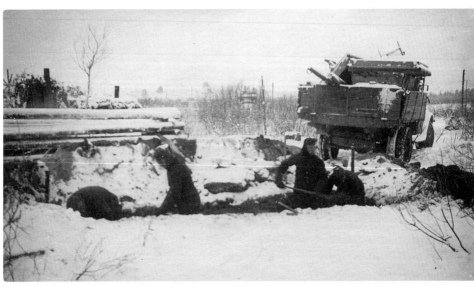

Horses and men suffer the same privations. These *Kanoniere* wait for the order to move forward with their gun. The snow keeps falling.

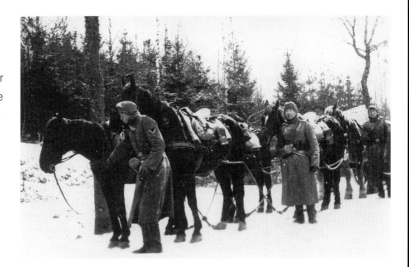

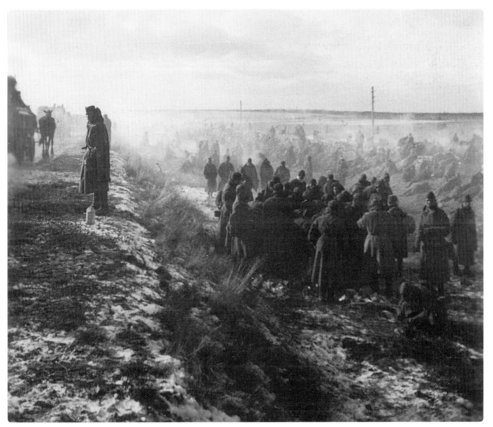

Popular myth leads one to believe that it was just the Germans who suffered with the onset of the brutal Russian winter. In reality much of the Red Army was suffering as well. Most of their supplies had been destroyed or lost. Only the Red Army units brought from Siberia, who were fully equipped for cold-weather operations, could operate efficiently in these conditions. The Germans in *Gebirgsjäger* units were equipped and trained for the cold. Here a huge mass of Red Army POWs are gathered in the depression between two major roads. These men are out of the wind but suffer just the same. They and the German guards are dressed alike in wool greatcoats.

Infantry with a Panzer IV move into action across the snow-covered field. An officer from a *Panzerjäger* unit watches from his staff car; most likely his men and guns are close by in a support position for this attack.

The gun and its target in a single image. A 10.5cm leFH 18 howitzer has been painted white. A *Kanonier* is reloading the gun while in the background a Russian town that is the target smokes as buildings catch fire from the barrage.

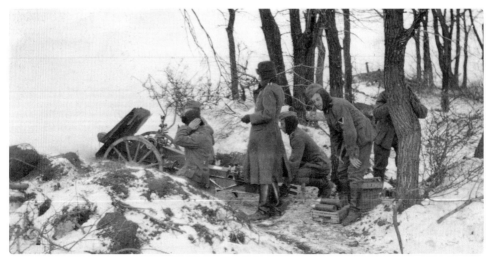

Much closer to the front and in direct support of the infantry, a 7.5cm le.IG 18. Two of the crew have adopted Red Army winter caps in order to keep warm, a fashion that would be all the rage this season with the well-dressed Landser.

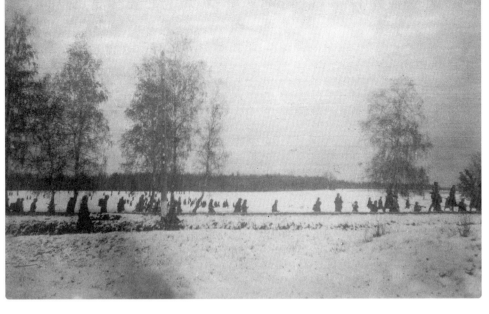

In open order across a wide front this Infantry Company begins the advance across the snow. Some have it easy and use the road while others are way out, struggling across the fields. Either way, cold-weather operations sap the strength out of even the healthiest of men. This is just another day at the front.

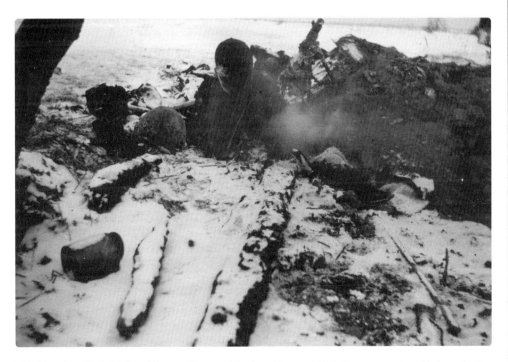

This Russian died fighting, his machine gun blazing. He was hit at close range by a high explosive round from one of the infantry support guns. The crater and he are still smoking.

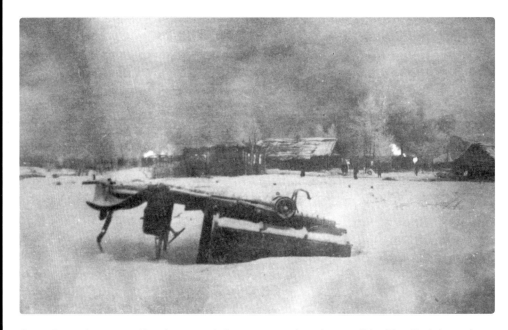

On 5 December something happened that was not thought possible. The Red Army threw everything it had against the worn-down Wehrmacht. Many fresh divisions brought in from Siberia had arrived and were equipped for these operations, plus they had not been battered by the onslaught of the Wehrmacht. The Germans were caught off guard and pushed back along great parts of the front. However, these German soldiers did not just turn and run, they made a fighting withdrawal in most cases. "5 Dec. 1941 We held the village as the Ivans attacked all day. We withdrew the next morning to another line, the village was just ashes by then."

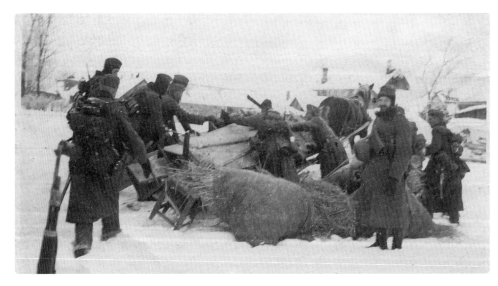

Speed was needed as many of the lines were shifting. For the first time the Landser really understood the problems his Red Army counterpart faced in the previous months. Men from this headquarters unit suffer from their hastiness: a wagon loaded improperly with everything they could fit on it has shed its load during the retreat. Most work quickly to fix the mess but one bearded fellow just smiles at the camera, taking the situation all in his stride.

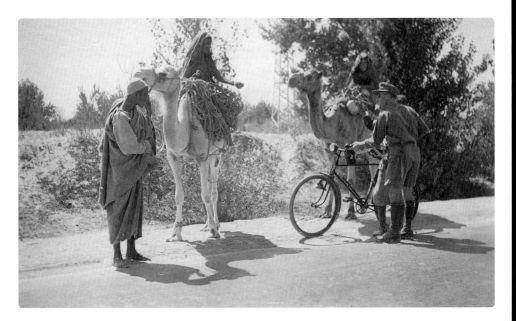

At the same moment in Tripoli this DAK soldier, 'Karl', chats with two Arab girls on camels.

Karl, the shorter man on the right, and his Kamerad stand proudly for this picture dated 23 December 1941. Meanwhile, in Russia, fellow Landsers are defending against heavy attacks by the Red Army.

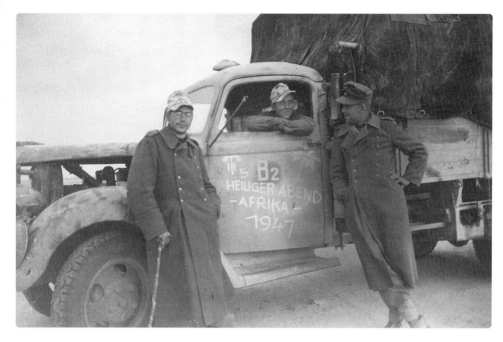

This DAK Artillery unit uses the door of a captured 8th Army Ford truck to record the date of the photograph. 'Christmas Eve, Africa 1941' is painted on below an old British marking and the famous DAK Palm Tree insignia. A British helmet hangs on the front fender and the engine cowlings have been removed to let it cool. Wearing their greatcoats against the cold of the desert at night, these battle-worn veterans think of home and loved ones.

A young *Unteroffizier* of the Afrikakorps poses in his new tropical shirt but still wears the earlier pattern of shoulder boards that would have been worn with his wool tunic.

This Artillery *Leutnant* wears the ribbon for the Iron Cross 2nd Class in his button hole, on his finely made tailored tunic with bullion insignia.

An Artillery *Hauptfeldwebel*, der Spiess as he was called by his men. He was known as the 'Mother of the Company', or battery in the case of the artillery. The rings of lace on his cuff indicate his position. This was an appointment and not a rank, as any grade of sergeant could be appointed to it. He wears the ribbon for the Iron Cross 2nd Class in his buttonhole and tucked into his tunic is his duty book. He kept this with information on every man under his charge. Many a soldier cringed when he saw der Spiess reach for his book to check something, or enter an adverse remark.

146

'Erwin, March 1941'. A young Infantry Landser poses in his Model 1940 uniform. He wears the company numbered buttons on his epaulettes, indicating he is a member of the 1st Company in his regiment.

'April 21 1941' is the date of this wedding portrait of a *Gebirgsjäger* and his young bride. He wears the issue uniform and visor cap with the distinctive Edelweiss in the centre of the cap worn only by these troops. He also wears a small moustache like the Führer's.

This is not the first time she has said goodbye to her husband as he left for service: this *Oberst* of Artillery and his wife share a day together before he leaves for his next duty. He wears a well-made officer's uniform and cap, his ribbons and Iron Cross indicate First World War and Reichswehr service. His buttonhole is adorned with the War Service Cross of 1939.

'June 2nd 1941. Dear Cousin, I am sending your this photo of me. I hope you are pleased that I am now an *Unteroffizier*. Best Wishes your Cousin, Hermann'. From Hermann Treitze to his cousin *Oberschuetze* Ernst Treitze, the latter a Senior Private in the 1st Kompanie of *Landesschützen-Bataillon* 714. Perhaps there is a little family rivalry. Hermann is now a sergeant in a *Pionier*, engineer, unit. The black piping on his cap and tunic insignia indicates this. He wears three ribbons showing service in the First World War and the Reichswehr. These are the 1914 Iron Cross 2nd Class, the 1914–18 Honour Cross with Swords for Combat Service and a 12 Year Service Medal. The fact that he is newly promoted can be discerned from the fact that his collar lace is worn stitched over his collar tab ends, rather than these being removed and repositioned as per regulations. This was allowed for expediency but would have to be corrected in time.

'As a remembrance of me, Ernst, June 18th 1941'. Ernst wears his Model 1940 uniform but with a twist, so to speak. His shoulder boards are rolled up and tucked under the tunic attachment loop almost in French fashion to keep pack straps from sliding off the shoulders. This is completely against German uniform regulations, but he has done it anyway, and had his portrait taken in this manner. He has paid his dues; Ernst wears a Black Wound Badge, perhaps for service in France or Poland.

The shoulder boards bear the cloth covers on them to prevent enemy eyes from seeing the metal numbers indicating the unit of this officer.

Opposite: 'For you dear Ursula, so that you may always have me before your eyes! Your Kurt. Spandau in September 1941'. Young Kurt is in his full dress uniform called a *Waffenrock*, piped in the white branch colour of the infantry. Production of this uniform stopped in 1939 but existing ones continued to be issued. His shoulder boards bear the wartime issue wool slip-on tabs indicating his unit, the 203rd Infantry Regiment, placed over the original numbers embroidered into the shoulder board when this tunic was first issued, a two-digit number. His eyeglasses are non-regulation black Bakelite. This regiment was part of the 76th Infantry Division; he would join it as a replacement as it pushed across the Ukraine and see the defensive battles that winter. His regiment died fighting in desperate street battles in the ruins of Stalingrad not quite sixteen months after his Ursula was sent this picture.

An officer and *Unteroffizier* of a Panzergrenadier regiment. The *Leutnant* wears an Iron Cross 2nd Class ribbon and the Infantry Assault Badge on his pocket. The officer's tunic appears to have a slightly darker green branch colour than the sergeant's and this did occur, especially when uniforms were tailored. Both wear the tabs that cover the numbers on the epaulettes. Taken in the early days of the Russian Campaign, these men have smiles of victory on their faces.

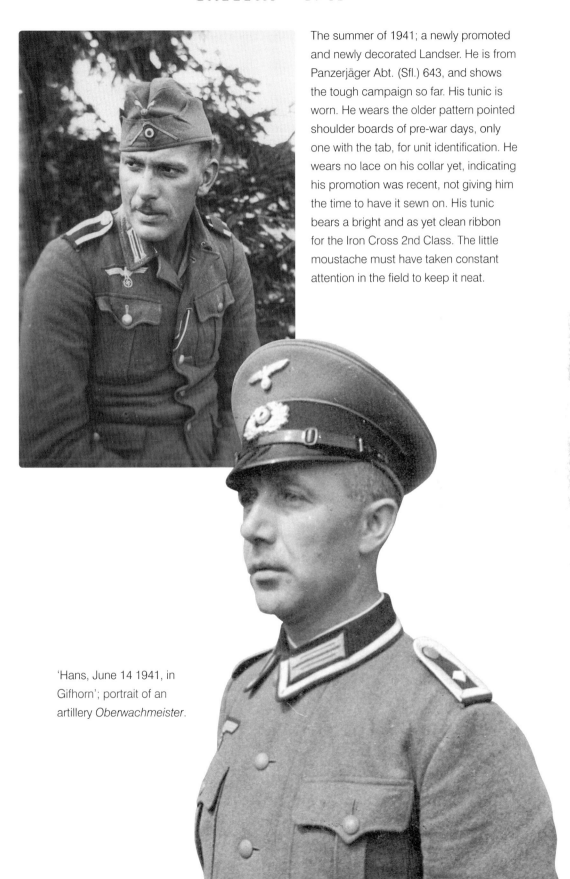

The summer of 1941; a newly promoted and newly decorated Landser. He is from Panzerjäger Abt. (Sfl.) 643, and shows the tough campaign so far. His tunic is worn. He wears the older pattern pointed shoulder boards of pre-war days, only one with the tab, for unit identification. He wears no lace on his collar yet, indicating his promotion was recent, not giving him the time to have it sewn on. His tunic bears a bright and as yet clean ribbon for the Iron Cross 2nd Class. The little moustache must have taken constant attention in the field to keep it neat.

'Hans, June 14 1941, in Gifhorn'; portrait of an artillery *Oberwachmeister*.

'In Remembrance of my leave and visit in September 1941 I send you this photo of me. Your kindness will never be forgotten. Rudi, October 28th 1941'. A smiling young Landser has thought enough of his hosts to send back a photograph with a nice dedication. He is wearing a well groomed Infantryman uniform. His shoulder boards bear the lace loops indicating he is in training to be promoted to the rank of *Unteroffizier*.

There is an air of confidence about this driver – 'Get in, I will get you there and back no matter how much lead they throw at us.' Pipe clenched in teeth and arm over the wheel, his youth is betrayed by the meagre attempt at a moustache. This was taken in Russia during the autumn of 1941. Four 98k Mauser rifles complete with muzzle covers are mounted in the weapon rack on the inside of the door.

'With Thanks from your Eduard. Russia, November 16th 1941'. Eduard at this time holds the rank of *Obergefreiter*. Since this chevron is held on by just one pin at the top, his promotion has probably been very recent – perhaps the same day as the photograph. He wears the pre-war pattern pointed shoulder boards and on them are not lace loops, indicating possible promotion; rather they are coloured loops, indicating company or battalion. In this case it would be company. Four colours were used: White for 1st and 5th Companies, Red for 2nd and 6th, Yellow for 3rd and 7th, finally Blue for 4th and 8th. If two strips were present, it would indicate battalion and company.

A battle-hardened veteran; this *Gebirgsjäger* stands in front of some building with a 1940 date on it. He needs a shave and his collar tabs are falling off, and he has been promoted in the field, with hastily sewn lace on his shoulder boards. His confident gaze overrides everything else; any commander would be content to have this man in his unit.

A young *Oberleutnant* from Panzer Regiment 6 displays the scars he has received in action. Unlike others who may have tried to hide them for this type of photograph, he turns his face so that they may be seen. He knows he is lucky to be alive.

The dapper Desert Landser, one of Rommel's finest, perches atop the hood of his Kubelwagen in his new tropical uniform. Helmet with goggles at a jaunty angle, a scarf worn like a film star around his neck and cigarette in hand, this young signalman personifies the confident image of the Afrikakorps as the world saw them in 1941.

1942

THE LANDSER
BEGINS TO DOUBT

IT HAD BEEN TWO YEARS AND FOUR MONTHS since the Second World War had begun in Europe. For almost all this time the German Army had been flushed with success. It had some very tough fights, especially against the British Expeditionary Forces in France and the Allies in Norway, but had always managed to overcome and take the laurels. The previous summer had seen successful operations in North Africa, with General Rommel mounting operations with very limited resources, pushing the British back and laying siege to Tobruk. In the East, on the Russian Front, thousands of the enemy's destroyed tanks, planes and artillery guns littered the battlefields as this army pushed ever eastwards. Endless columns of Russian prisoners trod westward in that slow shuffle of the tired and defeated. Landsers pushed forward with all due speed and force. The war in every soldier's mind would surely be over soon. It must be. The victories mounted one upon the other.

These victories, however, were won with much greater duress; the tactics were changing, the ground cost more to gain. The soldiers facing Germany began to learn and use ever more effective tactics to oppose the onslaught of the Landser. By the time the New Year of 1942 had been sung and toasted in, the Landser had found himself stopped at the gates of Moscow and fighting a gruelling winter battle against a tough and determined foe. He, for the first time, had to give ground and retreat under heavy attack. In the East he would begin this year unlike any other so far. He would be in mind-numbing cold, fighting hard – or perhaps beginning a brutal existence in Soviet captivity that he most likely would not survive. In North Africa, Rommel, too, was running into problems; the dogged resistance of the Desert Rats and the petulant resistance of his own High Command, who refused to send much-needed supplies and replacements. However, those Landsers who were stationed on other duties across Europe still had a relatively comfortable war. Occupation duties were not so bad – lots of work and patrolling, but there was almost always a village nearby with a café or bar, and girls. Occasionally, there would be a shot fired at them, or some other act of sabotage, but what was this compared to being at the front? These were the minor birth pangs of a growing resistance movement all over the occupied lands. When born and growing, it would prove a huge problem – though it must be said that in every country where thousands of men volunteered to fight a covert war against the German armed forces, as many would join pro-German paramilitary groups and even actual combat units, or otherwise collaborate. Those activists were at either end of the spectrum: most would settle down to a surly co-existence with the Germans, dealing with them day-to-day but staying away from them as best they could.

Spring brought good weather and renewed efforts in Russia. New troops, new equipment and new determination pushed the Landser farther East and South. The

Red Army was putting up a stiffer fight but still was no match as yet. Casualties mounted nevertheless; field hospitals and hospitals at home had never been so full. Men showing the scars of war began to become a much more common site across the Fatherland. Landsers who had lost an arm struggled with packs. Those who had lost a leg hopped on crutches and others moved in wheelchairs as they made the final trip home. The people helped them readily but it was a sign that this campaign would not be over as quickly as those that preceded it.

Throughout the summer of 1942 the news was optimistic and almost always good. Newspapers would declare in bold print the advances of the German Army; this town was taken or that city had fallen. The radio would broadcast the resounding defeat of one enemy army or another. Even television, a broadcast medium in its infancy, would celebrate German victories to the sounds of Wagner. By the end of August the Landser began to wonder once again if his war might soon be over. First, the raid on Dieppe by Allied Forces, mostly Canadian and British with a token force of US Rangers, had been utterly crushed. It was felt that the Allied invasion of Europe had been devastatingly repulsed. Many a Landser who was there expected Armistice terms to be sought by Great Britain and her Allies. In Russia, the 6th Army reached the city of Stalingrad on the Volga River. Surely now Russia would fall, with the Crimea and Kuban in German hands.

Within two months the war had changed dramatically. November would bring more than just the icy winds of the Russian winter to the minds of the Landsers stationed there. The beginning of the month saw the US military's first large-scale ground operation, the invasion of Vichy French Morocco in North Africa. This, despite initial resistance, resulted in an Armistice with the French. As a result, further operations by German troops to occupy all of Vichy France were undertaken – a drain of men and equipment needed elsewhere. This also put the Afrikakorps in a vice, with the Americans on one side and the British on the other. In the East, Stalingrad was becoming a meat grinder, for both German and Soviet troops. The vicious fighting had engulfed the 6th Army completely. By the end of the month the Red Army had launched a major flanking operation against the Romanian and Italian units supporting the Germans, surrounding the 6th Army and elements of the 4th Panzer Army. Hitler refused to let their commander, General von Paulus, execute a tactical withdrawal and regroup; he ordered the city to be held at all costs.

By Christmas 1942 every Landser in the German Army, while hesitant to say it, knew that the momentum had stalled. All was not lost but a palpable change was felt. It was no longer the glorious days of 1940. Should victory come now, it would be at a price that no one would have ever imagined the day that France surrendered.

The Landsers' theatre of operations – 1942

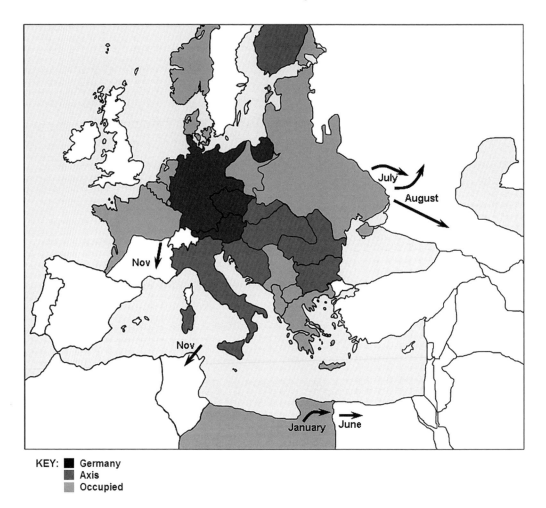

KEY: ■ Germany
■ Axis
■ Occupied

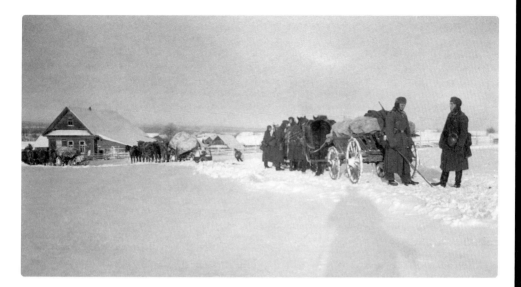

'We arrive at our new home in Kolobovo, New Year's Day 1942'. Kolobovo is now in the Russian Oblast, or province, of Ivanovo. The Red Army's Winter Offensive was successful on several counts, including the saving of Moscow, pushing the German Wehrmacht back along a wide front, and boosting Russian morale. But it ran out of steam and Red Army reserves petered out. Both armies were now in a stalemate in the snow. These Landsers are waiting by their baggage wagons for the final decisions on which houses to occupy and where to deploy.

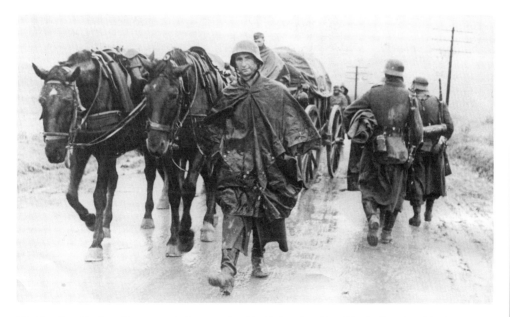

'On the Front before Sevastopol, January 1st 1942'. Another New Year's Day but this time in the southern sectors of this vast country, where the weather conditions were different. It was not snow or cold that was endured by the Landser here, but driving rain. One of the wagon drivers walks along leading his team, giving his legs a stretch; wearing his *Zeltbahn* over his greatcoat, he is still soaked through. Even the horses look miserable.

The cold conditions encountered were more severe than the German military were used to and had trained for in Germany. Necessity is the mother of invention and some new approaches were devised by ingenious soldiers; some learned from the local population and how they dealt with the season. The *Kraftfahrer*, truck driver, of this LG 3000 heavy truck has placed a thick layer of straw over the engine cowling to create a layer of insulation, keeping the engine heat in and him warmer in the cab.

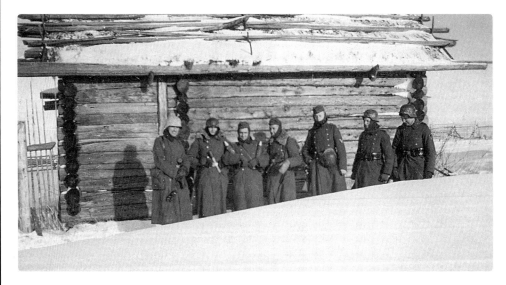

'Kolobovo, January 10th 1942; we go out on patrol, the weather is good'. A seven-man patrol prepares to make a sweep of the perimeter. They are lightly equipped with rifles, grenades and a minimum of gear, so they will not be straying far from their positions. On the left is the patrol leader with map case and compass, open and hanging on a lanyard from his belt. His helmet has been whitewashed. The third man from the left is cradling 7.5cm shells as if they were his children as a joke. Next to him one of his comrades has managed to find a civilian fur collar to add to his greatcoat for warmth. Many civilian overcoats of the era had such collars that were removable according to the season.

'The Coffee Hound and Sgt. Pudding Snout'. To any soldier, such monikers are self-explanatory. The Coffee Hound, a *Gefreiter* by rank, has procured a sheepskin collar for his greatcoat and is smoking a nice pipe, though he is probably thinking about finding another cup of coffee somewhere. To the right is *Unteroffizier* Pudding Snout, a nickname derived from his ability to sniff out and eat any desserts or sweets in the vicinity. The well-manicured goatee he sports would not be accepted on the parade ground in Germany but here at the front, that does not matter so much. He also wears a fur collar added to his greatcoat. His greatcoat is longer and is not regular issue, a private purchase of higher quality.

'The new Iron Cross Winners'. Despite the cold the paperwork is always done; recognition for earlier actions comes through and medals are awarded. In this case two men have the Iron Cross 2nd Class and the one in the centre the 1st Class.

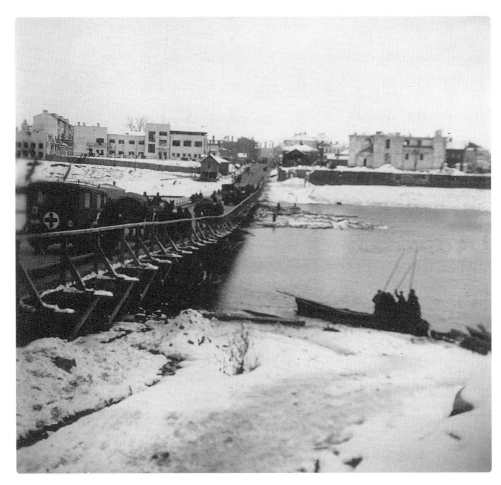

'Going to the rear for supplies, January 1942'. The convoy of wagons heads into a Russian city that has supply depots set up in it, probably because it has a railway depot.

Opposite: Comfort or suffering was primarily a question of logistics. Units having good supply chains fare well, those in tougher spots suffer the worst. Those who could, adapted, such as these three. All wear Red Army winter field hats; the soldier on the left has taken the precaution of adding German Army cap insignia, since a nervous sentry could mistake him for an Ivan. On their epaulettes the cloth loops with the regimental number have been turned underneath for security reasons. The two on the left have also been smart enough to obtain Russian winter felt boots. These were exceptionally warm and comfortable, better than any marching boot, German or Russian. Demographics played a part. *Unteroffizier* Werner Stahnke sums it up best: 'Being a city lad from Munich, the bitterness of that first Russian winter was something that adversely affected me, I had never known such hardship. The hunger I could deal with, as times were tough when I was a young boy, but being at the front like this was very different. However, I noticed that the young soldiers and men from the countryside, farmers and the like, took all this in their stride, knowing how to cope with such conditions in good spirits. Without them, we would have been dead many times. After this winter I always picked good farm boys for my section when I could do so.'

Obviously, white camouflage made sense; but *Gefreiter* Anton Sindelar explained a caveat to the authors: 'I was on guard duty in a trench at the front some time in January 1942. It was damn cold and it was boring to look out into No Man's Land but we had to do it. I then realised I was looking at figures in white creep forward and stop, and then again and again. Even though the world around was totally white, this was not that difficult to see. I then remembered something that I was told when I got to the front; I was told that snow doesn't move unless you shovel it. I fired and raised the alarm.' The barrel and shield of this M-18 15cm howitzer has been whitewashed. The breech has been covered by a tarpaulin to make sure it is ready for action at a moment's notice.

The snow trench. Even in areas to the rear these were dug to get from one spot to another without being observed. The side facing the enemy is piled higher to obscure the movements of troops inside the perimeter, lessons learned from the retreat of December 1941.

A company-sized patrol about to leave their garrison area in an occupied Polish town. All have white helmet covers and rolled with their blankets on their Tornistors are white snow smocks. Many have skis next to them. The Machine Gun section has special sleds which carry the skis, tripods, ammunition cans and packs of the NCOs: rank having its privileges. Germany was now combining training with occupation duties in order to maximise the use of manpower.

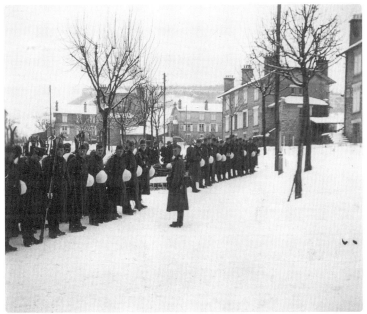

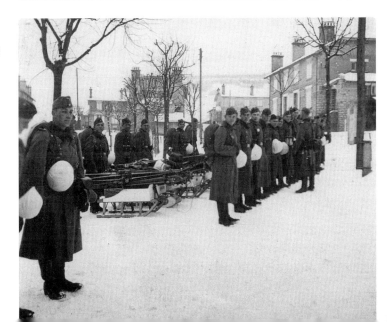

These Landsers are exhausted from battling both the cold and Ivan. They wear every piece of clothing they have to stay warm. One has a head wound but stays in the line. They all need a hot meal and sleep.

A morning stretch for one of these new replacements for the DAK. This group has set up camp in the courtyard of an Italian Barracks, the Fascio and "DUCE" are painted in black on the roof. Fresh uniforms betray them as *Grünschnäbel*, Green Beaks, the German slang for new men, greenhorns.

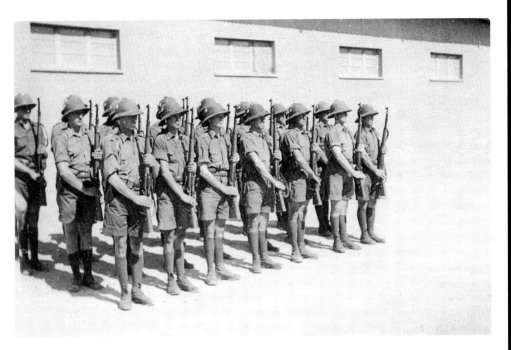

"Present Arms!" is the caption. One last formation and off to the desert. The new men have different uniforms, the high tropical boots have been replaced with ankle ones and high socks, easier to make and supply.

Dated February 18th 1942 this photograph shows a platoon of *Gebirgsjägers* and some of their battle trophies, three Ppsh-41 SMGs, along with MG-34s. These Mountain troopers fared better than almost all German combat troops, since they trained for winter operations in extreme conditions on a regular basis and had the proper equipment and uniforms. Several of these men wear the white snow cover for their mountain cap and all are decorated to some degree. This is a combat platoon fit for purpose.

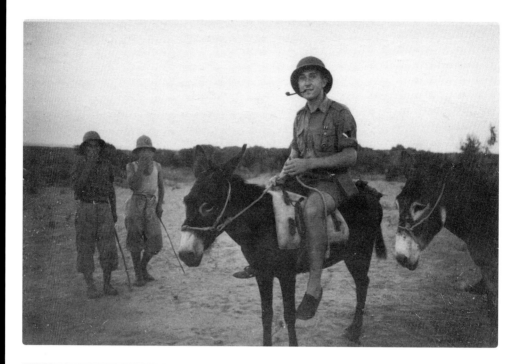

While in Libya, a decorated *Gefreiter* decides on a good photo opportunity. The Italian soldiers who lead the pack mules take a smoke break while watching this 'Tedeschi' being a silly ass. He wears a wool rather than tropical chevron, a Wound Badge and a ribbon for the Iron Cross 2nd Class. Do the pipe and slippers make him look English?

The ski trooper wears the white reversible anorak with the coloured identification bands on his arms. Once located, soldiers all in white can be shot at by both sides.

An empty MG-34 points off to nowhere as this Landser gets his souvenir photograph taken not far from the Russian village he is quartered in. The war in the rear areas is not so bad.

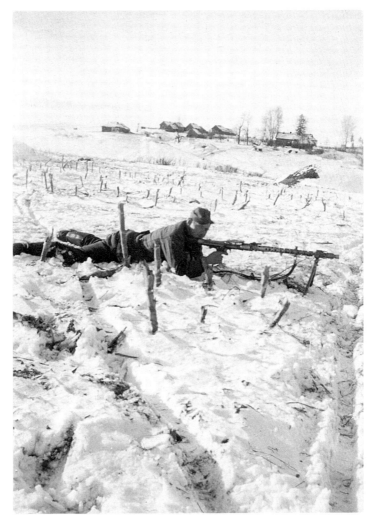

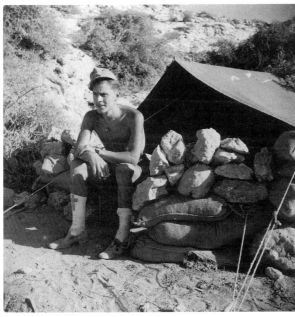

Different weather and terrain present their own problems for the men of the DAK. The tent is set up in between low hills or dunes with sand bags and rocks piled high to protect against the wind-blown sand. He wears shoes, not boots, and his ankles are bandaged. He has most likely been attacked by the sand fleas that love to go after ankles and the lower legs, leaving bites that can get infected owing to the uncontrollable urge to scratch. So smear on some salve, wrap them up – and endure. Then there were the flies.

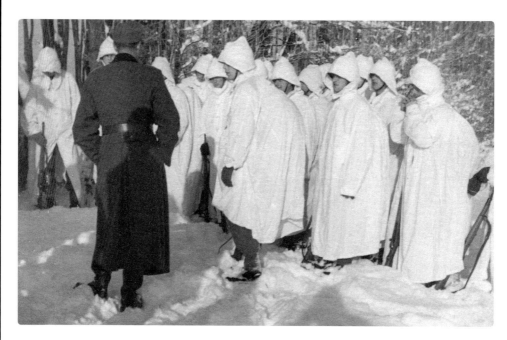

New doctrines on winter warfare are taught to replacements going to Russia, here in newly issued hooded winter over smocks.

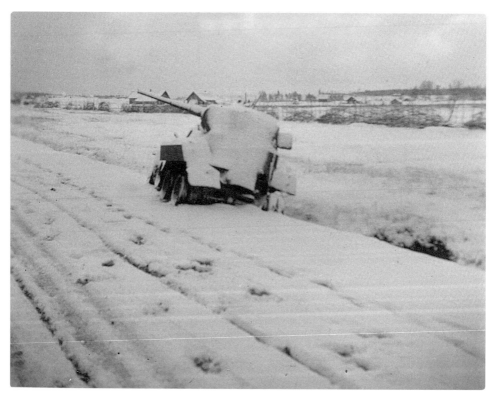

The snow-covered wreckage of the past summer's battles. Anything that could be put back to service was gone but those hulks beyond repair, such as this BT-5 in a new covering of snow, caught the eyes and lenses of newcomers.

Some use was found for such detritus: a derelict Soviet cargo and gun tractor is used by the newly arriving 331st Infantry Division as a road sign to direct units. These men were mostly Austrians who were sent to Army Group North.

A heavy sheepskin coat and Russian felt boots. Not all were so lucky.

Behind the lines in the occupied parts of the Soviet Union, life has returned to a certain level of normality. The citizens go about their routines as best they can under the circumstances, with bureaucrats in different uniforms and new kinds of papers to carry. German vehicles and troops pass through the streets with regularity, going to and coming back from the front.

Columns of Red Army POWs still march westwards through these places. Despite the setbacks of the previous December, victory was still on the mind of the Landser, although most knew someone now in Soviet captivity. Many Germans had been taken prisoner, but not anywhere near the numbers of the Red Army now in German hands.

In the Ukraine, Smigkobuch's Home Bakery is the backdrop. The two men appear to be pooling their resources to see if they have enough to purchase the loaf of bread on display in the right hand corner of the window. Perhaps the Ukrainian man's big furry hat caught the Landser's attention, or maybe the pretty girl next to him? Then again, it could have just been the smell of bread baking.

In Germany the need for warm clothing for the troops was handled in part through the 'WHW', the Winter Relief Programme, which originally began in 1931 to help poor German families during the winter months. This Landser stands bundled up in the cold next to a town clock placarded with a fund-raising poster for this organisation. Besides money, winter clothing could also be donated.

These infantrymen share a smoke with a much less warm *Kanonier*. The cold was becoming less and less of an issue as supplies arrived.

Some men are transferred from one extreme to another: this Panzer veteran from the 6th Panzer Regiment has been transferred to the DAK. He has been allocated to the 21st Panzer Division as experienced tank men are desperately needed by Rommel. He shares his Mediterranean cruise with a Luftwaffe Flak *Unteroffizier*. The awards on his chest show he has seen much combat and been wounded.

Laundry day in Libya. There is plenty of water to wash with, since these men are near the sea.

Relaxation in Tripoli before heading to the front. Standing in front of the building allocated as the 'Writing Room' for this unit, according to the sign on the door, he stands in his PT shorts and T-shirt. The other is in his tropical uniform; he wears no belt and pouches, but these are close at hand since he has not removed his combat suspenders, called 'Y-Straps' because of their shape. These are the standard leather issue pattern. The Writing Room was just that: a place where soldiers could write letters home with paper and pens provided by the unit if necessary. These were administered by the Army Postal Service, the *Feldpostdienst*, who would process the mail gathered here. The sign on the wall to the right gives the *Feldpost* number of this unit – 42126 – the number for the Replacement Battalion, *Feldersatz-Bataillon*, of the 21st Panzer Division.

The need of men to acclimatise to fighting in the climate of North Africa enabled them to get some light duty and R&R as their bodies adjusted, when the situation allowed. This picture shows a day on the Libyan coast.

In Tripoli during this time of year, the weather is just perfect for the regular wool uniform. This highly decorated *Oberst*, Colonel, meets with a Luftwaffe Liaison officer. The *Oberst* sports the German Cross on his tunic pocket, called the 'Order of the Fried Egg' by the lower ranks, along with several others that show combat service in both the First World War and the present conflict. In a twist, so to speak, he wears riding breeches not with riding boots but with puttees, as was common in the previous war.

Back in Russia: soon it will be the beginning of spring and the major campaigning will begin in earnest once more. In cities, towns and villages like this one, it is now German anti-communist propaganda that is in the windows.

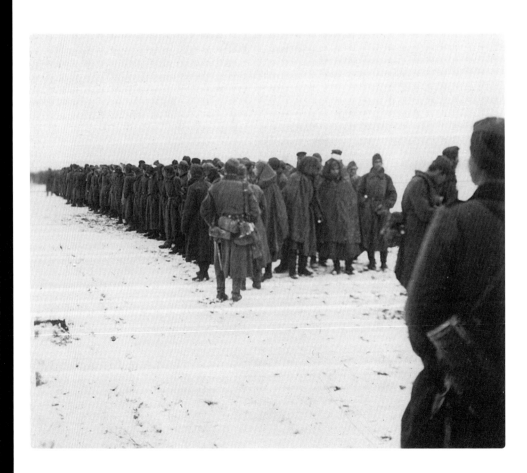

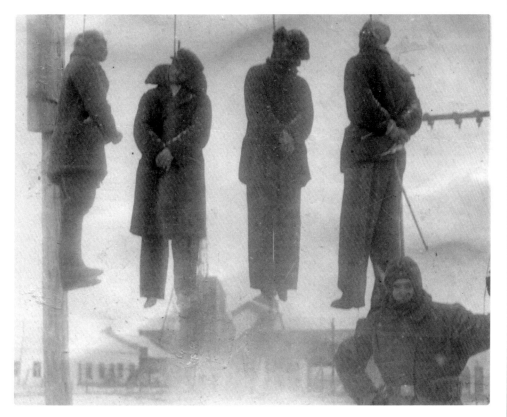

'Soviet Gallows used for Soviet Bandits, February 1942'. This war in the east would become more vicious as it wore on. Partisan groups were beginning to form; the Germans called them bandits. As the war continued, partisans all over occupied Europe would join the fight against the oppressive rule of the Reich. Brutality reigned on both sides. Germans were executed and mutilated, then left on the roadsides to instil fear, or bodies were hidden and never found. Very few German prisoners taken by partisans would survive. Germans would execute partisans they caught, some immediately and some publicly, like this, as examples. Caught in the middle were the civilians, executed by one side for supporting partisans or executed by the other for collaborating with the Germans. In any war, since the signing of the Geneva Convention, a non-uniformed combatant has very little or no protection from execution.

Opposite bottom: 21 February 1942. Despite the successful Red Army counter-attacks of December 1941, thousands of prisoners are still being taken and the recently captured POWs in this photo have suffered from the harsh winter just as much as any German Landser.

On the German Home Front not much has changed this winter. People go about their days as usual; some rationed items are getting scarcer, but otherwise things are not too bad.

On the northern sector of the front the Landser learned from his Finnish ally; he wears much the same uniform and uses the same tactics. Clad in heavy sheepskin uniforms this sharpshooter team poses for the camera. The use of such teams was a very effective tactic.

Four youths under guard; they are well dressed, two wear riding boots and they are well fed and confident. Those boots are polished. It appears that they have been rolling in the snow for some reason. The photograph is mystifying until one reads the caption: 'Putzgau, February 1942. Boys from the HJ (Hitler Youth) we captured in the training exercise. These "Bandits" tried to infiltrate our line.' The depot is in Germany near Dresden.

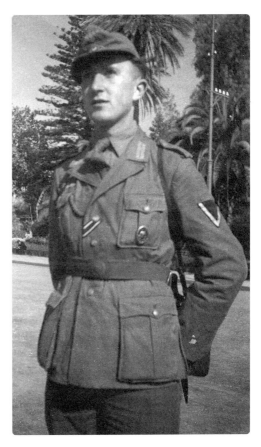

'Last Day before going to the front'. The same *Gefreiter* that borrowed the mule. He is a replacement who has seen combat elsewhere. He still prefers to wear the rank chevron for the wool service uniform, or no tropical chevrons were at hand to issue to him. He wears a whistle; the cord of this is visible going from the buttonhole to his right breast pocket. This is an indication of position: only men heading sections of any size were issued whistles, regardless of rank. He wears a Wound Badge on his other pocket and an Iron Cross 2nd Class ribbon in his buttonhole. This shows he is new to the DAK; regulations state that the ribbons will be worn in the second buttonhole. Due to the fact that the tropical uniform is open-collared, it was put in the first buttonhole; he wears it in the second one since he is new to the theatre.

The same *Gerfreiter* as in the previous image, but looking more relaxed in his shorts and shirt, despite his injured right hand. His tropical boots are of the newer ankle high pattern, rather than the knee high ones previously issued. These gave indications to more experienced Landsers that resources were being stretched at home.

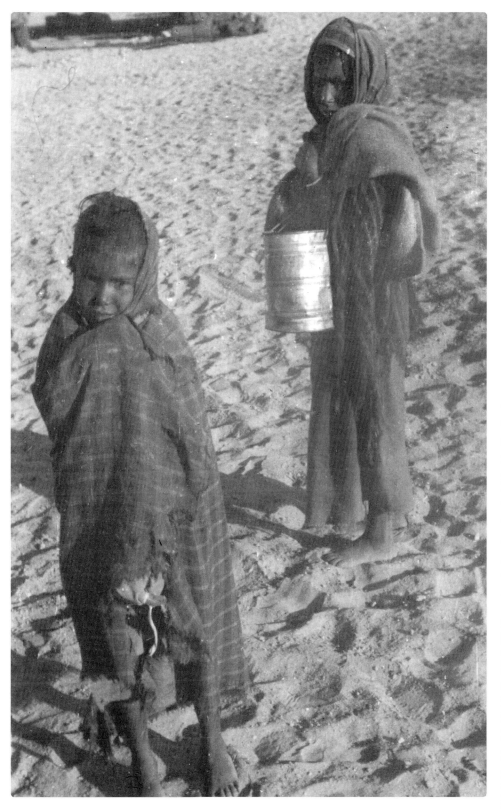

Simply captioned 'February 1942', the image of these poor Arab children is as striking now as it was when the Landser took it.

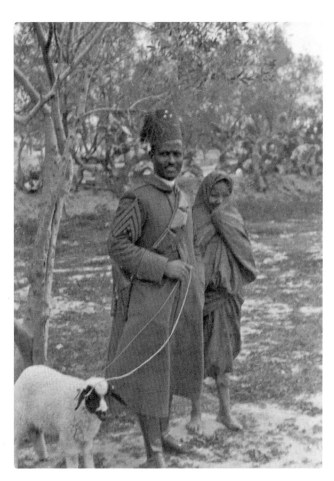

'Italian Colonial Police Sergeant with his wife and sheep, February 1942'. A native in a unique uniform was a subject that most soldiers of any army would have snapped. Although a police officer with a lamb on a leash goes one better.

'An Arab House, February 1942'. Just as in the Soviet Union, the Landser was struck with the ancient ways in which people were living in the modern world.

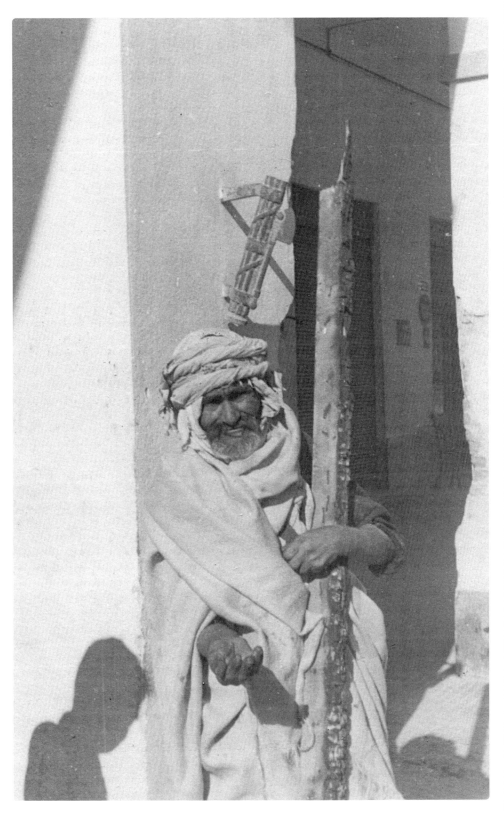

'A plea for help'. Holding a large discarded piece of wood, this older Arab man asks the Germans who have taken over an Italian government building to help him and his son.

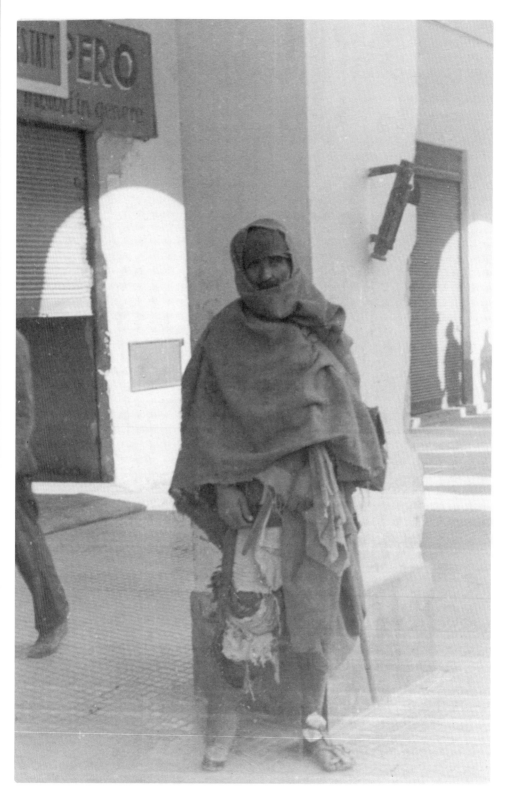

'For the Arab's son we have made a wooden leg'. His plea was answered and a wooden leg was made by the Landsers in this workshop. Both images are dated February 1942. The German repair workshop sign can be seen on the left, hung over the Italian one.

The child often comes out in men when something big with tyres and a motor is encountered. This Landser is no different: though he knows this beast of a truck will never move, he still must climb up behind the wheel and get the 'feel' of it. Even in the middle of a war, this is done.

The crew of this Horch Kfz-15, built for use as a command and control car in the field, pulls over and secures camouflage netting over their vehicle. This indicates they are planning to stay here for some time. The front tyre is covered with a *Zeltbahn* for the same purpose. The DAK soldier on the left wears the newer style short tropical boot, his comrade the older knee-high version. The latter was much better protection against sand fleas. The man in the short boots stands on a Jerry can used for fuel to do the work. The other cans are used for water, indicated by the white crosses.

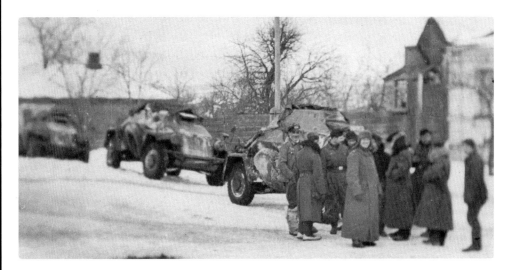

The crews of these Sd. Kfz. 221 armoured cars take a break after a patrol. People are affected by the cold to a greater or lesser extent. The moustached officer on the left in visor cap has his tunic open and hands in pockets in an unmilitary matter and wears large furry boots to keep his feet warm; next to him the soldier with back to camera wears a fur collar attached to his greatcoat and Russian felt boots. The man in a black Panzer cap just wears the one-piece coverall for vehicle crews – probably a farm boy. Smiling at the camera, the soldier in the foreground wears a Russian winter hat along with the felt boots and the long, heavy driver's greatcoat. The next four have the same coats with added fur collars turned up against the cold; most hands are thrust deep into warm pockets. The last soldier is a tough nut, bare-headed and wearing only tunic and gloves.

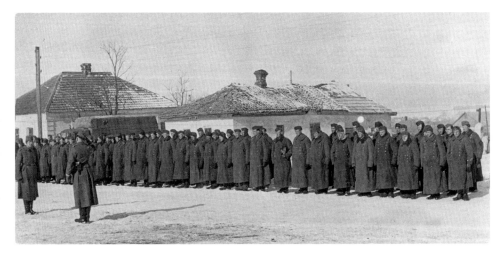

The first formation of the day, where duty assignments will be issued for this transportation company. They will be assigned to convoys or individual vehicles to provide whatever supplies are needed or convey troops to destinations. Except for the Spiess, along with a Senior NCO leading the formation and one driver, all of these men wear the driver's greatcoat and Russian felt boots. The gears of the German military machine are still meshing, despite the cold and snow of the Russian winter; everything did not come to a standstill, as popular history leads one to believe.

'Near our bunker, Russia, February 28th 1942'. Three infantry *Unteroffiziers*: all are decorated and two have been wounded. The Landser on the left wears the Iron Cross 1st Class on his tunic pocket and a scarf tied around his neck; he doesn't really seem happy about posing. The man on the right is the happiest, perhaps because he is newly promoted, as shown by the lace on the collar, sewn over the ends of his collar tabs. It could be this, or just a general feeling of gratitude at still being on this side of the dirt. All wear the ribbon for the Iron Cross 2nd Class.

In the desert, more smiles and camaraderie. German and Italian Infantrymen share a meal and some laughs. The cooking pit is on the left. The DAK soldier in his PT shorts still wears his watch, as there was a pocket for it in them.

THE LOST LANDSERS | 1942

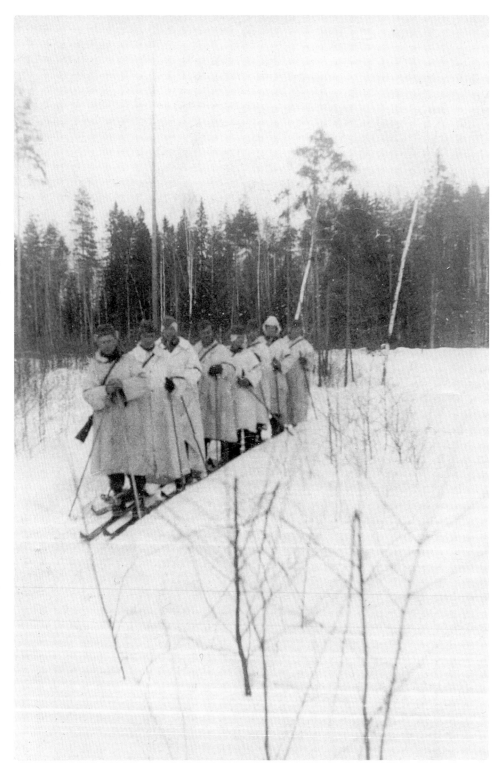

'Ski Patrol coming back into our lines, Feb. 1942'. The ability to mount operations on skis was not just a function of specialist units at this time. While these types of organisations existed, their purpose was for particular operations and not daily patrols in No Man's Land. Finding men who could ski was not a difficult thing in the German Army of this period.

'Our first 6 men Killed in Action, February 1942'. These two Landser from the *Panzerjäger* (Anti-tank) *Kompanie* of Infantry Regiment 365 visit the graves of their friends. This regiment was part of the 211th Infantry Division, whose men were leading a rather blessed life in southwest France until rushed to the East because of the Soviet Winter Offensive the previous December. They arrived in the first days of January 1942 and went straight into the attack against Soviet forces engaged against Army Group Centre.

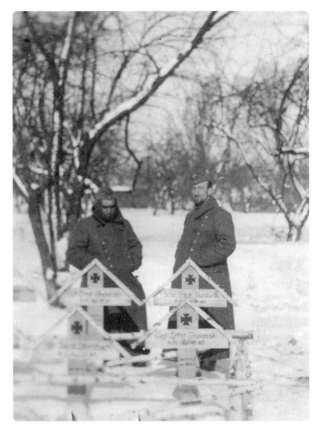

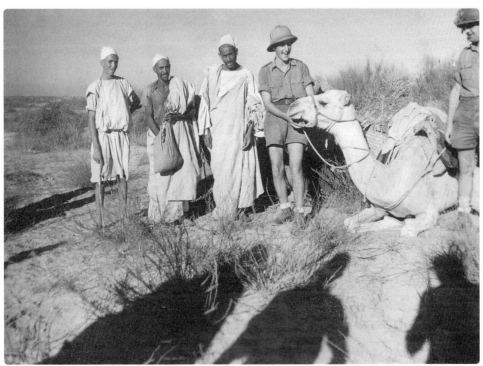

Amidst smiles from the owners, this DAK Landser delights in feeding a camel somewhere in the Libyan desert. Another story he may get to tell his children, if he survives the war.

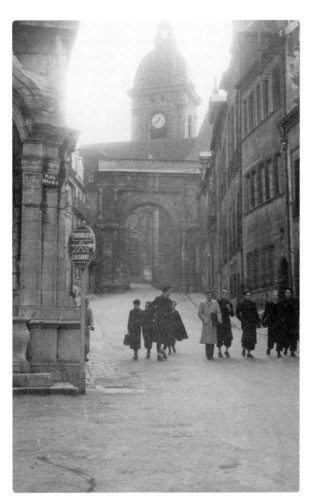

Landsers in France have the best life. One on a sight-seeing trip to Besançon snaps the Place Victor Hugo.

In the Netherlands, a work detail with Dutch Children. The boy on the right is wearing wooden clogs. Some of these men don't smile but rather think of the cold, wet hard work ahead of them.

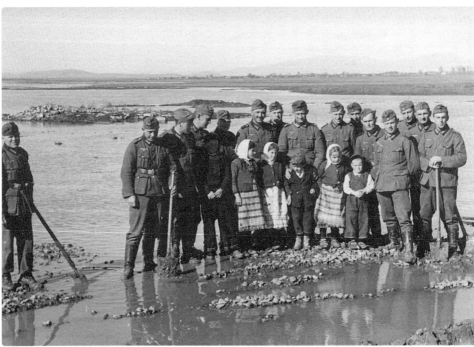

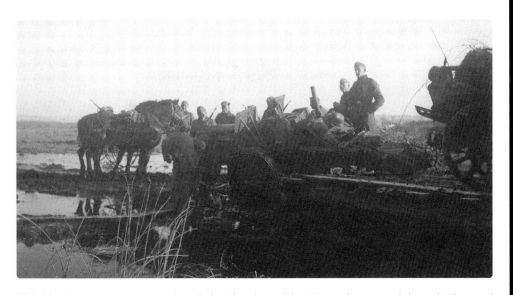

With March came warmer weather during the day, a blessing and a curse. It brought the mud again, which has caused the gun to slide to the right just before going over a bridge. This caught the wheel, causing it to jump the hitch on the caisson. More work and time lost, as the bridge is now out of use. The horse team has been unharnessed from the caisson and will pull the gun out of the mess so that it can be hooked to the caisson once again. The *Kanoniere* are attaching the straps to the gun to do this.

'Near Val-et-Châtillon, March 1942'. Older men from Landwehr units fill the gaps in the ranks and take on duties of occupation so the regular army and younger reserve units can be sent east, where the war will be shortly entering its second year. These men are on duty in France, and seem very happy about it too. Most do not wear shoulder boards, still in keeping with the old regulations, and two are wearing the old pattern three-buckle boots of the *Reichswehr* days.

On a warm day in early spring these *Frontschwein*, 'Front Pigs' – the nickname for those men living at the front – emerge from their winter quarters. These six Landsers are deemed worthy of a group photograph as they chose to grow beards during the winter months. Some have made a better job of it than others.

'Dead Ivans after a night attack, near the Sevastopol Front March 1942'. The Red Army pushes back whenever and wherever it can against the Germans.

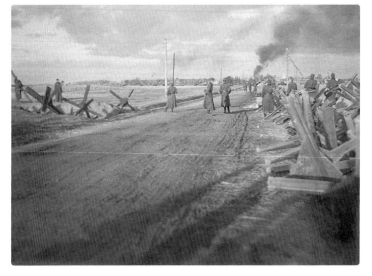

Offensive operations begin again at various levels of intensity all along the front. Here the Headquarters elements of an Infantry Regiment watch from the rear as the next town is attacked. They wait for the signal to advance. Smoke rises as they all watch the fight.

Far from the front, the spring seems to come easier and warmer. The duty is still rather pleasant; the patrols through the towns are not much more than gentle constitutionals on most days.

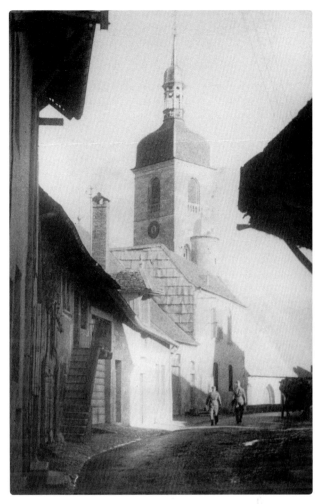

France, summer. All is peaceful. The Vichy Government is allied with Germany and has even had some confrontations with the British in the Mediterranean. But below it all a resistance movement has been forming, small but growing. On this day a warehouse in northern France has a German staff car parked outside it – a deal to get construction materials, or checking on meeting already agreed quotas may be the reason for the visit.

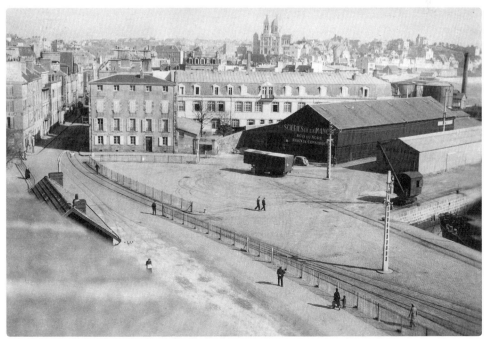

Happy times at the front were not unheard of and when one of the lucky few who got leave that winter returned to his unit bearing a large box of gifts, this was one. The question is whether his comrades are happier to see the *Unteroffizier* or the large package of goodies he brandishes.

'Unteroffizier Pudding Snout' and his section pose for many of the 'we survived this winter' group photos to be found in the albums of the veterans of the war in Russia. He still has his well-trimmed goatee; however, his expression implies, 'Get this over with, we have work to be doing.' There is ingenuity here in the flaunting of regulations to stay warm. Of the kneeling men, the two on either end have sewn fur flaps to their field caps. Should one of these caps be found by any collector today, many would condemn it with 'No, they never did that.' An old military lesson known by soldiers throughout time is that it is much easier to ask forgiveness than to ask permission.

'Marakovo, March 10th 1942. On the HUNT'. Lice-infested uniforms, especially during the winter months when washing was limited. These Landsers go after the tiny vermin with a vengeance to end the itching they have endured.

Washing in North Africa was just as difficult, but not because of freezing temperatures. The lack of water meant that every drop must be used for more important things, although when an oasis or well was found with ample water, a bath of some sort might be taken, both to wash and to cool down. This naked Landser prepares to dowse himself with a basin of water. His washcloth, soap and scrub brush are at the ready.

The body and uniforms were not the only things that needed a good clean after the winter. Weapons of all sizes and calibres, along with vehicles, all needed maintenance. This gun crew takes a little time out to play around for the camera.

Basking in the warm sun, rifles are cleaned. These men are battle-hardened veterans now and they know another season of campaigning in earnest is approaching.

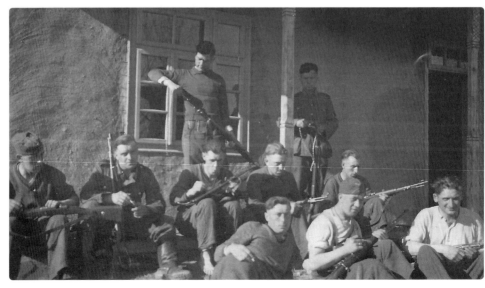

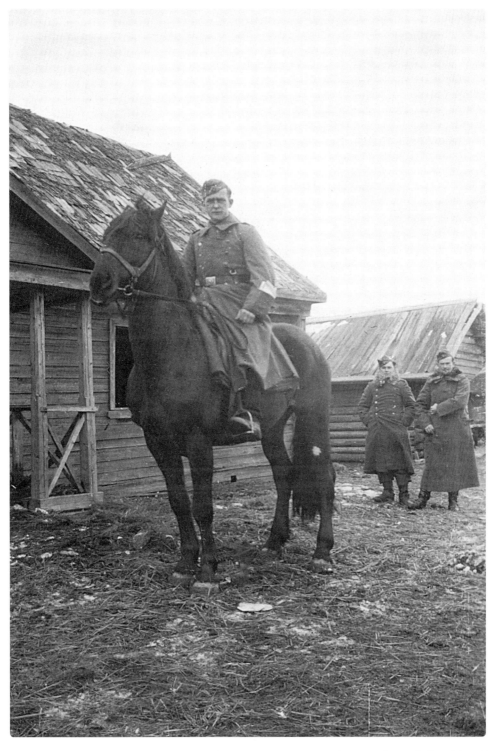

'March 1942, the Crusader and his stallion'. Under the watchful eye of the Coffee Hound and *Unteroffizier* Pudding Snout, the company messenger prepares to take despatches to headquarters. They are tucked into the cuff of his greatcoat. While the motorcycle is the first thing that comes to mind when one thinks of this job in a modern army, once again, more hooves were used for this task than wheels.

In the southern parts of Russia spring comes a bit earlier, bringing a new addition to the menu. Fresh raspberries are eagerly picked for a change of diet. A mess tin is used to gather them.

On the southern front near Sevastopol, this driver warms himself bare-chested in the sun. He needs a haircut but for now, ample applications of hair oil keep his crowning glory in place. Smoke rises from the other side of the hill: the fighting rages on.

Captioned 'The Rheumatic, March 1942'. The Landser walks with a cane but still remains at the front. He has shaved his head in the battle against lice. He wears ankle-high lace-up boots. While these had been issued for some decades in the German Army, since Imperial times, they were usually for rear area troops – the marching boot was for soldiers going to the front. As *Unteroffizier* Stahnke would write later: 'The more we saw men with lace up boots that year, the more we knew something was not going well with our logistics. It was an omen.'

In North Africa, this DAK soldier enjoys some fruit juices. This is one way the men would become acclimated to the zone. Wine was considered a fruit juice for this purpose.

The final performance at the Ancient Roman theatre was some time ago. Sightseeing while they can, these DAK Landsers take in everything of interest before going back to the front.

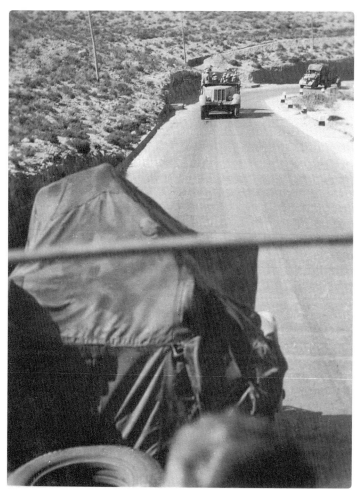

On the way to the front, heavily laden vehicles move along winding Tunisian roads.

More graves of the fallen have been added since the visit of some comrades a few weeks before, when it was just the first six fallen men of Infantry Regiment 365. The cost of war is growing in the East.

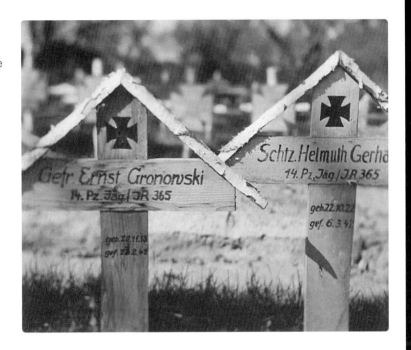

'Gifhorn, Germany March 1942'. Reservists say goodbye to their friends and other locals. The town has given them a small sendoff. Most of these men have reissued Czech bayonets for the Mauser -24(t).

2 April 1942. The DAK and supporting troops take this town near Tobruk. Agedabia would be held for some time. A native policeman approaches.

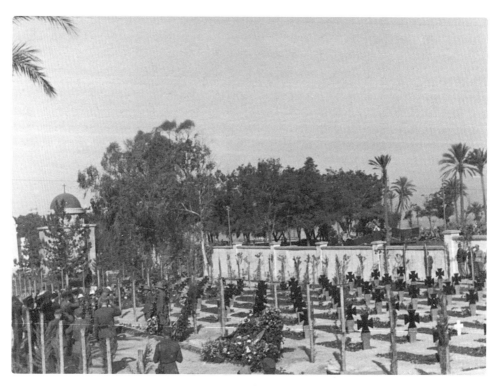

Just as in Russia, German military cemeteries are filling. Men are laid to rest in North Africa on 10 April with full military honours. The white pith helmets seen are those of the Italian Military Band sent to play for the funeral.

Dated the same day as the funeral, 'Three Tante Ju's bring in more supplies and men for us.' This is always a good sight for the Afrikakorps, starved of both.

Life is calm in this Alsatian town, now part of the Reich. Other than the posters and war news on the building on the right, one would not know the world was at war.

THE LOST LANDSERS | 1942

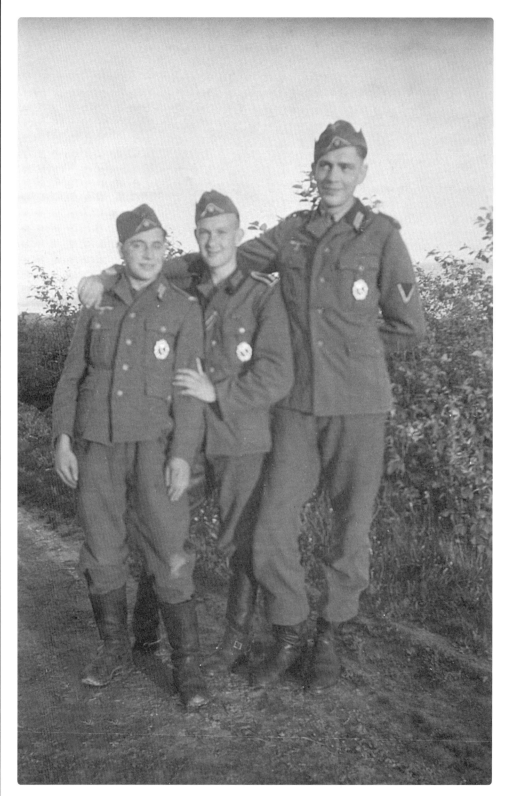

With spring come the awards long overdue from the autumn and winter. 'Three new Assault men'. Combat infantrymen, from the silver badge – *Infanteriesturmabziechen* – Infantry Assault Badge. Kolobovo, Russia, March 1942.

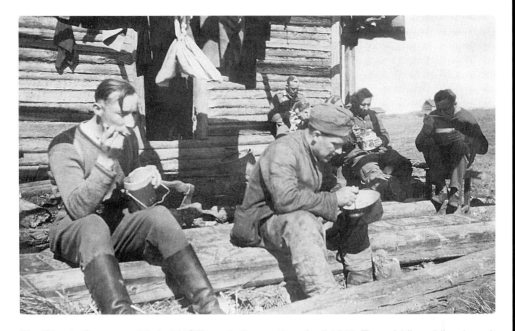

'The Bicycle Soup was thin but HOT' reads the caption, April 1942. The middle soldier doesn't use his mess tin and eats from the pot, since he most likely was the cook – actually a smart move, as he will get every last drop that was left in it. Some of these Landsers relax in comfort with slippers on, airing out blankets and clothing.

In Germany, a spring fair and carnival. Some men in uniform take their families out, while others who have someone far away on a distant battlefield or on occupation duty make the best of it for the benefit of the children. The biggest attraction seems to be the Loch Ness Monster ride.

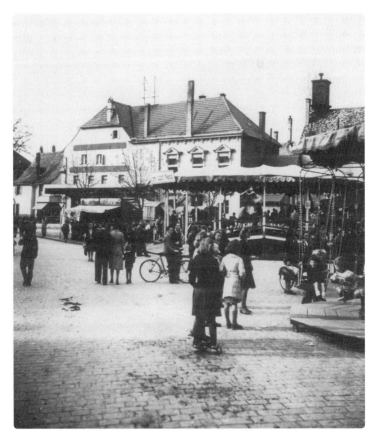

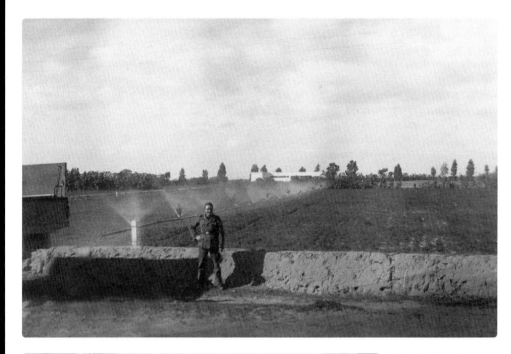

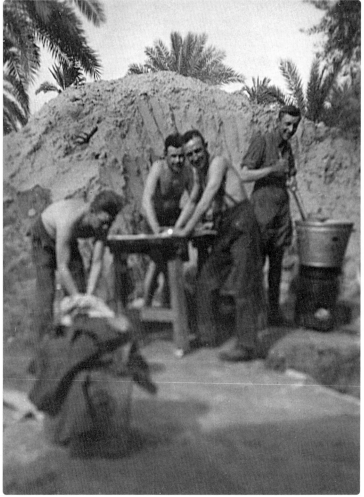

This DAK soldier had to have his photograph taken in front of a lush irrigated field in North Africa because no one would believe him since, to the entire world, the place was nothing but sand.

The irrigation makes it an ideal spot to catch up on one's laundry. Both images are dated 10 April 1942.

On the continent Europe is turned into a fortress by order of the Führer. Here in the Dunkirk sector, a large coastal artillery emplacement is in the middle of construction.

Another gun battery to the left of the one in the previous image is more complete. Every German Landser knows in 1942 that it is only a matter of time before an invasion from the West, especially with the United States entering the war against Germany the previous December.

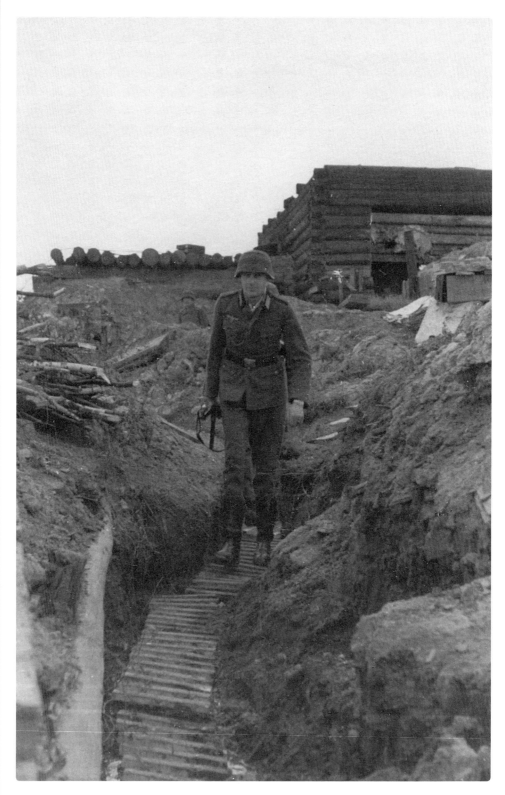

Back at the front in Russia, a new officer inspects the position of his company. This position has been well built up over the winter months and places like this will become the norm in certain sectors of the Eastern Front.

More and more auxiliaries of the army are employed to get certain jobs done even in occupied countries. The strain on manpower was beginning to show. Here, four drivers from the NSKK, the Party's transportation branch, an auxiliary arm of the Army, do some site-seeing in Belgrade after delivering supplies to troops in the area. The Hotel Moscow in the background is still there today. *Gefreiter* Anton Zellner, an artillery veteran from the Eastern and Italian front, put it succinctly to the authors: 'The more odd or weird the uniforms we saw, the more trouble we knew we were in.'

The next campaign seasons were beginning, the last snapshots taken. 'In the Desert, Spring 1942'.

At the front in North Africa, the experienced troops are making the best of it. This tent is well set up amidst the rocks to guard against sandstorms, with a gesture towards camouflage since the sparseness of greenery in the area made it redundant. Tunic and greatcoat are laid out on the tent to dry, more from sweat than from washing. The saddle bag from a motorcycle side car serves as a table for a mess kit. Of interest is the cap sitting on the high rock to the right. In this black and white image it does not catch the eye. However, in colour it would serve a purpose. The inside lining of Army issue DAK caps was red. This cap is placed inside out to serve as a recognition marker in an attempt to prevent fire from friendly aircraft.

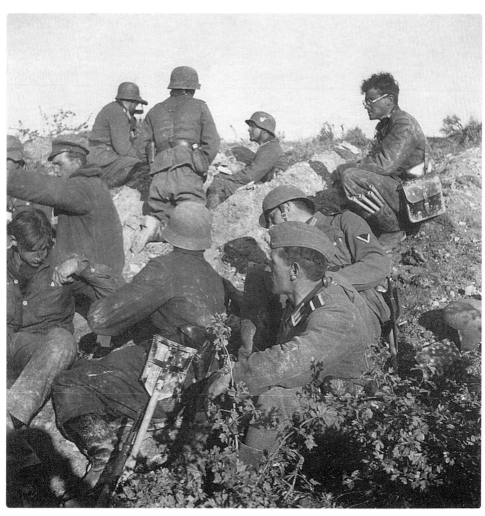

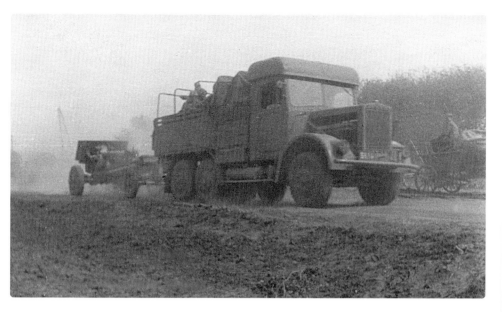

'Amidst clouds of dust we race forward to take up positions. May 1942.'

'Ships of the Sahara, May 1942'. The ships take a rest, as does the convoy on the way towards the front.

Opposite bottom: '16 May 1942. Before Kerch, the preparations'. These *Pioniere*, dirty and tired, readjust their positions outside the city of Kerch on the Crimean Peninsula. The Soviet units have caved in during the German operations to secure the area. The fighting has been hard, as evidenced by these men. In four days the city before them would fall and another German victory would be added to the year. The cost was not as high as one would have thought given the tenacious defence; once the Germans had pushed behind the Soviet lines it was only a matter of time before a complete collapse was underway.

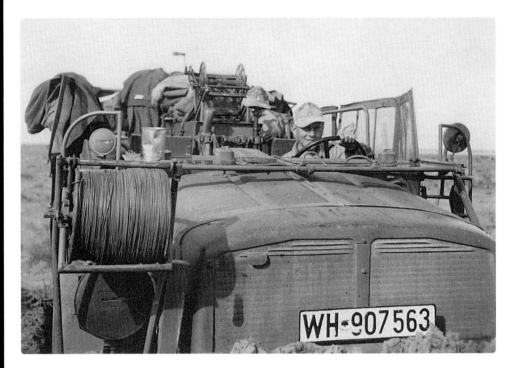

A sharp view of a Horch Pkw. Type-40 Signals Car. The reel on the left is used to pay out the wire over long distances; the centre mount in the back, devoid of wire at the moment, was used to reel it in. The cap of one of the crew serves as a dust cover for the muzzle of his rifle placed in one of the racks. The empty, dented ration can that serves some new purpose sits to the left on the front of the vehicle: any good soldier could find some use for it. These DAK Signal Men knew their job and did it well.

In a more temperate zone, an Opel Blitz splashes across a river at a fording point, much to the delight of the passengers.

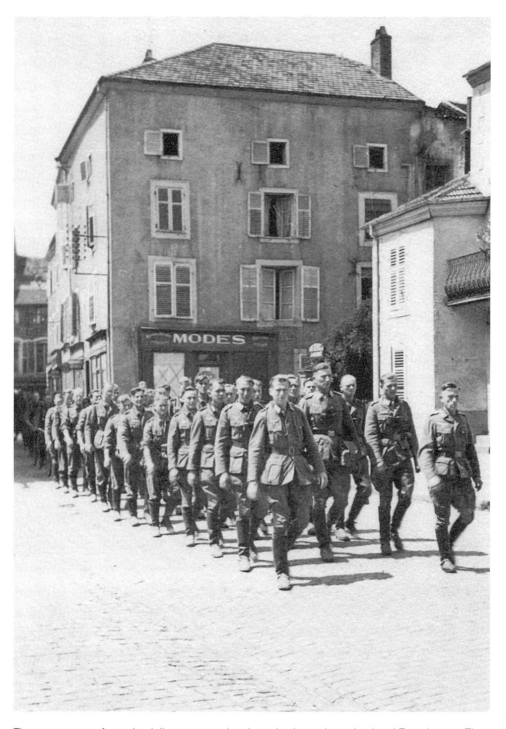

The company performs its daily route march to keep in shape through a local French town. They are bare-headed, with hats tucked into belts; most are unarmed. The marchers are followed by men on bicycles and wagons carrying packs, gear and weapons. The officer leading them has been decorated with the Iron Cross 2nd Class, so he has seen combat. These are the easy days in France; all too soon these days would change.

Opposite top: 'Our Bunker in Russia, spring 1942'. A *Gefreiter* and his comrade stand outside the entrance to their bunker. They have fared rather well through the winter hell and look none the worse for wear. A bottle of wine sits on a ledge behind them, as do their greatcoats, since it still gets cold at night and in the early hours. Field glasses for use when on sentry duty lies close at hand. In many places the war had evolved into a similar trench-line impasse as in the Great War.

Opposite bottom: As the sun rises in the east, this infantry column moves south; this year's campaigns are now pushing southwest. Many a Landser wonders why, since Moscow has not been taken yet.

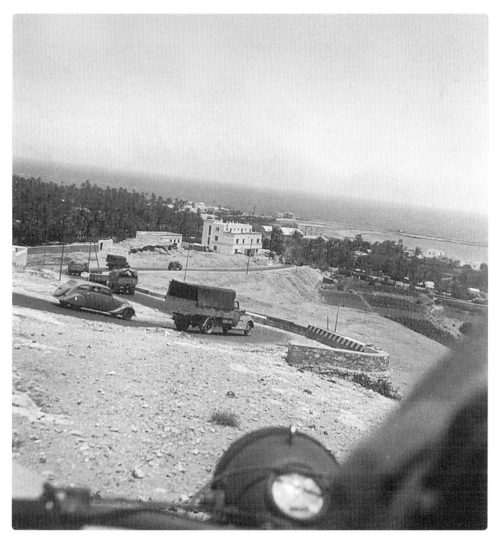

'The view from our road trip into Derna to get supplies'. This was taken from the front of a motorcycle. Amongst the column of DAK vehicles is a Peugeot 402 sedan. Many of these were captured from the French army in 1940 and subsequently put to use anywhere the Wehrmacht found itself.

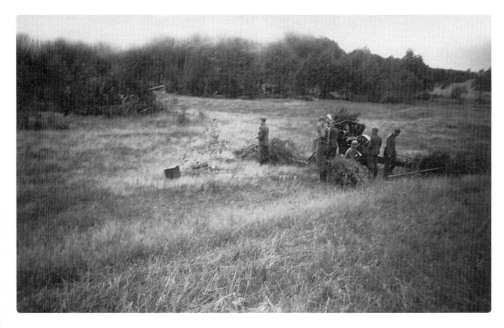

An artillery battery prepares to open up. While one gun is in a more open position, the rest are well hidden in the tree line. The war is beginning in earnest again.

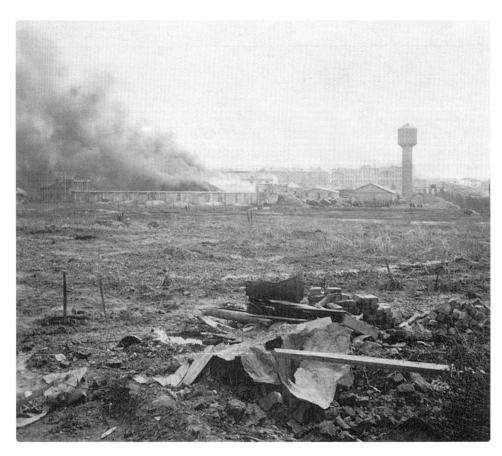

'Across No Man's Land. Our shells hit the Ivans, they are in disarray, June 18 1942.'

'ATTACK' says it all. This SDKFZ 10 goes over the top.

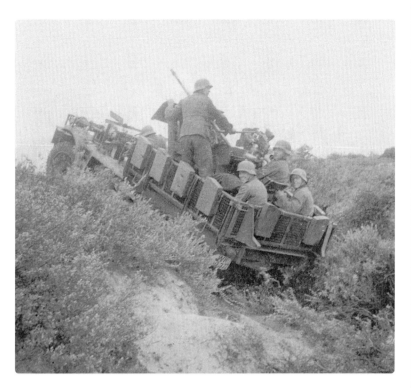

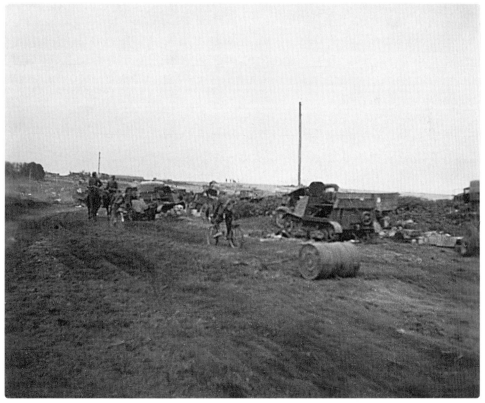

The advance begins once again; the scenes begin the summer of 1942 much as they had in the previous summer. Landsers on horseback and on bicycle inspect the wreckage in the fields alongside the main road. This is dated 28 June 1942.

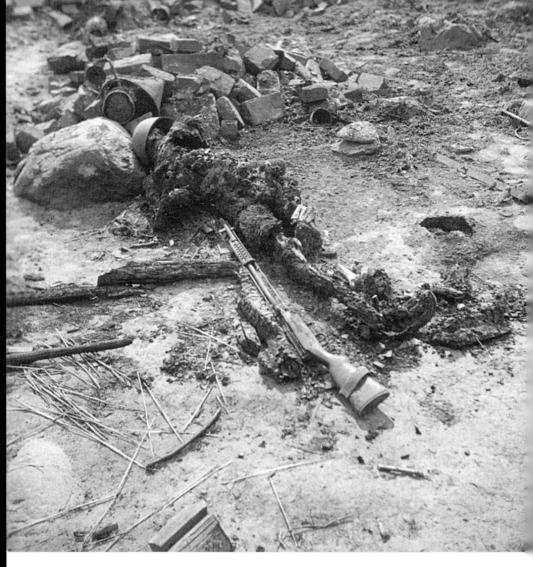

The *Kanoniere* have done their job well. Soviet positions and troops are smashed, paving the way for infantry to advance with less resistance. The grisly remains of this Red Army soldier armed with an SVT-41 semi automatic rifle are the result.

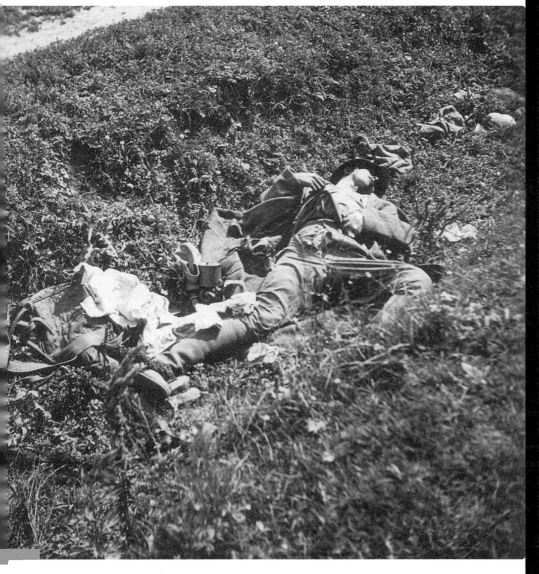

Further on another Ivan is found in a ditch; he looks to have been looted. His rifle, bayonet and cartridges boxes are all gone. 2 July 1942.

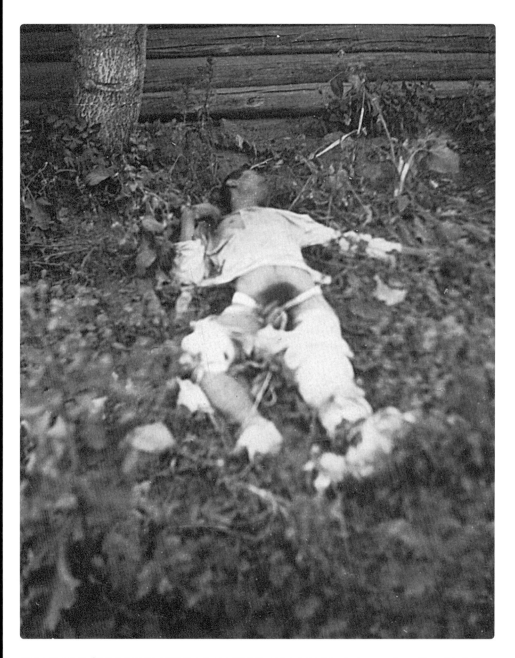

At an overrun Soviet headquarters a wounded Russian has crawled away from the aid station, choosing to die this way rather than face capture or some other end.

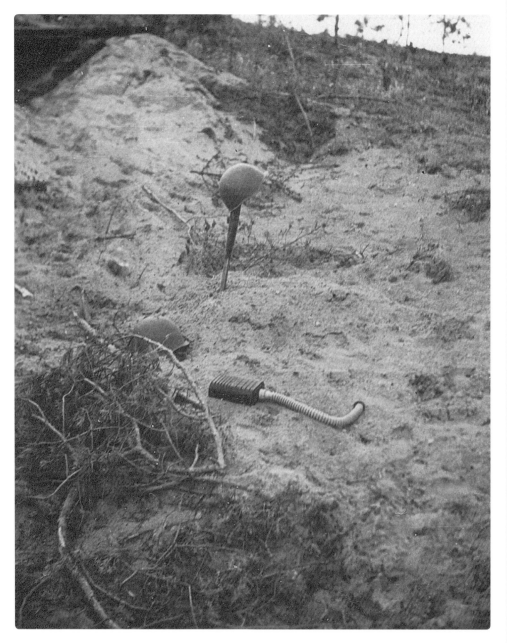

On the Crimea Front the graves of two Ivans are marked by helmets, one rifle and a gas mask. It was hasty but their comrades took the time to do it.

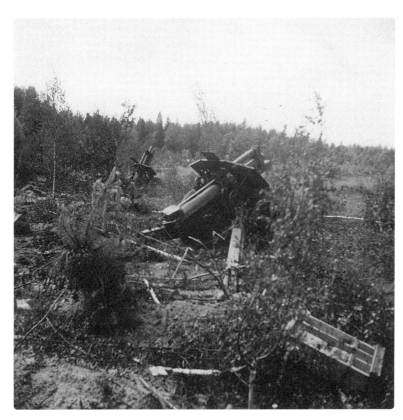

More Soviet Artillery captured. However, this time it was taken out firing on German positions. The days of headlong retreat are over.

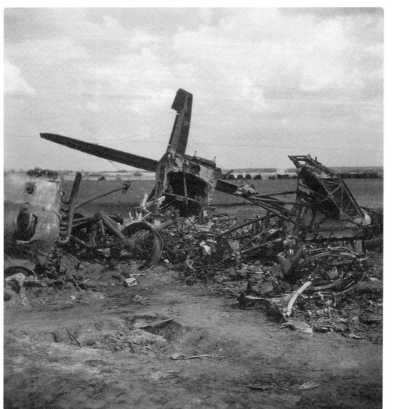

More Red Air Force planes caught on the ground or shot down and another airfield taken. The summer is shaping up much the same as the one before.

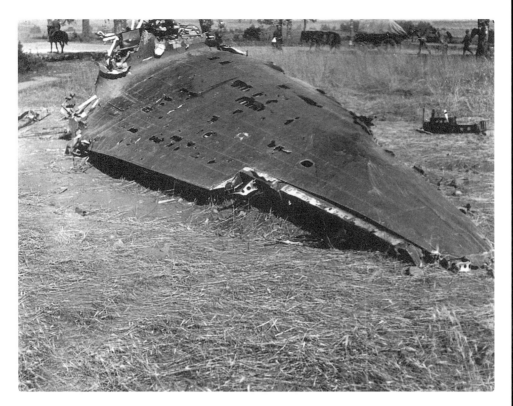

'Russian Bomber that attacked our convoy, he tried to crash into us after he had no bombs left but was shot out of the sky, June 1942.'

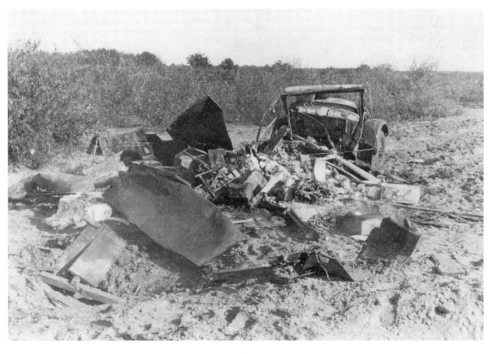

A German Horch shattered and burnt, hit by Soviet artillery. The Landsers know this is not a repeat of 1941; their leaders do not, yet.

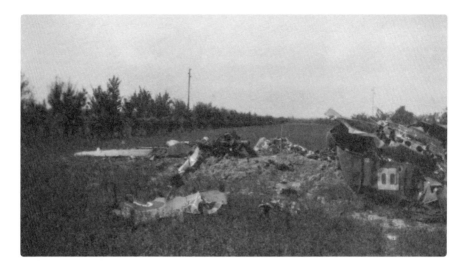

Things are changing and those Landsers at the lowest levels perhaps sense it more than those at the top. A tenser relationship with the people in occupied areas and the odd shots at patrols, bridge blown up or man missing, now indicate that something is amiss. In Southern France the remnants of a crashed RAF bomber are strewn along the edge of a field. They have known that the RAF has been bombing German cities by night since the early part of the war; however, they are now encountering the RAF far from where it would normally be flying.

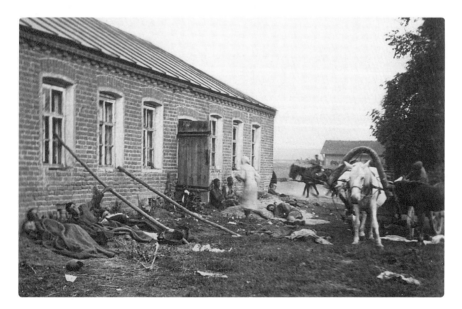

The quality of mercy. German and Russian wounded litter the ground outside this makeshift aid station. A Russian woman acting as nurse rushes inside, as a German horse-drawn gun emerges from behind the second building in the distance. An Ivan unloads more wounded from a Russian cart. On the ground are torn-off bandages from men brought in who needed better treatment. The long poles leaning against the building are there to turn blankets into stretchers. For once on this front, the uniform does not matter. Things like this did occur.

Out of the fight and maybe this Landser has a ticket home for a while. If not, he may be sent to some rest camp to recover far in the rear. His hand, neck and face show shrapnel damage from a shell or grenade. He stares in disbelief that he is still alive. Behind him a very tired comrade tries to eat something from the lid of his mess kit. His arms are heavy and he craves sleep more than food but his body needs both.

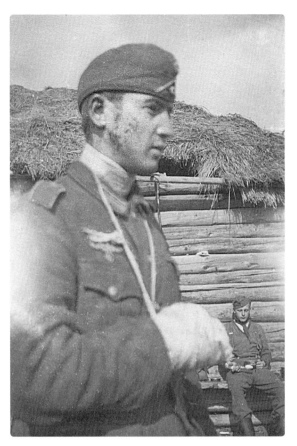

Back on the German Home Front, the sisters and mothers of those at the front do volunteer work to raise funds for the Red Cross: a scene repeated in every country with armies in the field during this war. London, Munich, Rome, New York and countless other places saw this task undertaken.

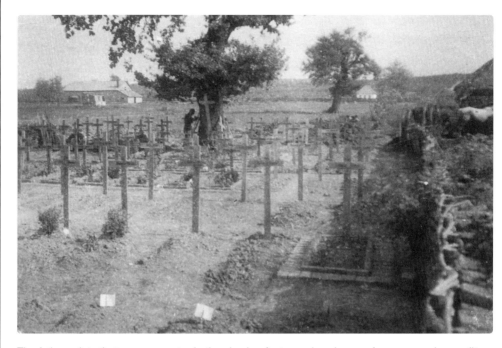

The fatigue duty that no one wants. In the shade of a tree a Landser performs a sombre, solitary task: he paints the names and dates of his fallen *Kameraden* upon the crosses that will mark their graves. A Russian farmer's field becomes a German Army cemetery.

In the Crimea this *Gebirgsjäger* of the 4th Gebirgs Division takes time out of the heavy fighting for a smoke break. He is well outside the range of any uniform regulations. He probably didn't really care much when his photograph was taken. He wears his beloved Mountain Cap with the distinct brown Bakelite buttons and regulation 'lemon squeeze' pinch at the top; this is where a proper soldier, with three fingers positioned correctly, grasps his cap to remove it. The Edelweiss is unseen but mounted on the side of his cap. He wears his M-40 HBT work tunic with breast eagle and shoulder boards, an accepted practice but still against regulations. The PT shorts and marching boots are for comfort, not parade ground.

Training of replacements still goes on, with intense combat courses to replenish older units and build new divisions. In this 1942 photograph recruits are training with the heavy machine gun, in this case an MG-34, on a tripod mount firing blanks at an 'enemy' force. Their helmets have coloured bands indicating which force they represent. While they wear the Model 1940 tunics, these young men wear helmets that are probably older than they are. They are a mix of German and Austrian patterns issued in the First World War – the German M-16 and Austrian M-17.

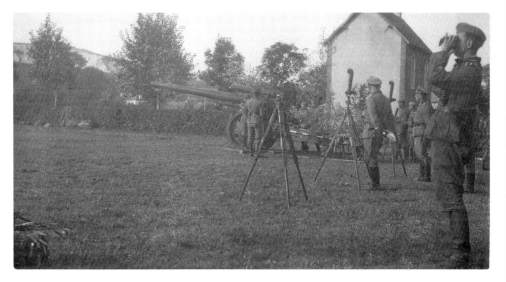

A heavy field howitzer, the 15cm *schwere Feldhaubitze* 18, prepares for a demonstration firing for senior officers and the Regimental Commander: 'Firing on the range in front of the Regimental Commander, Boulogne-sur-Mer, summer 1942'. This town was not far from Calais and now rumours of invasion were filtering through. American forces were known to be arriving in England. This was not sitting well with most Landsers. *Unteroffizier* Werner Stahnke remembered the reaction to Germany's declaration of war against the United States the previous December: 'We, at the front fighting vicious daily battles with Ivan, could not envision the madness that permeated Hitler and his ministers to declare war on the United States. It was actually the first time we began to grumble amongst ourselves openly.'

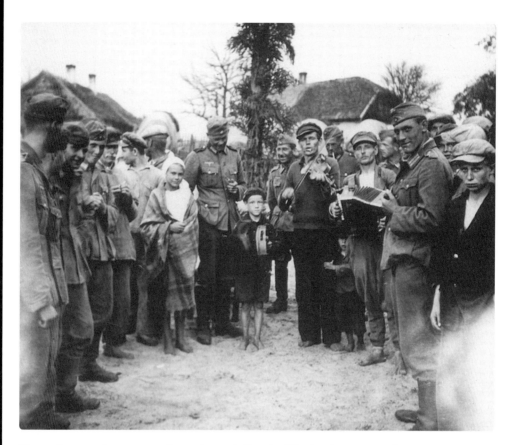

Pleasant moments were experienced even in Russia. 'The local peasants give us a concert, we brought beer and chocolate, summer 1942.' There are still those in the crowd with cautious looks upon their faces. At times, nevertheless, people will just be people, especially with music, beer and chocolate to hand.

Opposite top: A member of the local German garrison is piled onto by a mob of local children in a game, amusing his comrades. Most of these children are barefoot but at least for this moment they are all laughter and smiles. Despite the deeds of others and the propaganda, most Landsers did what they could for the local kids; most soldiers of all armies usually do.

Opposite bottom: A warm summer day of ease for these men behind the front. The German army took care to rotate as many units out of the fighting for rest as possible. This was done at every level of the German military, from Company to Army level. These men appear to get along very well with the family whose house they have been quartered in. The *Unteroffizier* in the middle has turned his Iron Cross into a watch fob.

At a stop during a patrol for lunch, the adopted dog of this *Gebirgsjäger* platoon is teased with a large piece of sausage by a smiling *Obergefreiter* Signalman. The wide open area and the lack of any attempt to stop in cover indicate that this is a secure area.

Not every citizen in the countries invaded and occupied by the Reich was hostile. In many places there was widespread support for Hitler, a fact that the post-war world constantly swept under the carpet. While there were forced labour camps and brutality, it is also true that there were volunteers serving with and fighting for the Reich; or, in this case, working for the Wehrmacht. This Russian wears some old cast-off tunic acquired somewhere along the line, his job is to care for the German horses in a veterinary hospital. Why he did so is unknown, but the daily meals might have something to do with it.

It was not only in North Africa that the Landser encountered camels. They were to be found in southern Russia as well. These two-humped beasts are Bactrian camels.

Left: Welcome home, son. A *Gebirgsjäger* shows up at the workplace of his father. From the apron, he may be a butcher, baker or cook. The son has seen much, judging from his awards and ribbons. He has been in combat as an infantryman, been wounded and decorated for bravery and endured the snows of Russia. Now he has made it home on leave – a well-earned one.

Below: 'The Spiess and *Obergefreiter* Wagener'. This little fellow probably ended up as the company mascot. A short break for the convoy as the advances continue, slower and not as far as last summer but still farther on towards some objective only known to 'Grofaz' in his infinite wisdom. This term was a mocking anagram for *Grosser Fuehrer alle Zeit,* which translates as 'Greatest Leader of All Time'. Insulting Hitler was a crime in the Wehrmacht. Though any group of soldiers will figure out a way around a regulation.

'*Gefreiter* Helmut Ahnert as an owl handler, June 1942'. Even at the front, men found time to pursue interests during the lulls in action. Notice how short *Gefreiter* Ahnert's tunic is, as well as the bottom pockets sewn flush along the edges. As in all armies, there did exist some unregulated fashion standards for the well-dressed combat soldier and for him, this was à la mode.

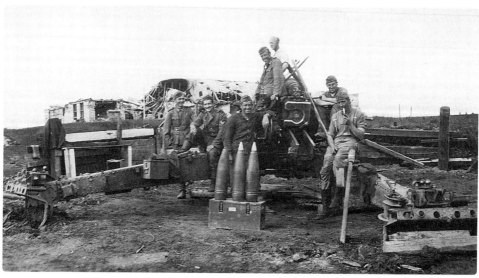

Opposite top: His tent, bleached white from the sun, is almost unrecognisable in the background as this DAK soldier takes a walk. The trees on either side give a clue that he may be at an oasis. His uniform is a mixture of old sun-faded items and a newer tunic, complete with awards that show that he has seen much combat and been wounded. At the time, June 1942, the British were in headlong retreat towards Egypt. The war, surely, would be over very soon.

Opposite bottom: Using a destroyed building for cover in Russia, this heavy field gun makes it difficult for the Ivans to see where the shelling is coming from. As well as being behind the building, the gun is on a slight reverse slope. The *Kanoniere* take a break between fire missions. It is hard work running this size of gun. These men are all pretty filthy, but that is the way in the field. To the right of the *Obergefreiter* with the large moustache, the *Kanonier* has used a small cap eagle on the front of his drill tunic, as opposed to the larger breast eagle.

While the countryside is green and spotted with trees here, the roads in southern Russia tended to turn into sandy tracks, making the going slow. A sentry stands his post alongside a wooden hut serving as a traffic control point. A convoy has just passed. On the firmer side of the road, a *Radfahr* soldier is off on his next mission.

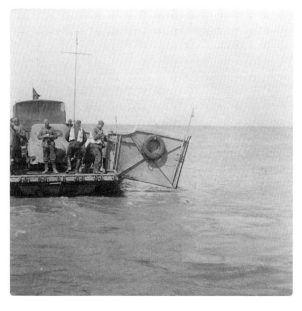

In the southern expanses of the Soviet Union the Black Sea was another obstacle, but not insurmountable. In fact, it was a less dusty and cooler way to get from point to point. The Luftwaffe still controlled the skies.

Two officers direct the allocation of goods and equipment for the trip. The senior officer 'stands guard' at the row of ration containers and a tub containing melons while his underlings secure machine guns, ammunition cans and packs.

More manpower is needed in Russia, so more men are called up and sent. These men are from a reserve infantry unit, taking a break from the long train ride and meeting with some Hungarians, one of Germany's more staunch allies, who are dressed more or less in rags. There are more uniform anomalies, something that occurred increasingly as the war continued. The kneeling soldier wears a white HBT work tunic but leather reinforced riding breeches, which may indicate that he is a horse-mounted despatch rider or on a horse team of a supply wagon. His boots are those worn by Gebirgsjägers and he wears wrap-around puttees. On these boots, spurs would be superfluous.

Still hazy, crazy days of summer in France in 1942, with nothing to disturb the serene duty life – yet. The Landser on the right shows off his newly acquired French revolver, a conversation piece when he is back from the war.

'On patrol in Poland, summer 1942'. Huge numbers of German troops are now required to garrison not only Germany proper but also the greater Third Reich. The woman has been included in the shot to add some local 'colour'; she averts her gaze. The young soldier on the left wears the SA Military Sports Badge; the *Unteroffizier* to the right wears his Wound Badge.

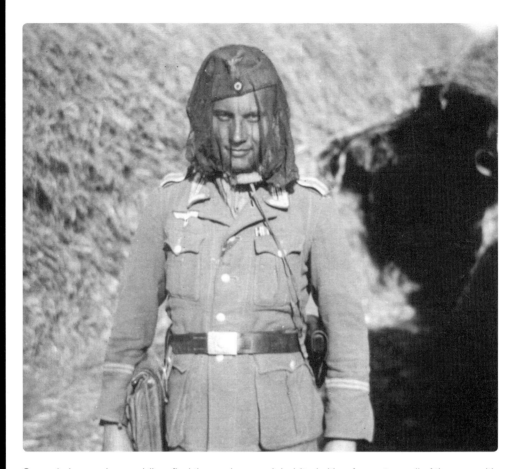

Several places where soldiers find themselves are inhabited either for parts or all of the year with biting vermin. This Spiess, with the rank of *Unteroffizier* indicating he is in a small independent unit, wears the green regulation insect head net as he stands in front of his bunker entrance in the Crimea. His ribbons tell a story; his buttonhole shows the ribbon for the medal now being issued to those who served in the first Russian winter – nicknamed 'The Order of the Frozen Meat' but officially *Winterschlacht im Osten 1941/42*. The bar on his chest shows first the War Merit Cross with Swords 2nd Class, which means he has shown bravery under fire, but not enough to earn the Iron Cross. And finally, the ribbon for the Westwall Medal, which indicates service in some capacity during the defence of the western borders during 1939 and 1940 prior to the French campaign. Now he is in the mosquito-infested Crimea, thinking he would rather be back in France. Not often seen, he wears the lanyard for his pistol, which appears to be a Browning.

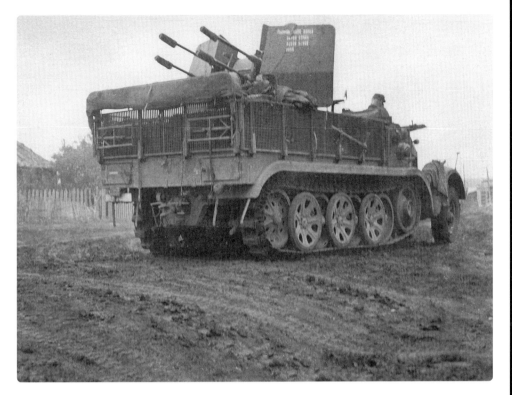

These two photographs are from *Gefreiter* Anton Beckler, who served in a motorised flak detachment assigned to the 17th Panzer Division. He was a crewman on this Sd.Kfz. 7/1. This motorised AA gun would account for over forty-five enemy aircraft before he was wounded and sent to France. This is how it appeared in the summer of 1942. The burning Ilyushin IL-2 Sturmovik fell prey to its firepower.

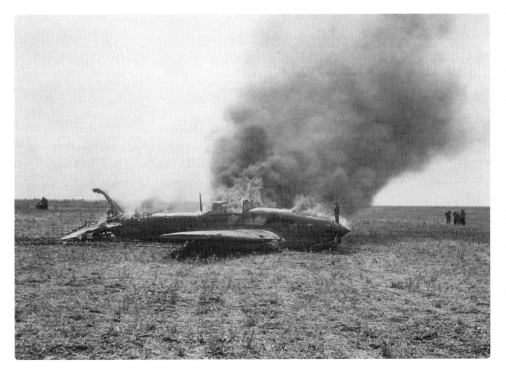

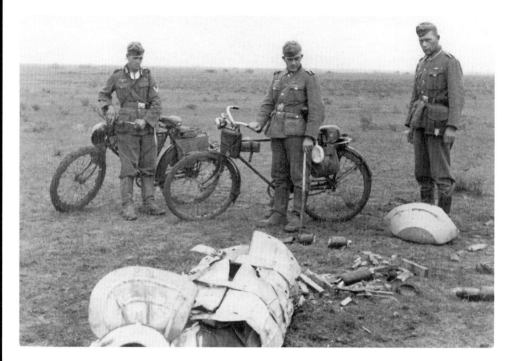

All over Europe from East to West the wreckage of aircraft fell from the skies. And in every place that was by any means accessible the local troops in the area had to check out the crash site, for intelligence gathering, retrieval of wounded POWs or burying the dead. These *Radfahrtruppen* stare intently at this pile of twisted metal that was once an aircraft. If you could read their thoughts they would be 'My God, men were probably in this thing when it hit the ground'. The mud on their tyres and boots indicates an arduous peddle across a wet field. The bicycles carry the requisite gear of a normal patrol in a safe rear area and they are only armed with pistols.

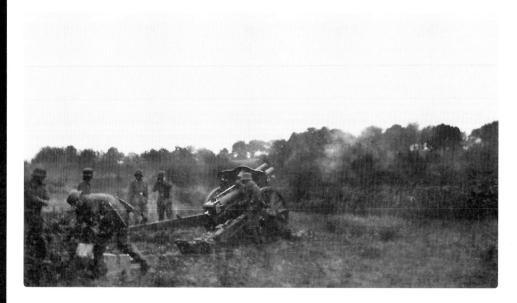

The thunder of artillery still rages on the Eastern Front. More objectives to be taken, more attacks to be made.

This Red Army machine-gun position in the Crimea has had a direct hit. The gun is far off to the upper left; ammunition cans lay to the left and right of where it once sat. The remains of the crew fill the trench closest to the camera; a deeper hole can be seen just beyond this human wreckage where these men and the gun once were in position. The bicycle of a *Radfahr* soldier leans up against the fence of the old Soviet perimeter. Many of the Reconnaissance elements in German Infantry divisions used horse- or bicycle-mounted platoons rather than motorcycles, because there were not enough of the latter to go around.

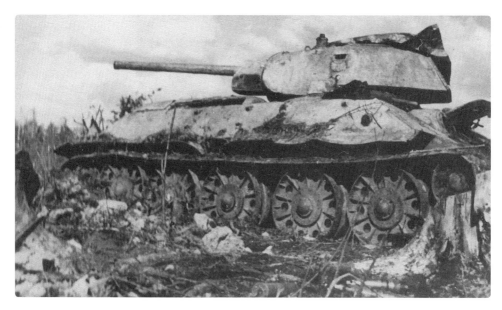

The T-34 was hit many times until finally an attack from the rear took it out of action.

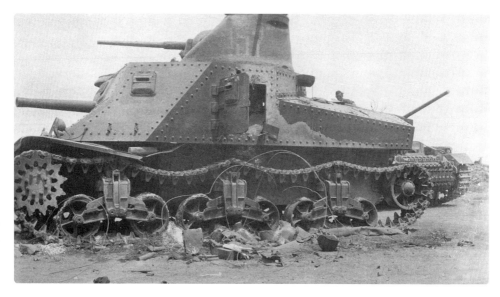

The logistical support of the United States was now being encountered by the Landser in Russia. Those stationed in Western Europe had seen US bombers fly overhead, but it was on the ground on the Eastern Front that an M-3 Lee medium tank had made it to the front. With a hull-mounted 75mm gun and top turret mounted 37mm gun, though mechanically reliable as well as being able to hold its own in a fight with lighter German armour, this tank soon lagged behind German developments in this field. As a result, by the time they arrived in Russia these were becoming obsolete and proved as unpopular with the Red Army tankers as they did with US ones. The Ivans nicknamed them, in a rough translation, the 'coffin for six brothers'. Tank Number 257 has lived up to that name. Hit hard on the opposite side, parts of the interior lie on the road blown out the side door, an upturned Soviet helmet from one of the crew among the mess. A Panzer III from the detachment that did the damage rolls up behind it.

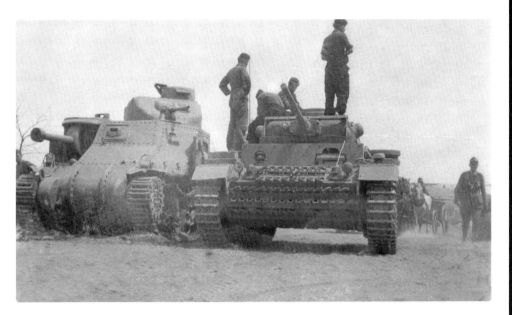

The same Panzer III – a heavily reinforced one to better survive hits from Soviet tanks and anti-tank guns – comes to rest on the road next to another knocked-out M-3 Lee. Note the different muzzle on the 75mm gun and turret angle, from the same action. *Unteroffizier* Werner Stahnke: 'It was one thing to see tins of American corned beef in the packs of the POWs and the dead but once we saw American trucks and tanks on the battlefield, a deep sense of dread took hold of many of us at lower levels of the army. We knew that we could win against Russian flesh and blood but not against this and American steel.'

The south of Russia was as hot and dusty as the North African desert. These *Gebirgsjägers* might have preferred the cold of the mountains to this dust.

A soldier just never knew when an opportunity to get some beer and relaxation would present itself. These Landsers have a keg of beer propped up on a medical supply chest. To the right there is even a bed to sleep off the effects.

Above: 'Preparing the firing position, Kubischka, summer 1942'. Their 7.5cm le.IG 18 in the background, these crewmen pause during the digging of the position. The younger Kamerad on the right stands hand in pocket, looking at the hole with shovel askew. His thoughts are easy to read: 'I really don't want to do this; I have dug enough holes in my life.' A sentiment endorsed by every soldier in every army throughout history.

Opposite bottom: 'The sauna was never cold, Makarovo, July 1942'. Even in the front line, some surprisingly luxurious installations could be found. A hot spring has been turned into a sauna, which also allowed for hot 'showers' of sorts. Hot water is a luxury most soldiers of every army cherish, and quite a morale booster.

Job done, the gun commander checks the work and the aiming stakes. The double stakes in the front right are the failsafe limit of the gun; a similar stake on the other side would be in place. These prevent firing onto friendly positions by mistake. The numerous smaller stakes the *Unteroffizier* is looking over are for pre-plotted target areas. Each stake is marked with a code and elevation requirements. The gun rail would then be centred on the stake and the gun loaded, adjusted and fired: a quick and effective way to bring fire on targets.

'Dress-Down Friday' at the front. A Landser being properly dressed in combat is not necessarily required to get the job done.

'The General visited our "Spritzer" after a hard action.' This gun must have put up quite a fight – note the shrapnel holes through the bottom shield. It was a sign of a much more determined resistance.

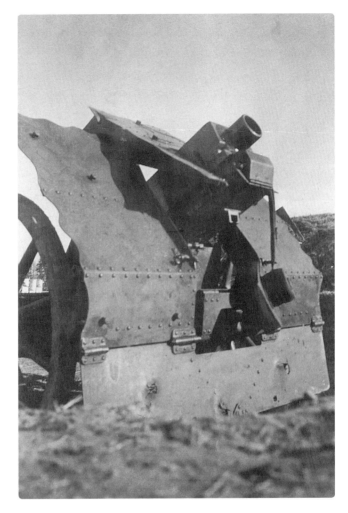

'No Man's Land'. The 'Spritzer' stood at this position. The German lines are in the closest wood line, the Russians are across the wide open clearing. They would attack again and again in waves.

In occupied France. At least four of these men are decorated in some way; they have been at the front. The easy times in the West are going to end, but never reach the level of carnage of the war with Russia.

'Infantry training, summer 1942'. The new men who would go to the Front. A close look at the uniforms indicates there are logistical problems or changes made to meet conditions at the Front. All sixteen of the young men here wear the new Model 1942 Field Cap, which has a two-button flap so the sides can be lowered and placed around the head to keep warm, something learned from the previous winter battles. The first and fourth man from the right wear converted Austrian pre-war tunics; the kneeling soldier second from right wears an even earlier converted version with scalloped pockets, an indication that everything that could be used was being issued. Finally, it can be argued that these men just don't seem to have the same sharpness of the soldiers of a year before.

3 September 1942. Three DAK replacements sightseeing at Pompeii on the way to the front. More uniform changes give clues to the thoughts of the high command: trousers will work better on the continent than shorts, should the campaign in the desert not turn out well; so will this new shirt.

'Early Morning Patrol, Northern Russia September 18th 1942'. In the north of Russia greatcoats and gloves are needed for the early morning and late in the day. Their belts tell of German supply shortages: they are French Army issue, captured in 1940.

The drive south-west continues, despite heavier resistance from the Red Army, the terrain and the weather. The men and vehicles of this motorised PAK (Anti-Tank) unit's HQ detachment struggle forward. The terrain has been reinforced, with cut trees making a 'corduroy road', as it resembled the pattern of this type of cloth. Even so, the officer's Sedan has become stuck. All hands, including the officer's, are gathered to extricate it; smoke billows as the engine is gunned and put under strain, while the rest of the column is stalled behind the vehicle. To the left, a motorcycle driver, clad in his distinctive rubberised coat, approaches to add another shoulder. Silently observing this scene stands a Russian civilian. The Landsers know that delays may affect the outcome of a battle, but the path of this advance leads only to another intense struggle in the rubble-strewn streets of Stalingrad.

The work of the support troops is never-ending and often thankless. A German mess section has set up shop in this Russian farm, the buckets of potatoes and prep work are all around. With a smile, this *Unteroffizier* pays this Russian boy for some little job he has done. He is happy as he looks at his German coins. One hopes the Russian Resistance was understanding of the innocent exchange.

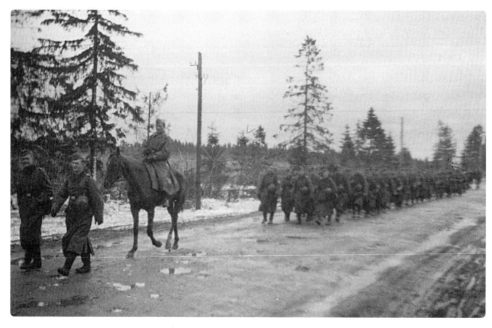

The first snowfalls return. This infantry company marches to the rear for some rest but they know another winter is upon them. The experiences of last year have taught them well but another year will pass without an end to this campaign.

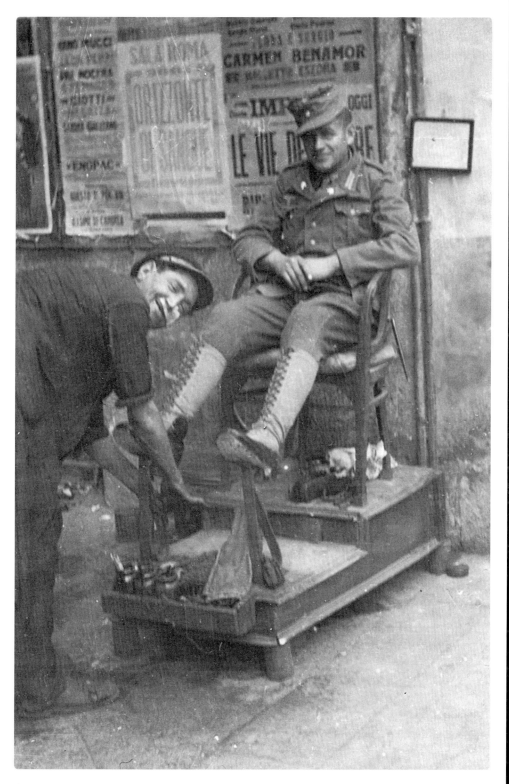

Opposite: 'Having my boots polished in Rome on leave, October 18th 1942'. This Panzer man, the skulls brightly shining on his lapels, has been lucky enough to get leave from the desert. He still wears the old pattern uniform, which denotes him as a veteran of the campaign, as do the faded canvas tops to the boots.

'Pesotchnya, Ukraine, October–November 1942. *Oberleutnant* von Holbe in front of the Officers latrine. This has a signal lamp, heater, phone and box for the paper'. The height of indulgence; even the instruction sheet can be seen just above the paper box inside of this super latrine. With the signal, any officer can see if the place is in use to save a walk in the snow; German efficiency and officers' privileges. The *Oberleutnant* wears a captured Russian winter cap with added German insignia, all the rage again this season.

Opposite bottom: 'Wolchow, 1942'. On the Leningrad Front, this swampy area was known for its inhospitable conditions and earned itself the nickname *der Arsch der Welt*, the arse of the world. These Landsers settle in for another winter. More evidence that the cold affects men differently and each dresses to fit his needs. One has a white helmet cover, knit hat and well-manicured goatee, another a homemade hat made by *Mutti* and heavy sheepskin coat but still looks cold. Just a tunic? Most likely a country boy. The man on the right isn't bothered at all, in fact something else has his attention – maybe someone is brewing some coffee out of the frame. Men react differently to these situations.

This year, the new winter combat uniform that just started to show up last winter is now arriving in large numbers. This infantry company is fully equipped; it is camouflaged on one side and reversible to white on the other. This winter the fighting will be different, but still another winter not bargained for in the snows of Russia.

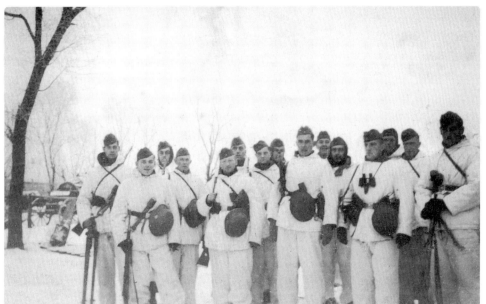

Another infantry section goes out to take up a section of the line, not on patrol. First, the white side of the winter uniform is out, which is more suited for less mobile operations – any good soldier knows to shoot at 'moving snow'. They wear light gear, no packs and they have an MG-34, on the extreme right. One man carries the AA tripod for it, on the far left. While an encumbrance on a patrol this tripod is a good platform in a trench or a position with cover. Again, this winter the fighting would not be as the last, the Landser has become just as adept in the conditions as the Siberians he faced a year ago.

Everywhere across Europe, to the steppes of southern Russia and in the deserts of North Africa, groups of Landsers did their very best to celebrate another Christmas, the fourth one of the war. This little outpost has made the effort to get a tree for the day. Right now these men know that their *Kameraden* are struggling for their very lives in the hell of Stalingrad and the vaunted Afrikakorps is fighting on, but the situation is bleak. Christmas for the German Landser in 1942 does not prompt prayers for a victorious end to the war, but just for survival.

GALLERY
THE LANDSERS OF 1942

Wearing his new sheepskin vest, this infantryman had his portrait taken in Riga, Latvia, in January 1942.

A *Kanonier* sporting his visor cap and wearing his new ribbon showing he has survived the winter battles of the Russian Front. His shoulder board has the coloured loops to indicate a specific Battery within his Regiment; they appear to be red, which would mean the 2nd.

'Your Willi, Southern France, 30th May 1942'. The shadow of a palm forms the backdrop to this portrait of an infantryman. Willi has his collar open in the warm climate, his collar liner tucked aside. He wears no shirt. He too wears the coloured loops on his shoulder boards but in the infantry this denotes Company, not Battery.

'Our Wedding Day, June 2nd 1942.' The *Gefreiter* wears his uniform proudly; but the tunic is a converted captured Dutch army one: nothing is being let go to waste.

This *Oberst*, who from his other photographs we know is a *Gebirgsjäger*, smiles broadly as he sits on a park bench in the sun. He wears his dress cape and shoes: he is not going out into the field any time soon. His beard would make any Mountain Man jealous, although his haircut is well within regulations.

Larger numbers of older men are being called to active duty. This rather portly *Obergefreiter* in an infantry unit does not fit the bill for any propaganda photograph on the cover of *Signal*. (Nor does his wife.) However, he has done his duty to the Fatherland and wears the Silver Wound Badge proudly. He has been wounded at least three times in order to get this award: unlucky at being hit this many times, very lucky at being alive to have this picture taken. He too wears the Company ID loops, but very thin ones, because even these little things are becoming harder to supply.

This Medical *Unteroffizier* pictured in the spring wears a tunic and cap of earlier issue that show much use; his glasses are not of the regulation issue pattern. The second photograph is captioned 'In front of the Aid Station, Summer 1942'. He now wears a cap of wartime manufacture, his other must have fallen apart. His glasses are now the regulation issue pattern and he wears a clean white Drillich tunic with mixed insignia. The collar lace is the regulation pattern for his rank but he has added a breast eagle and shoulder boards which denote the same rank. At this point in the war no one really cares about his personal uniform tastes while he is treating the sick and wounded.

'Anton, summer 1942'. This Engineer is from *Pionier* Battalion 213, as indicated by his unit identification tabs. The division performed so badly that any decent assets were transferred, including all their artillery and motorised equipment. What was left of the 213th Infantry Division was turned into the 213th Security Division and the men spent the whole of 1942 guarding the rear depots of Army Group South. With such troops as this poor soul's unit, it is understandable why partisans were beginning to have success in engagements in the rear areas. *Obergefreiter* Josef Brass of *Pionier* Battalion 321 remembered: 'We were a front line experienced combat unit and never had much trouble with partisans at all. They would always attack those lazy or disorganised troops in the rear, since we would simply destroy them. The only time we were attacked in Russia by these bandits resulted in over 30 dead, all theirs and it lasted no more than 15 minutes.' Anton and men of his calibre would not fare so well.

An *Unteroffizier* with his family: a photograph for him to carry, to remember every day his reasons for staying alive.

Three brothers. The first one is wearing a highly tailored version of the Tropical Uniform, but this has all standard continental insignia, with white shirt and tropical tie. He wears the Iron Cross 2nd Class and interestingly, two Italian medals, the Italian War Merit Cross for bravery and the Italian-German North African Campaign Medal. The one in the centre is an *Oberzahlmeister*, an officer in the Paymaster Corps: his ribbons show that he has survived the winter battles of 1941/42 and was awarded the War Merit Cross 2nd class for some act of bravery. On his chest he has the Equestrian Badge that shows he is a rather proficient horseman. The third brother also wears a finely tailored tunic with an exceptionally pointed collar; he and the first are both *Unteroffiziers*. Like his brother, he wears the Italian-German Campaign Medal but with the addition of the General Assault Badge: this award means he has met the criteria of direct combat but is not in the infantry, which has a specific badge just for this. This family has seen quite a bit of war so far.

'In memory of your kindness, Oskar 1942'. A well-mannered young man smiles quietly for his picture in a crisp new uniform. His fate is unknown.

The happy family. This older reservist is a member of *Sicherungsbattaillon* 814, which was a lightly armed security unit used for rear area protection and guard duties. He proudly wears the ribbon for service on the Westwall; with a family, he probably prefers this rather safer, more mundane duty along the German border with France. Not everyone wanted to be a hero of the Reich.

'Your son, Georg, August 2nd 1942'. This bears the stamp of a photographer in Gouda, Holland. In his best uniform, Georg has taken time out of his occupation to visit the market. Perhaps he has a craving for some cheese.

Left: This young soldier could be on the cover of any German magazine. The stern, determined young Infantryman does his best to look the part. Even at this stage the numbered buttons on shoulder boards are still being used. His insignia indicate he is in the Kompanie Nr.3 of the *Infanterieschule* at Potsdam. This was one of the better places to be trained and he would soon be putting all he learned to good use at the front.

Below: Headquarters men in the Russian summer heat. To the left is an *Obergefreiter* who has placed all his insignia on his HBT work tunic because at this time the German Army lacked a summer combat uniform for places where Tropical colours were not suited. The practice proved so widespread that the regulations were ignored and a new tunic in this material in the same cut as the issue wool one would be forthcoming by the end of the year. Next to him an *Oberfeldwebel* has done the same with the addition of his ribbons, also contrary to regulations but widely ignored. His messed hair and socks with slippers indicate he may have just been roused from a nap. The next three men are all in more standard attire for the field. On the right sits a motorcycle, most likely a Zundapp, used for despatch work.

The Afrikakorps veteran. Sun-bleached tunic and bearing a look of a proud soldier. He does wear a new private purchase shirt and tie, but he will not give up that tunic that meant so much. Some of the very few veterans left even to this day retain that one uniform item that meant so much, carefully hung in a closet or folded in a chest, never to be discarded.

Back in the desert, out of the studio, this is the way the Landser remembers his days there. A uniform covered in dust and sand, his battered and faded cap and the chill of the desert morning. No Landser from the Afrikakorps ever forgot his pride.

Above: The DAK Landser does his best impersonation of David Niven, complete with captured British officer's shirt. His nonchalant stance, moustached smile and cap at a jaunty angle gives him the impression of being right out of central Hollywood casting.

Left: 'Hugo, July 1st 1942'. Training now complete, this young man will head to his new posting somewhere across Europe, Russia or North Africa.

The Landser on the Eastern Front has a different look. He stares intently at his photographer: his eyes are bagged, his face dirty and unshaven. Field glasses showing much wear and tear hang around his neck.

Opposite: Two for the road. These two soldiers from *Nachrichten* (Signals) *Abteilung* 6 take driver training at the Divisional Depot in Bielefeld. Truck number 2 behind them has the standard military licence plate and the *FAHRSCHULE*, Driving School, placard on the bumper. The rest of the 6th Infantry Division is heavily engaged in Russia with Army Group Centre. When done with this training they will return to the front. The one on the right has non-regulation glasses. They both wear their new issue *Gamaschen*, or leggings. These had been around since before the war but in very limited use; now more and more are being issued, as the leather for marching boots is getting scarce and these are issued first to the infantry. The man on the left has his *Gamaschen* on the wrong legs. Let us hope he could figure out which pedal was which when driving.

This unique image of an older Landser with an unusual rank insignia is dated 19 May 1942. The normal insignia for a senior private would be one of a 'pip' on this same style circle, sewn on the same spot on the sleeve. This has a single bar of lace in lieu of the pip; we don't know why. Strange insignia was beginning to appear in the army by the end of the year, as volunteer units from many former enemy countries and POWs began to form.

Wearing a homemade sweater from *Mutti* or some other female relative.

These brothers have chosen different arms for any number of reasons. The brother on the left is in the *Kriegsmarine*, the German Navy. The *Obergefreiter* of Artillery on the right has seen much service. He wears the Iron Cross 2nd Class ribbon in his buttonhole, the Russian Front ribbon above his pocket and a Black Wound Badge on his chest. His chevron looks straight down because it is sewn on at an angle, so that when he stands to attention it appears as it does now. This was done quite often, even though it was contrary to regulations.

This DAK *Obergefreiter*, looking rather more comfortable than in his portrait on p.273, wears an ascot scarf. He wears his chevron at the same angle as the soldier in the previous image. With elbow bent, it looks perfectly straight.

Another young man finishes training to head off to some front, probably Russia; it is where the need is greatest. His hair is in the perfect regulation army cut, always a sign of someone fresh out of training or in a garrison posting.

Unteroffizier 'Pudding Snout'. His nickname indicates his skill at foraging in tough situations. He has the Iron Cross 2nd Class for bravery and the Westwall ribbon, so he has been a soldier a long time. He has missed a few buttons on his tunic and his goatee has grown a bit, but in the snows of the Russian winter it is doubtful that he will be brought up on charges for being out of uniform.

The toughest guy in town. Germans have always loved westerns and in this photograph a scene from one such movie is emulated by a Landser in North Africa. Revolver tucked in his belt, cigarette in mouth and standing in the 'tough hombre' pose, this fellow has a comical look. The revolver is a captured British Webley. His shirt also comes from British stocks. The men of the DAK were neglected by their own logistical system because of the war in Russia, so why waste perfectly good clothing, since in the desert every uniform ends up sun-faded khaki?

In his dress uniform, this young man shows a steely determination, though the apprehension of what he will face in combat is there in his expression. Simply captioned on the reverse with 'Rudolf Velabil, On the 23rd of September 1942 died a hero's death at the gates of Leningrad.'

Index

If you enjoyed this book, you may also be interested in …

Normandiefront: D-Day to Saint-Lô through German Eyes
VINCE MILANO AND BRUCE CONNER

'This book is an important piece in the enormous Normandy jigsaw and should be on the reading list of anyone interested in "the other side of the wire" on D-Day.' *Navy News*

With over 200 photographs and priceless interviews with German veterans, *Normandiefront* is the story of how one German division changed the course of the invasion. It explains why the Americans on Omaha Beach suffered The Longest Day of all.

978 0 7524 7145 7

Death on the Don: The Destruction of Germany's Allies on the Eastern Front, 1941–1944
JONATHAN TRIGG

Not all the men who took part in the largest invasion in history – Operation Barbarossa – were Germans. Over 500,000 were Romanians, Italians, Hungarians, Slovaks and Croatians – Hitler's Axis allies. Sometimes badly led, often badly equipped, they fought and died in the East for a foreign power. How and why?

978 0 7524 9010 6

We Died with our Boots Clean: The Youngest Royal Marine Commando in WWII
KENNETH MCALPINE

'This fascinating book once again proves that the truest records of the Second World War lie in the memories of the ordinary soldiers who fought on the ground.' *The Sunday Times*

At the age of seventeen, Kenneth McAlpine ran away from Repton school to join Churchill's new elite special force, the Royal Marine Commandos. As the youngest member of the youngest fighting unit, and after three months of the toughest training, he found himself fighting on the beaches of Normandy.

978 0 7524 6042 0

Visit our website and discover thousands of other History Press books.

www.thehistorypress.co.uk